Collage
with Photoshop

Written by Russell Sparkman, Edited by AGOSTO and AXXi

ROCKPORT PUBLISHERS • GLOUCESTER, MASSACHUSETTS
Distributed by North Light Books • Cincinnati, Ohio

Collage with Photoshop
by Russell Sparkman

Copyright 1995 © Mu, Inc. and AXXi, Inc.
Text © by Russell Sparkman

First published in Japan in 1994 by Mu, Inc., and distributed by
Graphic-sha Publishing Co., Ltd., Tokyo, Japan

Distributed in the USA by :

North Light, an imprint of F & W Publications

 1507 Dana Avenue
 Cincinnati, Ohio 45207
 Telephone: (513) 531-2222

All rights reserved. No part of this book may be reproduced in any form without written permission of the copyright owners. All images in this book have been reproduced with the knowledge and prior consent of the artists concerned and no responsibility is accepted by producer, publisher or printer for any infringement of copyright or otherwise, arising from the contents of this publication. Every effort has been made to ensure that credits accurately comply with information supplied.

Distributed worldwide ex-Japan, Hong Kong, Singapore, Taiwan and China by :
Rockport Publishers, Inc.
33 Commercial Street
Gloucester, Massachusetts 01930
Telephone : (508) 282-9590
Fax : (508) 283-2742
ISBN 1-56496-210-5
10 9 8 7 6 5 4 3 2
Printed in Hong Kong by Everbest Printing Co., Ltd.

Preface

New ideas are generated when a large amount of information enters the brain and is distilled. Naturally, the quantity of input affects the quality of the output. This basic law of the information world also applies to art: The more images assimilated, the better. When these images combine and reach critical mass, something new is born that is more powerful than its individual elements.

Image-processing applications such as Adobe Photoshop used on desktop computers, can bring about the creation of numerous new images in a very short time. They give artists incalculable freedom not found in traditional media such as paper and canvas, helping them add different special effects to images, combine multiple images, and even bring old images back to vibrant life. The advent of Specular Collage, with its ability to handle large numbers of images simultaneously, sparked a revolution in image processing.

The creative processes of 14 modern American Macintosh artists are recorded in this book. It shows the master techniques they apply using Collage, Photoshop, Painter and other graphics programs and demonstrates exactly how they veered off into unknown visual territory to create new images. All of the interviews and descriptions were conducted and written by Russell Sparkman, a computer artist, instructor and writer on computer imaging techniques who has worked in both Japan and the United States.

This narrative provides insight into the methods and shortcuts of 14 premier artists. For readers unfamiliar with Collage, or who have not had enough time to master all of the program's functions, the best starting point is the 10-page section entitled "Basic Collage," in which Sparkman explains the program's fundamentals using his own original artwork. Also included is an update on Collage 2.0.1, describing the powerful new performance characteristics Collage now offers, such as support for Power Macintosh and the CMYK format, Photoshop 3.0 compatibility, and shadow and feather palettes. This Collage update is located at the back of the book.

The Gallery pages represent the second most significant element, presenting a collection of artwork by the 14 artists featured. This extensive, full-color gallery showcases the work of the artists and provides creative and incentive ideas for the experienced and novice artist alike.

This book was a collaborative effort involving Japanese and American graphic design industry professionals. Three of us— art director Kazumoto Yokouchi of Axxi; writer Russell Sparkman; and myself as editor— were joined later by Chris Rutter, the project coordinator. We began making calls on the artists early last spring, and in three weeks covered six cities on both coasts of the American continent. We will never forget the natural collage of fresh spring greenery we saw as we drove our rental car through Amherst, Seattle, Philadelphia, San Francisco, San Diego, and Newburyport, nor the singular workplaces of the artists we visited there.

I would like to express my appreciation to Mr. Adam Lavine, president of Specular International and his employees; Mr. Shigeru Kawamata, vice president of MU, Inc., who gave us his kind support throughout the project; and Mr. Toshiro Kuze of Graphic-Sha Publishing, who kindly assented to distribute this book. Finally, I wish to thank the 14 artists whose works and methods appear herein for their full and unstinting cooperation.

Spring 1995
Ichiro Hirose, Editor

Collage
with Photoshop

Preface .. 3
Introduction ... 7
About Collage 8
Basic Collage 10
Collage 2.0.1 Features 206
Credit .. 209
About Author / Editor 210

Joseph Kelter .. 22

Glenn Mitsui .. 36

Diane Fenster .. 50

Steve Lyons .. 66

Jeff Brice .. 78

Thirst .. 92

Pamela Hobbs .. 108

Contents

Lance Hidy 120

SKOLOS/WEDELL 128

Marcolina Design/Dan Marcolina 142

John Hersey 156

David Carson 166

Bert Monroy 180

Jack Davis 192

Introduction

When Jeff Brice told me he was excited about this new application, Specular Collage, I knew it had to be an impressive design tool. New technology doesn't beguile Brice. Creative options do. When other designers flocked to Photoshop, he was content to keep working in ColorStudio. He's working in Photoshop more often now — but only because the Collage-Photoshop combination gives him more artistic control than previous working methods did.

Throughout this book, you'll see the work of artists who are every bit as demanding as Brice. They won't settle for anything less than excellence in their work, and this trait has placed them in the forefront of electronic design. This is the caliber of artists we look for in the projects we follow in Step-By-Step Graphics and Step-By-Step Electronic Design, and in fact, we've featured most of these designers in those publications. We know their design standards are so high that they'll always bring out the best in the software they use. The Collage manual can tell you how the program functions, but this book — and the work featured here — will show you how creative it can be.

<div style="text-align:right">
Talitha Harper

Editor in Chief, Step-By-Step Electronic Design

Electronic Design Editor, Step-By-Step Graphics
</div>

About Collage

If you're an illustrator or graphic designer who regularly uses Adobe Photoshop to create digital illustrations, you may have noticed an interesting phenomenon related to saving changes made to images. The permanence of the saved changes is directly proportional to the number of Save As versions of the image you make along the way. The fewer the Save As versions, the greater the likelihood you'll settle for an image that you're less than satisfied with.

The problem intensifies when the image is made of many elements composited together with complex masks and numerous filter effects. It becomes impossible to explore creative options without filling up precious hard drive space with multiple versions of the same image.

These are some of the issues that Andrei Herasimchuk, 2-D Product Manager at Specular International in Amherst, MA, found himself facing when he first conceived of the idea for Specular Collage. Herasimchuk was in the process of using Photoshop 2.5 to create a brochure image for one of Specular's other products, Infini-D, when he received a phone call from computer artist Joseph Kelter. During the course of the conversation Herasimchuk began complaining about the project.

"I kind of grumbled to Kelter about having to use Photoshop to create an 8.5 by 11 inch cover page containing about 10 to12 elements, with shadows, transparency and rotations," recalls Herasimchuk. The conversation, he says, eventually turned to the topic of high-end imaging systems, such as Quantel Paintbox.

"We were going on and on about how great those systems were because they had this object-oriented approach to imaging where you could just pick things up and move them around at will," explains Herasimchuk. The story would have ended there, except that Herasimchuk couldn't shake the feeling that there must be a similar solution for the Macintosh.

"I woke up the next morning," Herasimchuk explains, "and while I was in the shower it suddenly dawned on me that there was really no good reason there wasn't a program like that on the Macintosh. It's just that nobody had done it yet."

Herasimchuk's shower revelation came to him in late November 1992, and by the end of December he had designed the concept which formed the basis for Collage. "I showed it to Adam Lavine, President of Specular International, and vice-president Dennis Chen, and they loved the program," Herasimchuk explains, "they were the guys with the authority to make it happen and they did." Collage 1.0 went into development full-time in January 1993, he adds, and was officially released in December 1993.

The fruit of the Collage development team's labor is a specialized program that's used primarily as a tool to composite bitmap images imported from other programs. Except for using fonts, Collage has no image or shape generating ability of its own, nor does it have a sophisticated set of paint tools or color correction features.

That's because Specular didn't set out to reinvent the wheel when it designed Collage, says Herasimchuk. Rather than develop a full set of image editing features similar to those that already exist in Photoshop, he explains, the intention was to create an auxiliary program that was an entirely new approach to creating digital images. "Basically, what I wanted was a QuarkXPress that had a photocompositing engine inside of it," adds Herasimchuk.

The result is that Collage has a very limited set of image manipulation tools. But what the program lacks in quantity of features, it makes up for in quality of function.

For example, the Collage development team incorporated a system of handling bitmap images as individual objects, stacked in layers. At any time, the location of the images in the vertical hierarchy of layers can be changed and the images can be moved about the canvas freely. To be fair, this is not an

entirely new approach on the Macintosh. Fractal Design Painter X2 and HSC Live Picture introduced object-oriented bitmaps on separate layers in 1993, and Adobe Systems released Photoshop 3.0 with its own layering scheme in the fall of 1994.

But what sets Collage apart from these other programs is its method of managing high-resolution imaging tasks on the Mac. When a project starts in Collage, high-resolution images created in Photoshop, or elsewhere, are imported, singularly or in groups. During the import process, a low-resolution copy, called a proxy, is made of each imported image and stored in a special folder. From that point on, as the image is composited in Collage, all commands, such as special effects, cropping, or scaling, take place using the proxies.

When a project is finished, it's rendered. The rendering process takes the instructions that were applied to the proxies and uses them to composite a final image using the original high resolution elements. Since this is a time consuming process, the most common scenario is to render while you sleep.

"That's one of the interesting things about Collage," explains Herasimchuk, " You don't work on the actual image. What you're working on is a representation of it. That comes straight from a 3-D point of view where you're working on a wireframe or flat-shape, then you render the real version later. That's really the same thing you do in Collage."

And like a 3-D program, where endless versions of an image can be rendered, no version of a Collage image is ever final. The proxy system means that images can be modified and re-rendered indefinitely, without the worry of filling disk space with multiple Save As versions. While these features are strong, Collage would be only a production tool if that's all there was to the program. But there's more. Collage features a "live" method of using masks imported with images by allowing the user to turn the mask on or off. When combined with another Collage feature, Transfer Methods, the creative possibilities are boundless.

Just as boundless, it seems, are the constant changes and upgrades that software companies make to their products. And Specular's approach to Collage is no exception. This book project began with Collage 1.0, and by the time the English version went to press (the book was first published in Japanese in October, 1994), Specular had released Collage 2.0.1.

In addition to adding features such as the ability to import CMYK files and to create larger image sizes, Specular's release of Collage 2.0.1 addressed two major changes in the industry.

First, Specular upgraded Collage to run in native mode on Apple Computer's new Power Macintoshes. As expected, the speed of the program, from compositing elements to adding special effects such as feathering and shadowing, has been greatly increased. Second, Specular strengthened Collage's role as a companion program to Photoshop by incorporating the ability to render and save images into Photoshop 3.0's new multi-layer format. This means that images can be quickly composited in Collage and then re-opened in Photoshop for further editing on individual layers. (Additional new features of Collage 2.0.1 are described in the chapter titled "Collage 2.0.1 Features").

By staying current with Photoshop 3.0's layering capability, Collage remains a useful tool for compositing large images which would otherwise bog down all but the most powerful Macintoshes. This means that if you're one of those artists who's continually pushing the limits of available RAM and scratch disk space, Specular Collage 2.0.1 could be the solution you're looking for.

The Mind Seeks

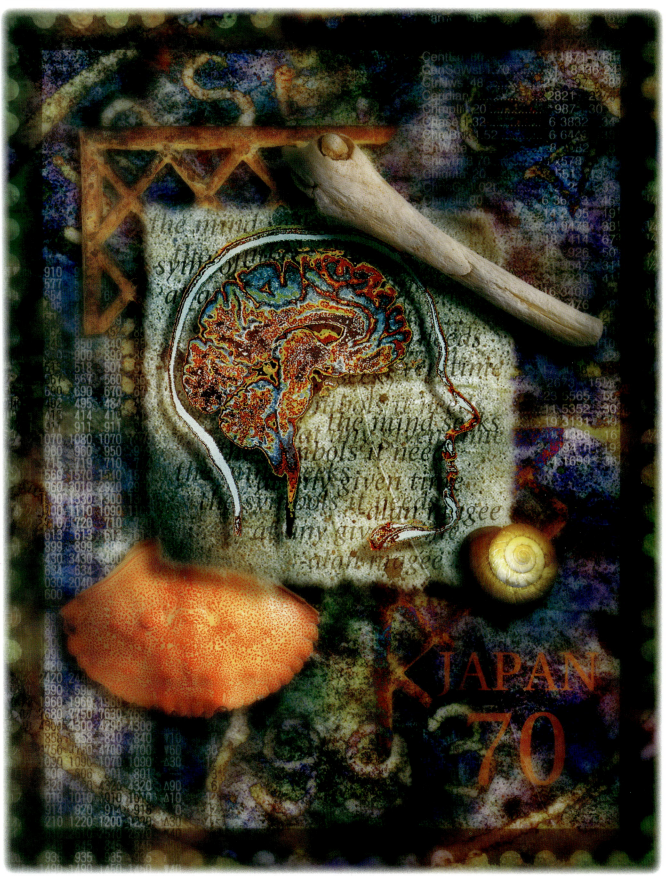

This work, entitled "The Mind Seeks," was created by Russell Sparkman to illustrate the basic features of Collage.

By Russell Sparkman

Basic Collage

❶

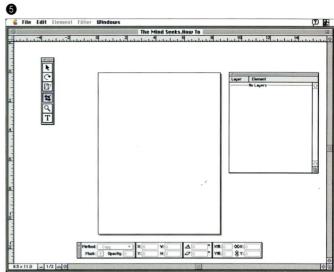

❺

Step 1

The first step in all Specular Collage image compositions is to use another program, such as Adobe Photoshop, to prepare bit-mapped image files for use as source material. Almost all of the images that are used as source files to create the illustration, "The Mind Seeks," in Collage began life as Photo CD and flatbed scans. These scans were opened one at a time in Photoshop, where they were prepared for use in Collage. Preparation included not only color corrections, touch-ups and filter effects, but also the creation of masks for separating foreground objects from their backgrounds. All the files were saved, with their masks, in Photoshop 2.5 format (*Fig. 1*).

Step 4

The four main features of the Collage interface appear on the monitor immediately after saving the new project (*Fig. 5*). These include the Tool palette (left), a canvas (middle), the Information palette (bottom) and the Element palette (right).

❷

Step 2

After preparing source files in Photoshop, the next step is to open Collage and create a new canvas using the New Project dialog box. Collage includes a selection of preset canvas sizes, and custom size canvases are created by entering dimensions into the Width and Height fields (*Fig. 2*).

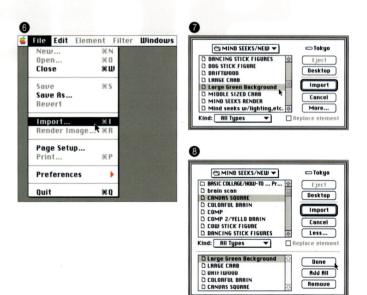

❻ ❼

❽

❸ ❹

Step 3

After clicking OK in the New Project dialog box, Collage asks for a name for the new project and then prompts the user to Save (*Fig. 3*). Saving the project creates two items — a Project file and a folder that holds the low-resolution proxies (*Fig. 4*).

Step 5

Before work can begin in Collage, it's necessary to import the bitmapped source images by choosing Import from the File menu (*Fig. 6*). The Import dialog box provides an option to import images one at a time (*Fig. 7*) or in groups (*Fig. 8*). After clicking Done, Collage begins a behind-the-scenes process of creating low-resolution proxies of the higher resolution source images and saving them into the project's proxy folder. Depending on the total number and sizes of files imported, this process can generally provide enough time to make coffee or to cold-call a prospective client.

Collage with Photoshop

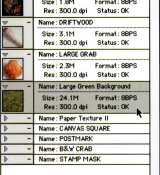

Step 6

After the import process is completed, each entry in the Element palette represents a low-resolution proxy of an imported image. These entries contain information about the original images including file size, file status and a thumbnail-sized view of the original image (*Fig. 9*).

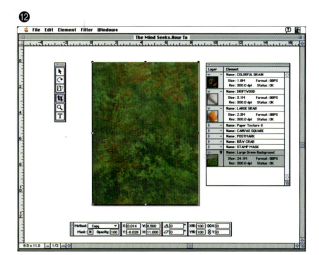

Step 8

After several steps involving much work and little play, the process becomes more interesting as the fun of creating the new image in Collage actually begins. For "The Mind Seeks" the first element to be placed onto the canvas is the scan of the green textured background. This is accomplished by clicking and dragging it from the Element palette (*Fig. 12*).

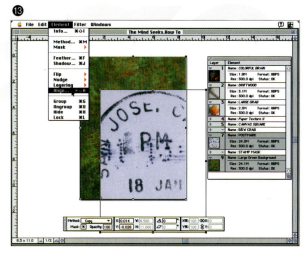

Step 7

Since Collage handles bitmapped images as separate objects on separate layers, it's possible to move images between layers at will. Layers in Collage are stacked one atop the other and are managed in the Element palette, with the top element representing the highest layer and the bottom element, the lowest layer. Moving images between layers (changing layering order) is accomplished by simply clicking and dragging an entry to a new position in the stack. Here, the file named Large Green Background is moved from the middle layer (*Fig. 10*) to the bottom layer (*Fig. 11*) by changing its position in the Element palette.

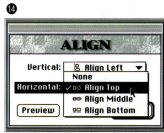

Step 9

The process of building the "The Mind Seeks" image starting with the background continues with the addition of a large postmark onto the canvas. The postmark has exactly the same dimensions as the green background. When the postmark first appears on the canvas, its position is over the lower right hand corner of the background (*Fig. 13*). Since the postmark was originally sized in Photoshop to line up exactly over the background, the Align dialog box is selected from the Element menu to align the two images by matching their top and left edges (*Fig. 14*).

Basic Collage 13

Basic Collage

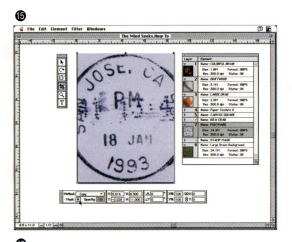

Step 10

After the postmark is aligned with the background, the background becomes completely obscured from view *(Fig. 15)*. However, a mask had been prepared in Photoshop to select only the black linework of the postmark. In Collage, this mask is made active by turning on the Mask option on the Information palette. With the postmark's mask turned on, the background element appears through the foreground element *(Fig. 16)*.

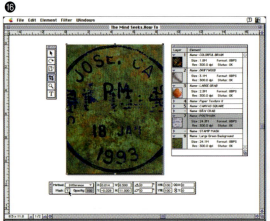

Step 11

The next element added to the image, and placed on a layer between the postmark and the background, is a grayscale file representing the shape of a postage stamp *(Fig. 17)*.

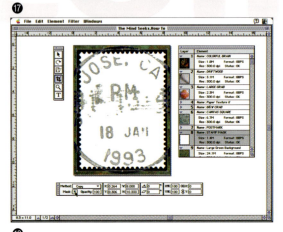

Step 12

In Collage, all images first appear on the canvas in a default Copy method, one of nine Transfer Methods available through either the Method dialog box or the Information palette. Since the Transfer Methods affect how images blend, they can be applied for either special effects or completely utilitarian uses. In this case, the white portion of the postage stamp element is made transparent by using the Multiply method *(Fig. 18)*.

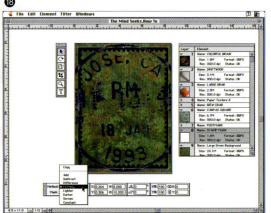

Collage with Photoshop

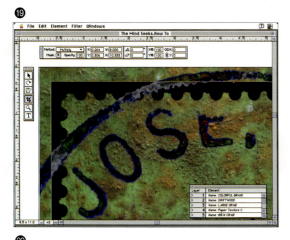

Step 13

With the white portion of the stamp image removed, the black border of the stamp looks too solid and heavy *(Fig. 19)*. To blend the black stamp border into the background, Method is selected from the Element menu. The Method dialog box works similarly to Photoshop's Composite Controls. The Canvas slider in the Color Range controls is adjusted to gradually bring some of the lighter background tones through the darker tones of the stamp border *(Fig. 20)*.

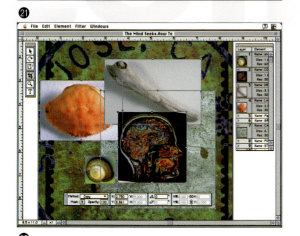

Step 14

At this stage, the background elements are in place and, to keep them from being accidentally shifted, they are selected and grouped into one element. Then additional components are added to the canvas by clicking and dragging them from the Element palette onto the canvas *(Fig. 21)*.

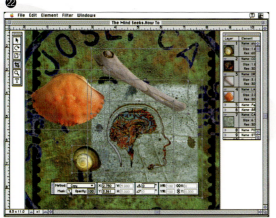

Step 15

Collage allows groups of selected objects to be given the same command. Here, all the newly added images are selected by shift-clicking on the corresponding items in the Element palette. Then, by activating the Mask option on the Information palette, all masks are turned on at the same time *(Fig. 22)*.

Basic Collage

Basic Collage

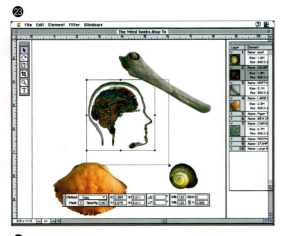

Step 16

Scaling, rotating, and skewing images in Collage can all be achieved with tools from the Toolbox, or by entering values in the Information palette. In this case, the Arrow tool is used to select and drag a point on the image frame to increase the size of the brain image *(Fig. 23)*. (To demonstrate this, the background elements have been hidden by choosing Hide from the Element menu.)

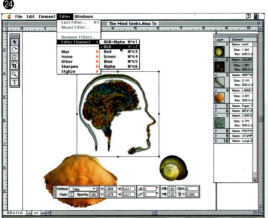

Step 17

By scaling the image of the brain, some softening could be expected in the final rendered image due to interpolation. To compensate, the Sharpen filter is used. First, only the RGB channel is selected by choosing Filter Channel from the Filter menu and RGB from the submenu *(Fig. 24)*. Then, Sharpen is selected from the Filter menu and applied to the image *(Fig. 25)*.

NOTE: Collage provides a range of filters and allows the use of many Photoshop plug-in filters. However, because Collage works with low-resolution proxies that are later rendered into higher-resolution image, only filters which are resolution-independent work predictably.

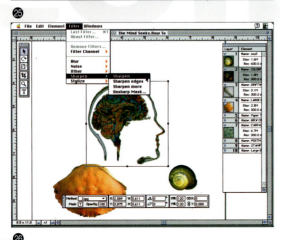

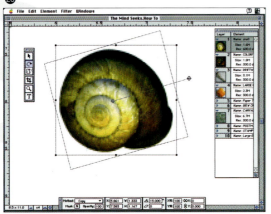

Step 18

After placing the snail shell onto the canvas, the darker shadow that appears at the top of the shell looks out of place. The shell's light source appears as if it is coming from a different direction than the light source for the other objects on the canvas. To fit the shell into the picture better, the Rotate tool is used to manually rotate the shell *(Fig. 26)*. Rotation can also be specified by entering the degrees of rotation in the Information palette.

16 *Collage with Photoshop*

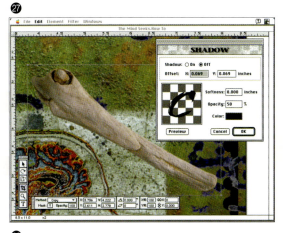

Step 19

Shadows play an essential role in adding depth and dimension to an image. In Collage, this effect is accomplished by adjusting attributes in the Shadow dialog box *(Fig. 27)*. You may select this by choosing Shadow from the Element menu.

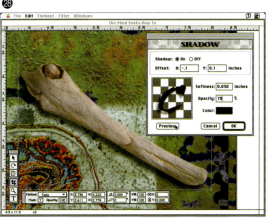

Step 20

All attributes of a shadow cast by an object can be controlled from the Shadow dialog box. Here, the shadow cast by the driftwood is shifted to the left and down by entering a negative number into the X coordinate box and a positive number in the Y coordinates box. Degrees of softness, opacity and even shadow colors can be precisely controlled by clicking the Preview button to test different settings *(Fig. 28)*. To ensure uniformity of appearance, multiple objects that will cast shadows can be selected and given the same shadow attribute at the same time.

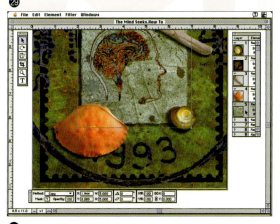

Step 21

At any point, an element in Collage can be moved to a different layer. Here, the crab shell is too prominent and would look better tucked under the swatch of material *(Fig. 29)*.

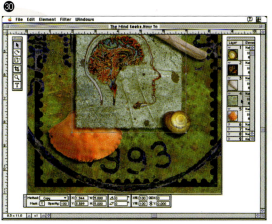

Step 22

After selecting the swatch of material in the Element palette, it is dragged onto a layer higher than the crab shell. Now the swatch and its shadow appear to be hovering above the canvas and the crab shell *(Fig. 30)*.

Basic Collage

Basic Collage

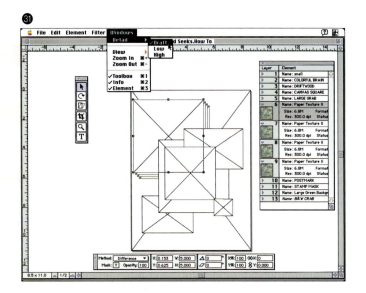

Step 23

When many elements with multiple attributes such as feathering, shadows, rotations, and Transfer Methods are placed onto the canvas, screen redraw rates can slow down appreciably. To overcome this problem, Collage offers a choice of three Detail modes, from fastest to slowest. The Draft mode shows only an opaque frame for each image, and is the fastest mode for moving objects about the canvas. The Low mode shows the image but with features like shadows and feathering disabled and the High mode, which is the slowest, displays all elements with full effects. Here, Draft mode has been turned on so that four pieces of a background texture can be quickly distributed around the image *(Fig. 31)*.

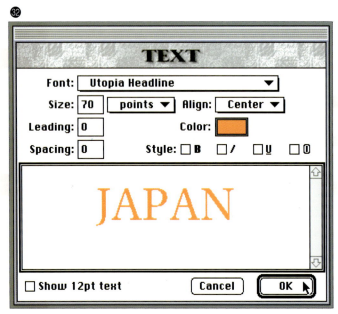

Step 24

Type is needed to add to the symbolic appearance of a stamp in this illustration. This is accomplished within Collage by using the Text tool to set type attributes such as font, type size, alignment, and color *(Fig. 32)*. Type comes into Collage with a Mask turned on and can be manipulated like any other image file.

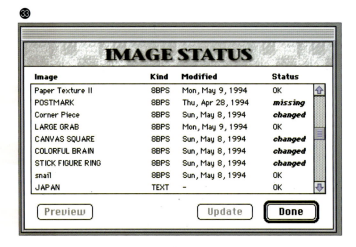

Step 25

Image files imported into Collage are not sacrosanct. Even after extensive work has been done in Collage, the original source images can continue to be edited in Photoshop without having to import an entirely new version. After most of the work was done to "The Mind Seeks" in Collage, some modification of the original files was needed. For example, in Photoshop, additional work was done on some masks and color adjustments were made to some images. Back in Collage, when Image Status is selected from the Edit menu, the Image Status dialog box appears. The Status column indicates that changes have been made to the source images and need to be updated. The missing status of Postmark resulted from moving the image from one folder to the other, and Collage indicated that it needed to know the location of the image *(Fig. 33)*.

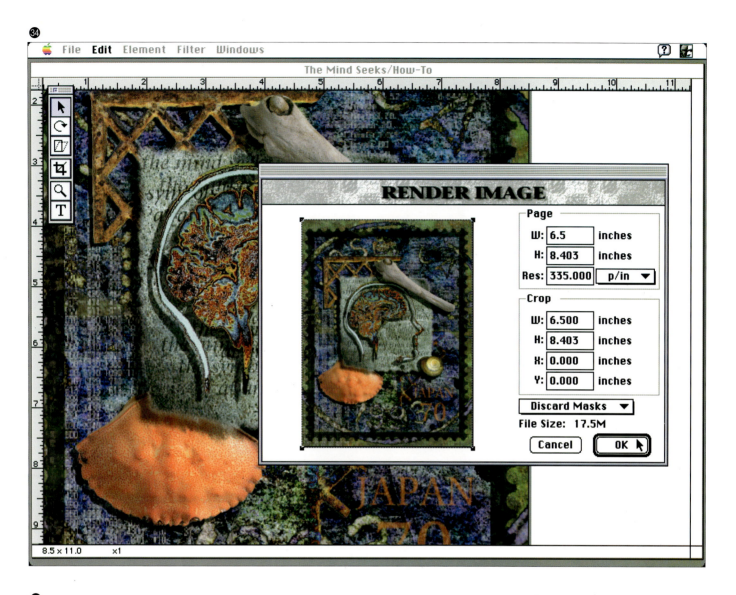

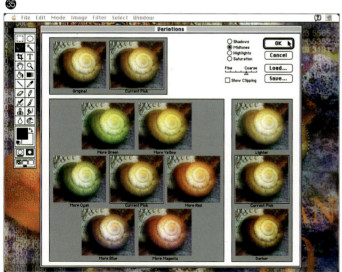

Step 26

The final step in Collage is to render the composited image. The Render Image dialog box provides a range of choices, including file size, cropping, file format, and mask options *(Fig. 34)*. While the resulting rendered file is a single bit-mapped image, the original Collage project retains its object-oriented properties. This means that additional editing and re-rendering options are limitless. After an image is rendered and saved as either a PICT, TIFF or Photoshop 2.5 format file, it can be opened in any program supporting those formats. In this case, "The Mind Seeks" is opened in Photoshop where special effects, such as selectively toned areas with the Variations feature, are added as a final touch *(Fig. 35)*.

The Collage Gallery

**FOURTEEN ELECTRONIC DESIGNERS
GO STEP BY STEP THROUGH THEIR ARTWORK**

Joseph Kelter

Joseph Kelter, the owner of Bad Cat Design in New Hope, Pennsylvania, has been creating artwork on computer systems since the early 1980s. After graduating with a degree in painting and illustration from Hussian School of Art in Philadelphia, in 1988, his experience led him to full-time work creating digital artwork on a Lightspeed computer graphics system.

Kelter describes his early days of digital imaging on "ancient computer systems" that ran on the UNIX operating system, as being fraught with challenges. For example, whenever the systems crashed, he had to learn UNIX programming to bring them back up and running. "I was a hack," he admits, "I did whatever it took to get the job done." Today, Kelter is busy creating computer generated illustrations for companies such as American Airlines, General Foods, Macworld, and Specular International. And his Quadra 800 allows him to be more creative with less effort than in his early days.

"I like what I'm doing in print," Kelter says with an eye toward the future, "but I'd like to get more into animation." A self-professed 3-D and animation software junkie, he reads everything he can about virtual reality and has begun creating video work using an Avid Media Suite Pro video system.

The Material Order
1994 / Self-Promotion
Software: Adobe Photoshop2.5.1, Adobe Illustrator5.0.1, Specular Infini-D2.5.2, Specular Collage1.0.1, Specular TextureScape beta, Aldus FreeHand4.0a, Fractal Design Painter2.0a

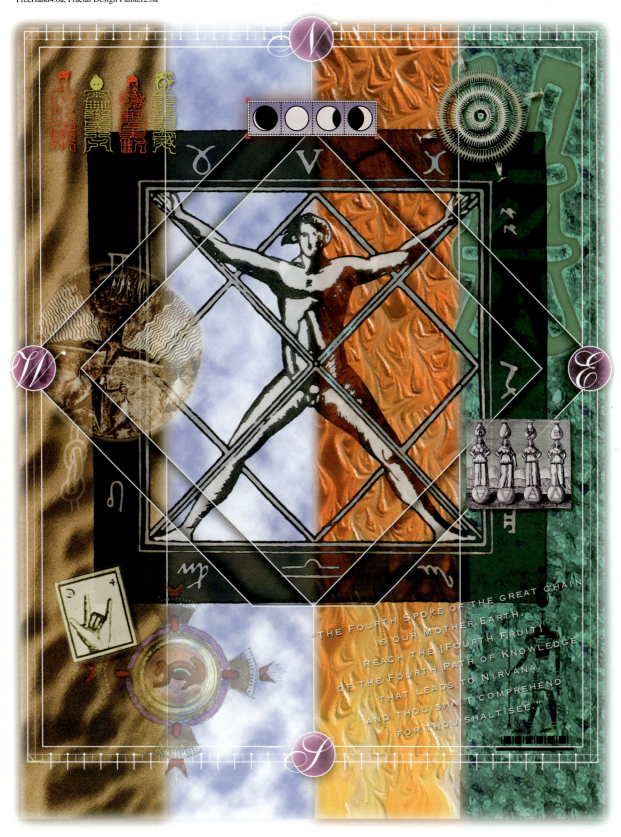

Kelter created "The Material Order" as part of a conceptual series to promote his studio, Bad Cat Design. According to Kelter, the image incorporates cultural images and symbols, such as the four natural elements of Earth, Wind, Fire, and Water, to illustrate interpretations of "The Material Order" by various civilizations, based on the number four.

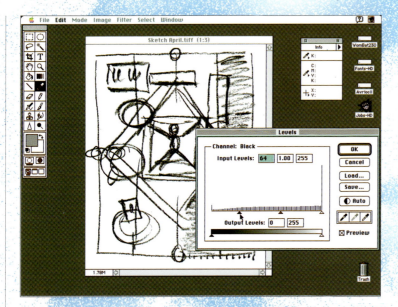

Step 1

As a starting point for "The Material Order," Kelter created a pencil sketch of the illustration, which he then scanned and opened in Adobe Photoshop. In Photoshop, Kelter increased the contrast of the black-and-white sketch using the Levels dialog box. Because he intended to use this sketch as a reference in Aldus FreeHand 4.0, he saved the file in TIFF format.

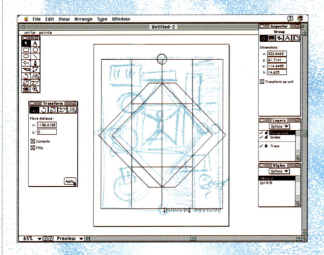

Step 2

In FreeHand, Kelter placed the TIFF image into a new file. Using the Layers palette, he placed the sketch on the background layer in order to use it as a template for tracing. Then, using FreeHand's drawing tools, he created the image's basic linework. To accurately size and position shapes and rules, Kelter used FreeHand's Inspector and Transform palettes. After completing the linework, he exported the file in Illustrator 3.0 format so that it could be opened in Illustrator 5.0.

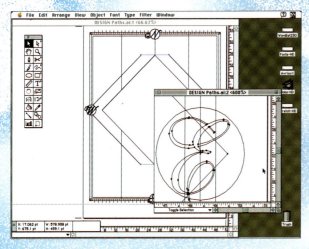

Step 3

Next, Kelter opened the file in Adobe Illustrator 5.0 where he fine-tuned the linework. Kelter likes to make fine-tuning adjustments to EPS files in Illustrator, rather than FreeHand, prior to exporting them to Photoshop because Adobe Illustrator ensures a higher degree of accuracy in line weights and type placement.

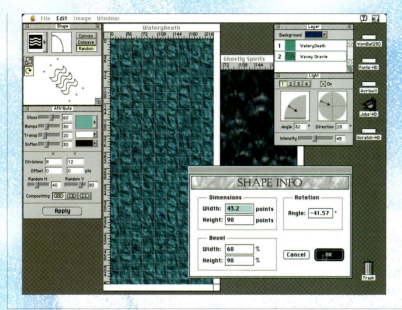

Step 4

To symbolize the elements of Earth, Wind, Fire, and Water that make up the image's background, Kelter used computer-generated textures and a scanned photograph of sand dunes. The stylized water texture, as well as the sky texture, were created in Specular TextureScape, a texture-generating program which uses PostScript shapes as the basis for the texture. The water texture began with a wavy outline which was enhanced with attributes such as lighting, color, and bump-mapping to get just the right look and feel.

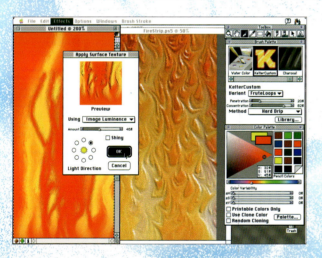

Step 5

Next, Kelter went to work on the fire texture using Fractal Design Painter. He began by laying down red and orange colors. Then, using a custom brush, he blended the colors together by smearing one into the other, creating a flame-like texture. To further enhance the effect, he used Painter's Apply Surface Texture dialog box to add depth and dimension to the flames.

Step 6

After finishing work on the fire texture, Kelter created an illustration (keeping Painter open) based on Hopi Kiva wall paintings. The colors of the illustration were built up by layering lighter tones over the darker using Painter's Charcoal and the Chalk brushes.

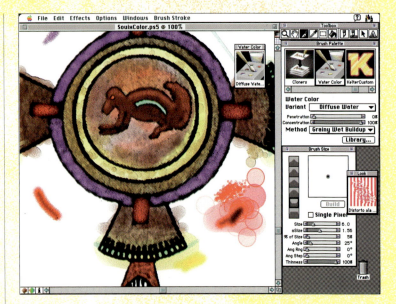

Step 7

Because Kelter wanted the colors of the Hopi illustration to have a more earthy, weathered appearance, he diffused the Charcoal and Chalk colors using Painter's Water Color brushes.

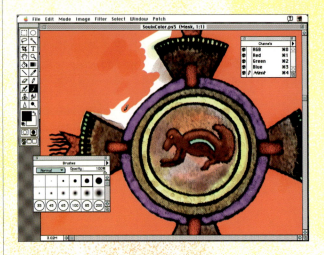

Step 8

To be able to use the Hopi illustration in Collage, Kelter needed to create a mask. He used Photoshop's Quick Mask mode to paint in the mask. He then saved the selection in channel #4.

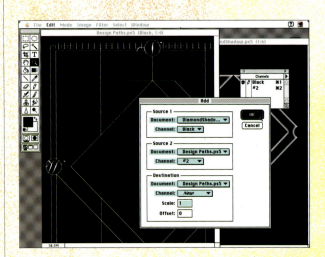

Step 9

Kelter created the shadows that appear inside the diamond shape of the final image to add a sense of depth. To create these shadows, Kelter used a series of Photoshop Calculate commands to generate a mask which would later be used in Collage to create the shadow.

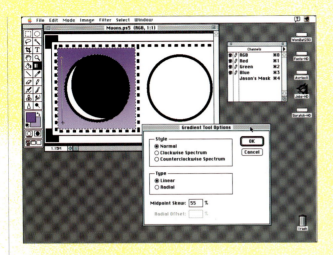

Step 10

The four phases of the moon began as Illustrator files, which were then opened in Photoshop. Kelter selected areas in which he wanted to add color, then used the Gradient tool. The file was then saved, with a mask, as a Photoshop 2.5 file.

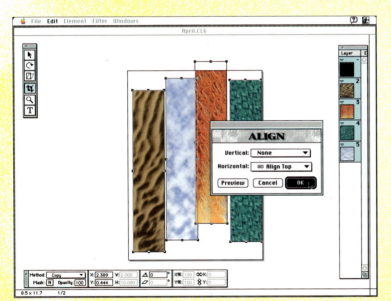

Step 11

After Kelter finished creating the many elements he planned to use in "The Material Order", he opened Collage. Then he imported the Earth, Wind, Fire, and Water components and dragged them onto the canvas. Next, he used Collage's Align dialog box to precisely position the images next to each other.

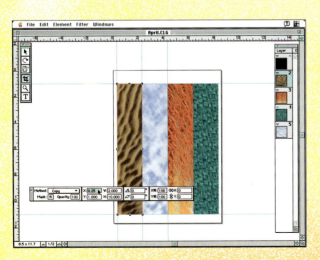

Step 12

After aligning the background elements, Kelter used the Information palette and guides to precisely size the elements to be sure they would align properly with the linework he created in Illustrator. Kelter points out that Collage allows the user to work in either a very free-form style or with a high degree of precision.

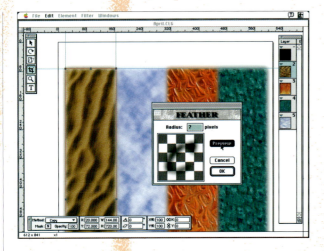

Step 13

Next, he applied feathering to each of the background elements to smoothly blend one into the other. Because Collage allows the artist to preview the feathering before clicking OK, Kelter was able to choose precisely the look he wanted.

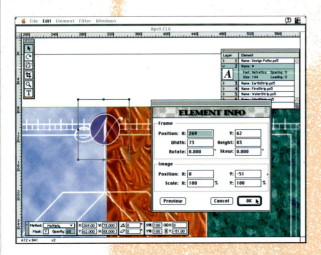

Step 14

Collage does not provide drawing tools but if the artist employs a little ingenuity, he or she can generate a wide range of shapes using the Text tool. For example, in working on "The Material Order," Kelter used the Text tool to create large bullets to use as feathered, transparent circles under each of the compass points. The bullets were placed into position using the Element Info dialog box.

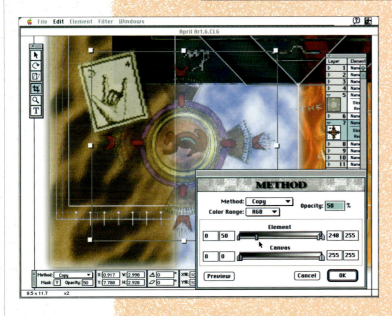

Step 15

To blend the various components into the background, Kelter made use of the Method dialog box, which functions almost identically to Photoshop's Composite Controls dialog box. By adjusting the Element slider of the Method dialog box, Kelter was able to subtly weave the background texture in and out of the foreground, Hopi Indian artwork.

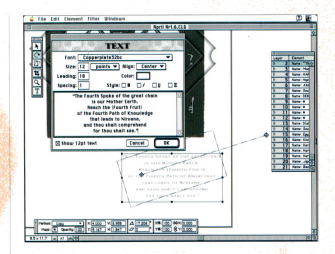

Step 16

Kelter used Collage's Text dialog box to enter type directly from within the program. By viewing the text in 12 point size, he was able to see all the type at once so that he could edit line breaks and align the text. After clicking OK, he rotated the type and created a drop shadow to make it more legible.

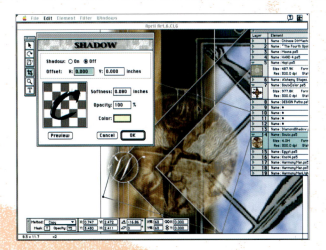

Step 17

After Kelter composited the Sioux Indian shield into the image, he gave it a slight glow by creating a shadow with an offset of 0,0.

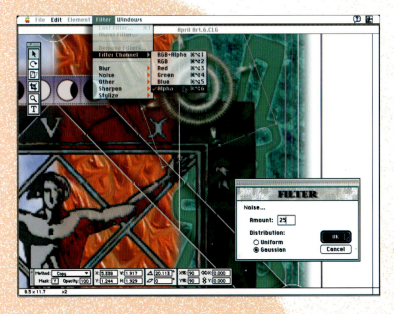

Step 18

When some objects were composited using the Method dialog box to blend one into the other, their edges took on a slightly rough appearance. To match the shadow to the object's edge, Kelter selected only the object's alpha channel and applied the Add Noise filter. After tweaking elements in Collage, the image was rendered and saved using the Render Image dialog box. As a final touch, Kelter opened the image in Photoshop and fine-tuned the colors.

Gallery
Joseph Kelter

SYSTEM:
Apple 16" monitor, Apple 13" monitor, Macintosh Quadra 800, 24MB RAM, 230MB internal hard drive, 2GB external hard drive, pressure-sensitive tablet, 44/88MB SyQuest drive, RISC accelerator, 600dpi flatbed scanner, 2GB DAT tape drive.

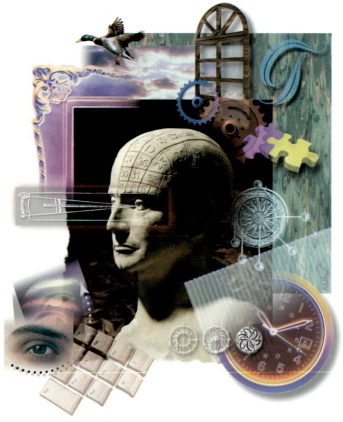

Collage

1993 / Specular International : Package Illustration
Software: Adobe Photoshop2.5.1, Adobe Illustrator5.0.1, Specular Collage beta, Specular Infini-D2.5.1, Aldus FreeHand3.1

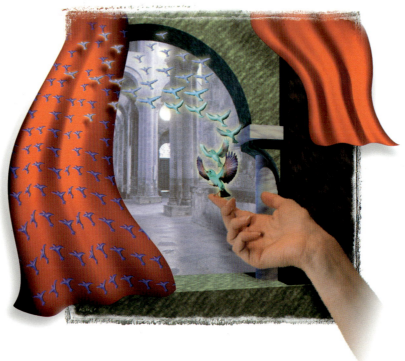

TextureScape

1994 / Specular International : Package Illustration
Software: Adobe Photoshop2.5.1, Adobe Illustrator5.0.1, Specular Collage1.0, Specular Infini-D2.5.1, Specular TextureScape beta, Aldus FreeHand4.0, Ray Dream Designer beta, Alias Sketch! beta

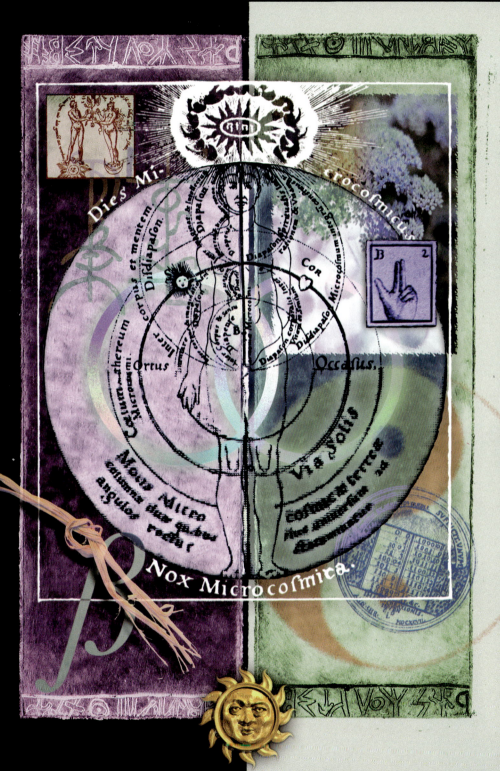

Gallery
Joseph Kelter

Photoshop Accelerators
1993 / Macworld Communications : Editorial Illustration
Software: Specular Infini-D2.5.1, Specular Collage1.0, Adobe Photoshop2.5.1, Adobe Illustrator5.0

Global Market
1994 / Marlton Technologies : Annual Report
Software: Alias Sketch2.0 beta, Specular Infini-D2.5.2, Adobe Photoshop2.5.1

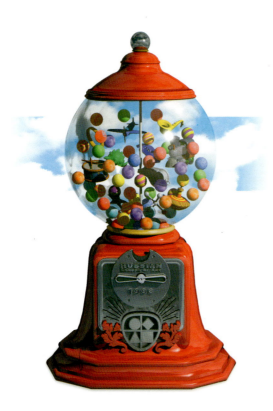

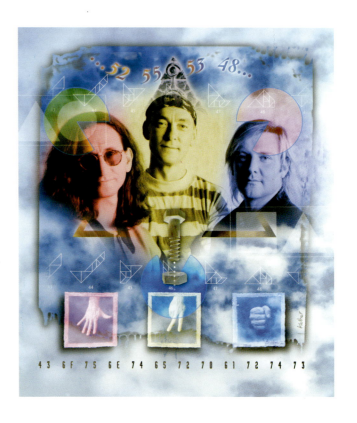

Prize Inside!
1993 / Hussian School of Art : Promotion
Software: Adobe Photoshop2.5.1, Adobe Illustrator5.0.1, Specular Collage1.0.1, Specular Infini-D2.5.1

RUSH Reconsidered
1993 / Request Media Inc. : Editorial Illustration
Software: Adobe Photoshop2.5.1, Adobe Illustrator5.0.1, Specular Collage1.0.1, Specular Infini-D2.5.1

Ending the Nightmare on Lime Street

1994 / American Airlines : Magazine Illustration

Gallery
Joseph Kelter

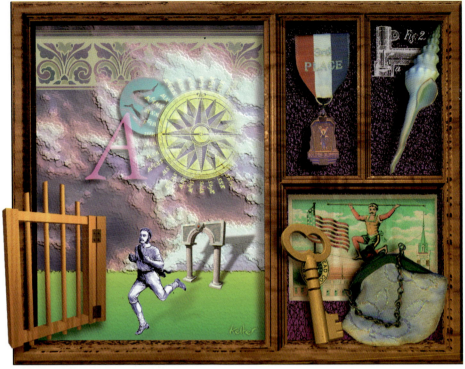

Max Made Me Do It

1993 / Macworld Communication : Editorial Illustration
Software: Adobe Photoshop2.5.1, Adobe Illustrator5.0.1, Specular Collage beta,
Specular Infini-D2.5.1, Fractal Design Painter2.0a

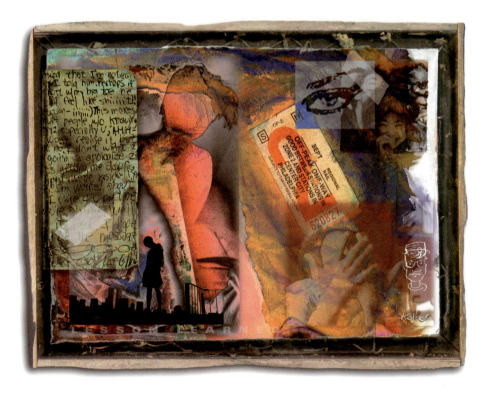

Lesson Learned

1993 / Personal
Software: Adobe Photoshop2.5.1, Specular Collage1.0,
Fractal Design Painter2.0a

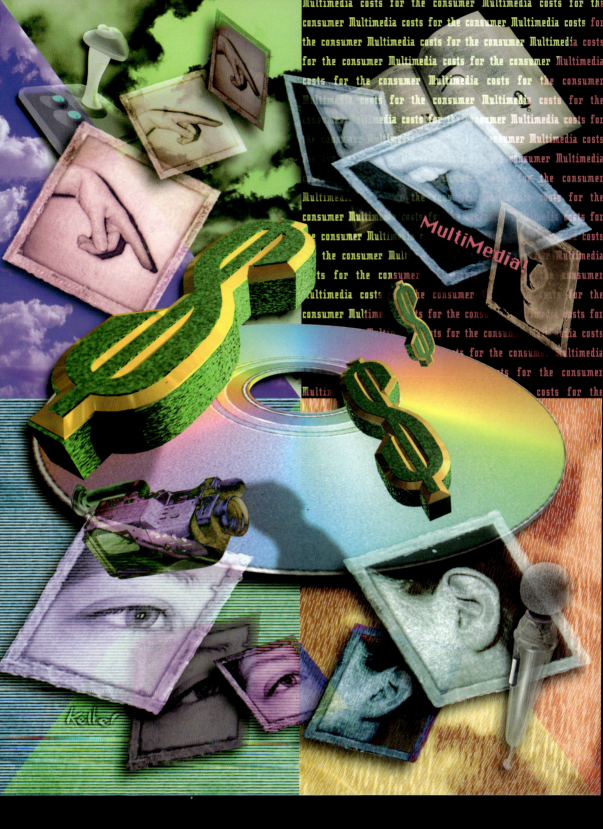

Multimedia Costs

1993 / Upside Publishing : Illustration
Software: Adobe Photoshop2.5.1, Adobe Illustrator5.0.1, Specular Collage1.0.1,
Specular Infini-D2.5.2, Specular TextureScape beta, Aldus FreeHand4.0a,
Fractal Design Painter2.0a, Ray Dream Designer3.0.1

Glenn Mitsui

Glenn Mitsui is a partner, with Jesse Doquilo and Randy Lim, in Studio MD, a Seattle-based computer graphics design firm. Mitsui began his computer graphics career when he left Seattle Community College to work for the Boeing Company, Incorporated's design and computer services, creating presentation slides on a Genagraphics system. In 1989, when Mitsui and Doquilo started Studio MD, they decided to base their business on providing graphic design services on computer. At that time, Mitsui points out, many designers and illustrators were only beginning to debate whether to pursue the new computer graphics technology. But computer design "was already our niche," says Mitsui. "It was what we were going for right from the start."

Mitsui, a jazz enthusiast, equates the process of learning how to produce quality art on the computer to the lengthy process of mastering a jazz instrument. Only after learning the fundamentals, he says, does the technical burden begin to fall away and the creativity begins to show through. Mitsui's own early start in computer graphics has pushed him up the steepest part of that learning curve, ahead of most. Now, in collaboration with his Studio MD partners, Mitsui routinely and easily uses his computer design skills to produce artwork for companies such as Microsoft, Inc., Apple Computer, IBM, USWest Communication, and Macworld Magazine.

Senseless
1994 / Personal
Software: Adobe Photoshop2.5.1, Aldus FreeHand3.0, Specular Collage1.0

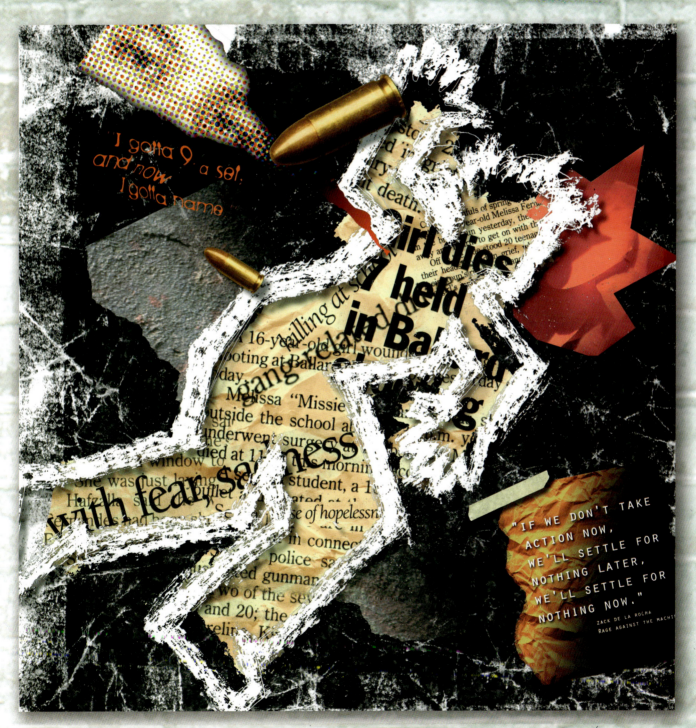

Glenn Mitsui's "Senseless" was inspired by the sudden, drive-by shooting death of his niece's high school friend. "It's not a pretty picture," he says of the image, "but then it shouldn't be."

Step by Step
GLENN MITSUI

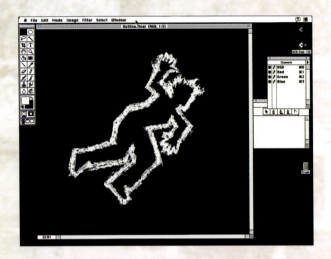

Step 1

Mitsui began by sketching a figure outline with a soft pencil on a piece of paper placed over a cement walkway. The sketch was scanned at 300 ppi in grayscale mode. Then, in Adobe Photoshop, he used the Curves dialog box to increase the scan's contrast to tones of either black or white. Finally, he duplicated the channel into a second channel and inverted it to use as a mask in Specular Collage.

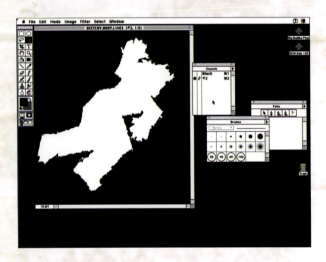

Step 2

Using the Magic Wand tool in Photoshop, Mitsui selected the interior parts of the sketched outline and filled them with white. This process created a mask which would later be used in Collage to separate the body, with an added texture, from its background.

Step 3

To create a crumpled paper texture, Mitsui scanned a sheet of crumpled paper. He then adjusted the contrast of the scan and added color to it by converting the file to Indexed Color mode. In this mode he created a custom color palette to add a range of brown tones to the paper texture.

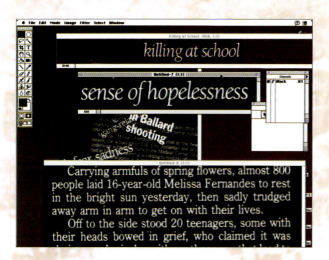

Step 4

Mitsui collected a number of newspaper articles about the shooting and scanned them. Then he assembled these into a collage of white text on a black background.

Step 5

Mitsui loaded a selection of the figure from the mask in Step 2 into a blank white RGB file and pasted the colorized scan of the crumpled paper into the selection.

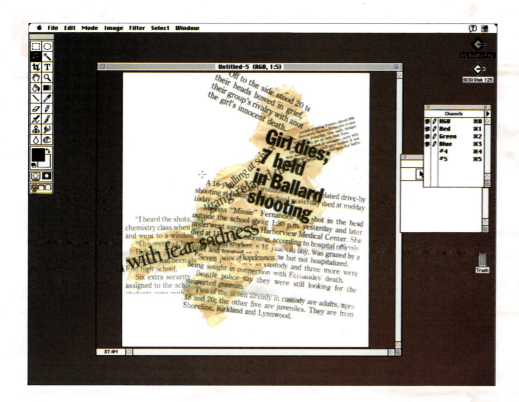

Step 6

Still in Photoshop, Mitsui created a new channel, Channel #5, and pasted the newspaper print collage into the new channel. Then, to add the newsprint to the paper texture, he loaded the selection from Channel #5 and filled the selection with 90% black in the RGB layer.

Step 7

Mitsui used Aldus FreeHand to create the type that exists outside of the figure's outline. Then, he imported the FreeHand file into Photoshop and used the Smudge tool to blur the type. He then copied the type and placed it into a mask channel.

Step 8

After creating the different components of "Senseless" in Photoshop, Mitsui opened Collage and imported the elements. He created the background using a scan of light-colored cement with the intention of using its lighter tones to emphasize drop shadows.

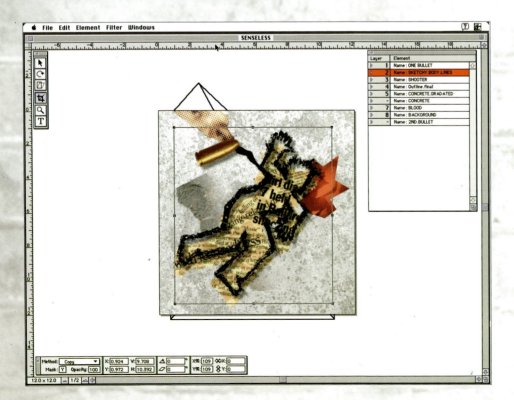

Step 9

Mitsui began to assemble on the Collage canvas the various elements he had created in Photoshop. By the time a number of them were put into place, he realized the light background was not right for the mood of the picture.

Step 10

To create a darker background texture, Mitsui returned to Photoshop. Using the Indexed Color mode with a custom color palette, he darkened the file.

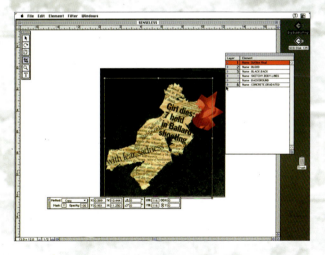

Step 11

Switching back to Collage, Mitsui imported the darker background, over which he placed a geometric shape filled with roses to represent blood. Then, he added the body figure filled with the paper texture and type.

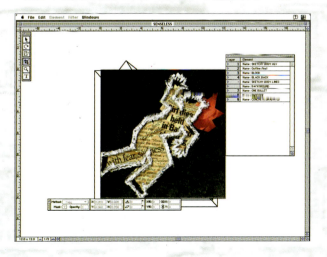

Step 12

Next, he added the sketched white outline to the image. The mask was turned on, which left just the white outlines showing. Then, using the Shadow dialog box, Mitsui added shadows under the outline to give the image depth.

Step 13

To create an additional accent underneath the figure of the body, Mitsui returned to Photoshop and made a gradated mask to select a portion of concrete.

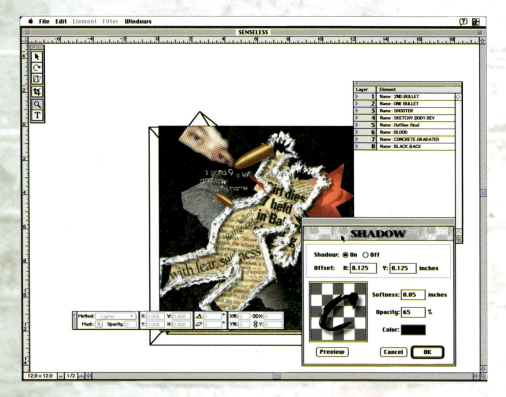

Step 14

After adding the concrete section to the background, Mitsui added bullets to the image.
He created bullets by scanning real bullets on a flatbed scanner. Then, in Photoshop, he selected each bullet and created a mask for it. The bullets were imported into Collage and he turned on their masks. After scaling, rotating and positioning the bullets, Mitsui added shadows to the objects.

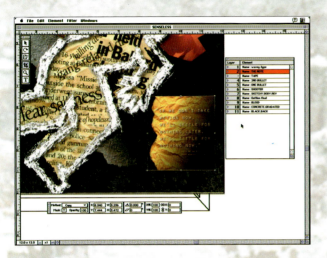

Step 15

Now, the final elements were added to the image in Collage, including the note. Having reached this point, the image was nearly completed. However, after studying the image, Mitsui felt the overall image looked too clean and he wanted to make it more rough, less tidy.

Step 16

To make the background look more distressed, Mitsui took a sheet of paper which had been thoroughly blackened by a photocopy machine and crumpled it. Then he took masking tape, applied it to the edges and lifted it up again. The paper was then scanned, inverted, and placed into Channel #4 of the background file.

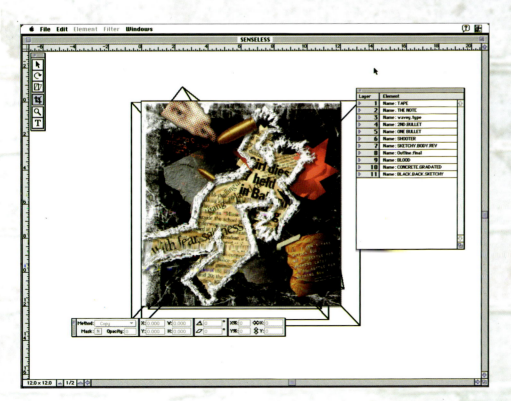

Step 17

When Mitsui updated the background file in Collage to include the mask he had created in Step 16, he only needed to turn the mask function on to finish the image by distressing the background. According to Mitsui, Collage's ability to update and modify images saved him from having to start the image over again. "The new background," he says, "was dropped in without taking away my whole weekend." The final image was then rendered at 12" by 12" at 300 ppi.

SYSTEM:
19" color RasterOps monitor, Macintosh IIcx, 32MB RAM, 33Mhz Radius Rocket accelerator, 540MB internal hard drive, 128MB optical disk drive, 44MB Micronet SyQuest drive, Micronet color scanner

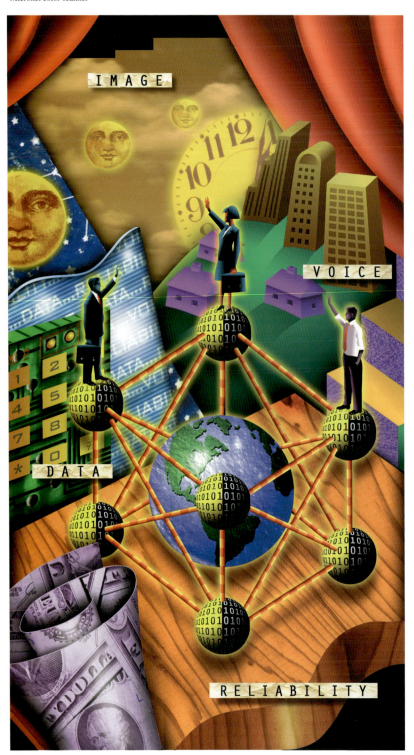

The Global Network
1994 / US West Communications, Inc. : Brochure Illustration
Software: Adobe Photoshop2.5.1, Aldus FreeHand3.0,
Kai's Power Tools, Fractal Design Painter 2.0

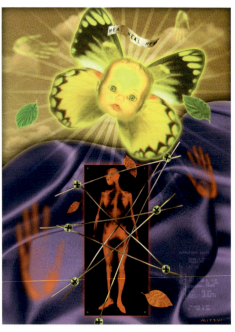

Miraculous Recoveries
1994 / Psychology Today magazine : Editorial Illustration
Software: Adobe Photoshop2.5.1, Fractal Design Painter2.0, Ray Dream Designer3.0, Aldus FreeHand 3.0

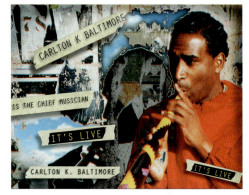

Carlton K. Baltimore
1994 / Carlton K. Baltimore, singer : Audio Cassette Label
Software: Adobe Photoshop2.5.1,
Fractal Design Painter2.0

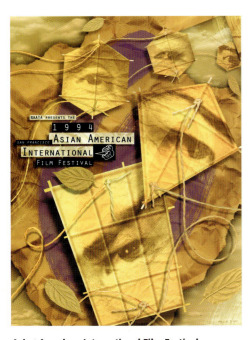

Asian-American International Film Festival
1994 / National Asian-American Telecommunications
Association : Brochure Cover
Software: Adobe Photoshop 2.5.1, Aldus FreeHand 3.0

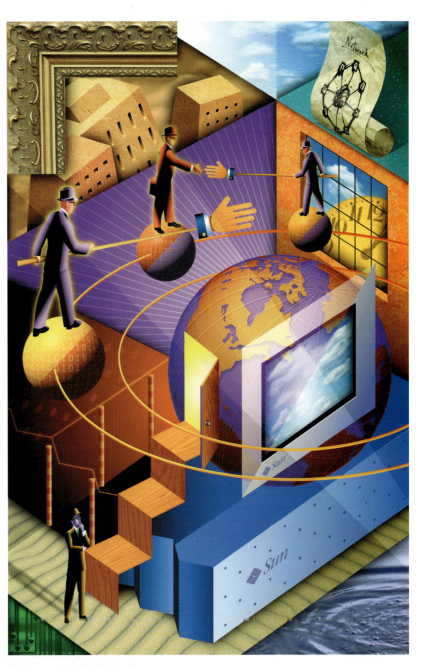

The Computer is the Network
1994 / Sun Microsystems, Inc. : Poster
Software: Adobe Photoshop 2.5.1, Aldus FreeHand 3.0, Ray Dream Designer 3.0, Fractal Design Painter 2.0

Glenn Mitsui

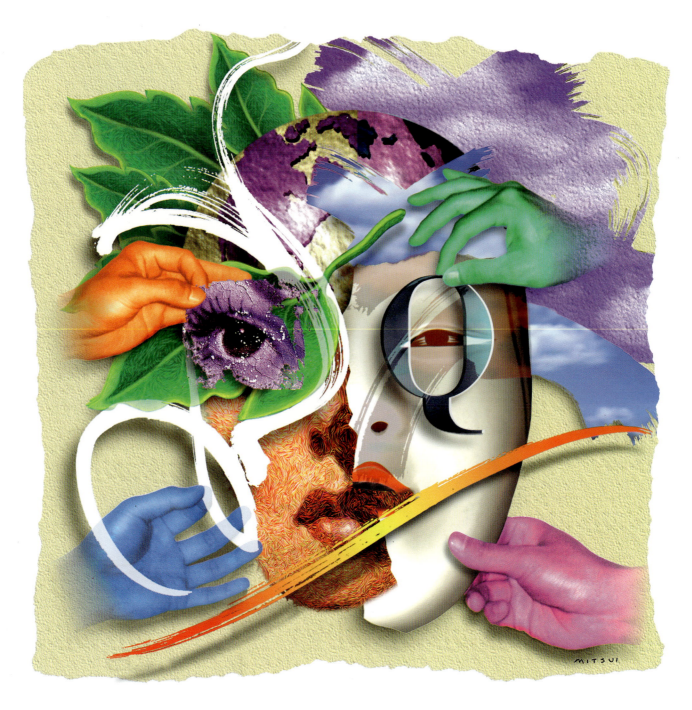

Painter X-2

1993 / Fractal Design Corporation : Advertisement
Software: Fractal Design Painter2.0, Fractal Design Painter X-2

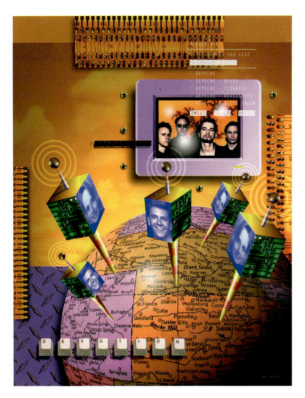

Depeche Mode

1993 / Entertainment Weekly magazine : Editorial Illustration
Software: Adobe Photoshop2.5.1, Kai's Power Tools1.0,
Fractal Design Painter2.0, Ray Dream Designer3.0

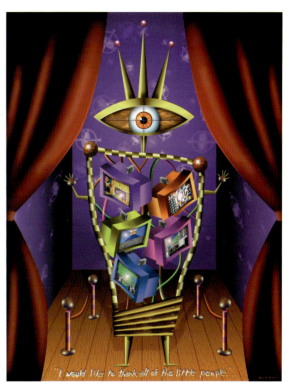

Game Hall of Fame

1993 / Macworld Magazine : Editorial Illustration
Software: Adobe Photoshop2.5.1, Aldus FreeHand3.0,
Fractal Design Painter2.0, Ray Dream
Designer2.0, Kai's Power Tools

Publish

1993 / Publish magazine : Editorial Illustration
Software: Fractal Design Painter2.0, Adobe Photoshop2.5.1,
Aldus FreeHand3.0, Kai's Power Tools

The Seybold Conference

1994 / Computer Artist magazine : Cover Illustration
Software: Adobe Photoshop2.5.1, Aldus FreeHand3.0,
Fractal Design Painter2.0, Kai's Power Tools

Glenn Mitsui

Gallery
GLENN MITSUI

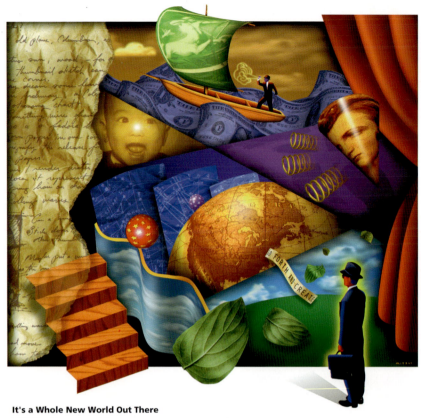

It's a Whole New World Out There

1994 / Ray Dream, Inc. : Advertisement
Software: Ray Dream Designer3.0, Adobe Photoshop2.5.1, Aldus FreeHand3.0

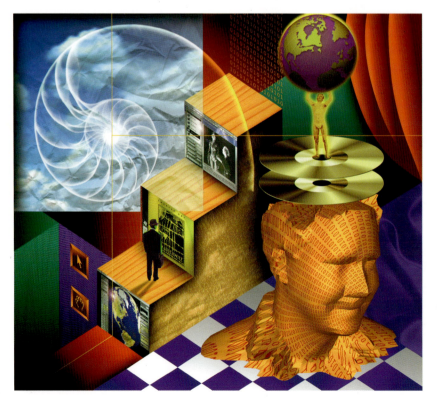

New Media

1994 / Entertainment Weekly magazine : Editorial Illustration
Software: Adobe Photoshop2.5.1, Aldus FreeHand3.0, Cybermesh,
Ray Dream Designer3.0, Kai's Power Tools

48 *Collage with Photoshop*

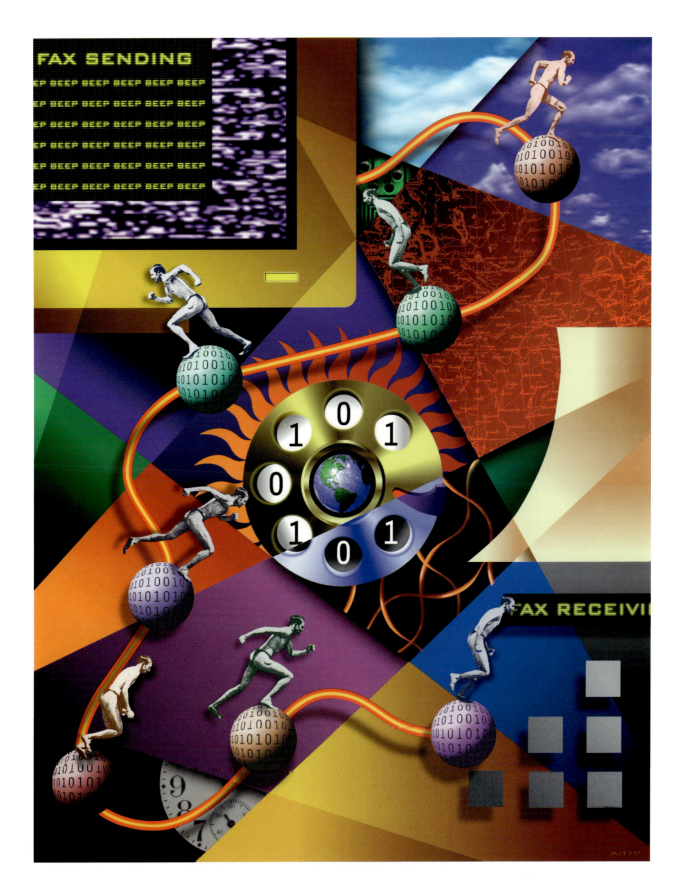

High-Speed Modems

1993 / Macworld magazine : Editorial Illustration
Software: Adobe Photoshop2.5.1, Aldus FreeHand3.0, Fractal Design Painter2.0, Kai's Power Tools

Diane Fenster

Throughout her New Jersey childhood, Diane Fenster dreamed of becoming an artist. However, when she was college age, she chose instead to follow her parents' advice and pursued a degree in biology as a more "practical" path. Years later, a move to California put Fenster back on the art track and she began studying graphic design. "I decided to follow my heart and soul rather than be practical," she explains, "California can do that to people."

According to Fenster, she learned design by picking up skills "here and there." Eventually, she landed a design job at the School of Science at San Francisco State University "more because of my science background than my graphic skills...." Fenster's dedication to computer imaging began in 1985, when she started using the Macintosh as a design production tool. She didn't take the Mac seriously as an art tool at first. Then, in 1989, she had an opportunity to experiment with photo manipulation on the Macintosh. Fenster recalls that it was love at first sight.

Fenster says she has had many steamy love affairs with Macintosh imaging software since then, Adobe Photoshop being her longest running digital fling to date. Her illustrations and artwork have been printed and exhibited widely, including as part of the 1994 Digital Masters exhibit at the Ansel Adams Gallery in San Francisco.

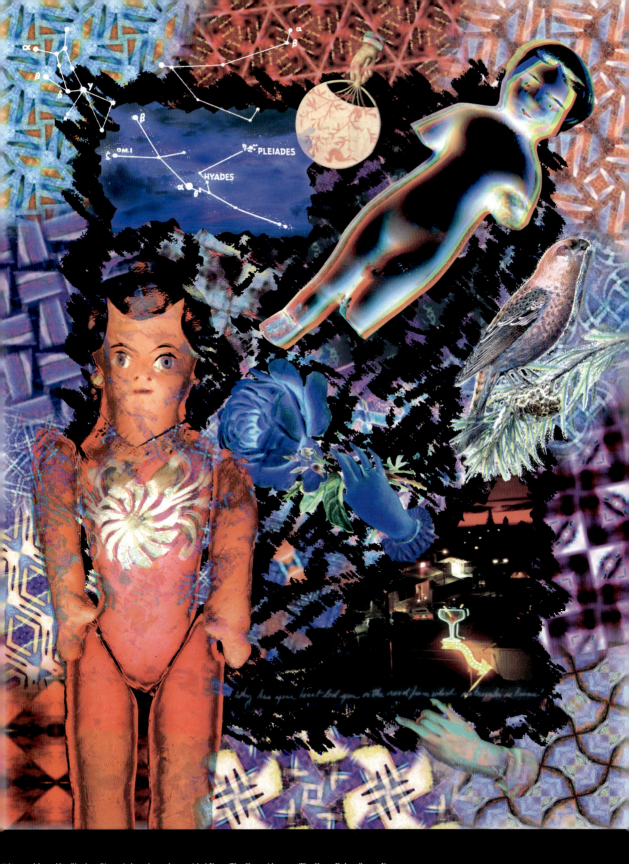

Step by Step — Diane Fenster

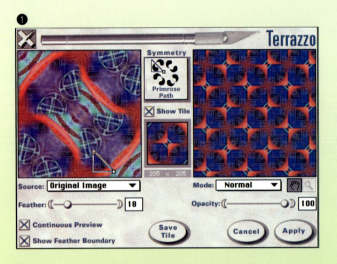

Step 1

Diane Fenster started "Innana Meets Her Shadow Sister" by creating a number of textured rectangles. To create the tiling patterns that fill the rectangles, she used a beta version of an Adobe Photoshop plug-in filter from Xaos Tools called Terrazzo *(Fig. 1)*.

Step 2

When the textured rectangles were finished, Fenster opened Specular Collage and imported the shapes. Then she used the rectangles to fill the Collage canvas with overlapped and rotated textures. The textures were blended into each other in Collage by using the Feather dialog box *(Fig. 2)*.

Step 3

Because the background was comprised of a large number of individually rotated and feathered objects *(Fig. 3)*, Collage's screen redraw began to slow down. To speed the process along, Fenster rendered the background into a single image file. She saved it in PICT format.

Step 4

Because Fenster had scaled up the background textures in Collage, they took on a slightly jagged appearance after rendering. Fenster fixed the problem by applying a small amount of the Motion Blur filter in Photoshop *(Fig. 4)*. After saving the change, she again imported the background image into Collage as a single file, instead of many files.

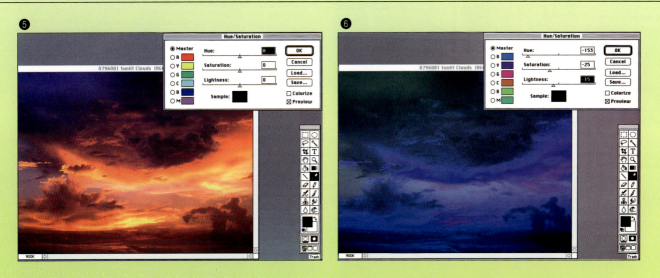

Step 5

Back in Photoshop, Fenster imported a photograph of the sky *(Fig. 5)* from a stock Photo CD to use as a backdrop for the constellation Taurus. Next, using the controls in Photoshop's Hue/Saturation dialog box, Fenster changed the warmer sunset tones to approximate the cooler colors of the night sky *(Fig. 6)*.

Step·by·Step *Diane Fenster*

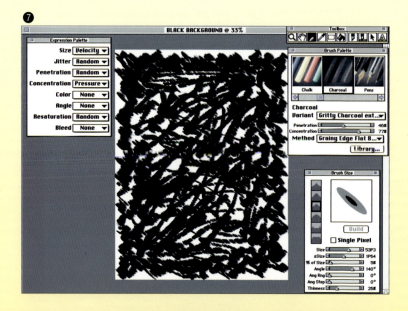

Step 6

The element which contains both the solid black pattern and the photograph that appears in the center of Fenster's final image, was started in Fractal Design Painter. Using the Gritty Charcoal variant of Charcoal on the Brush palette, she painted a random black-and-white texture *(Fig. 7)*. This image was saved as an RGB PICT file and opened in Photoshop. In Photoshop, Fenster filled in the lower right corner of the black-and-white file with black using the Pencil tool. Then, she roughly selected the area with the Pen tool *(Fig. 8)*. After converting the Pen path to a selection, she pasted the scanned photograph into the file *(Fig. 9)*.

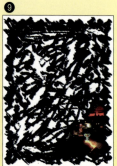

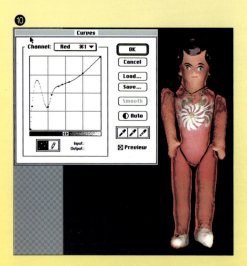

Step 7

The papier-mâché doll that Fenster used in the lower left corner of her image was scanned face down on a flatbed scanner. Then, in Photoshop, Fenster used the Curves dialog box to bring out red highlights *(Fig. 10)*. She saved this image as a PICT file and named it Nora 2.

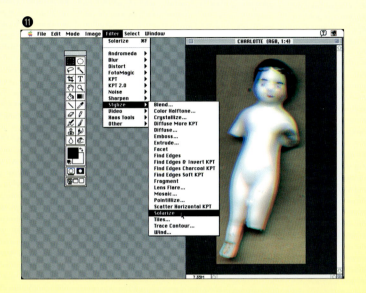
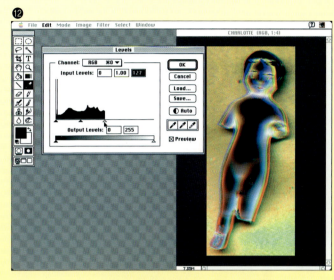
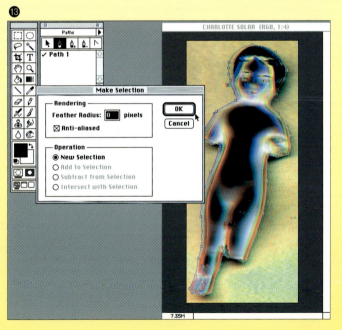
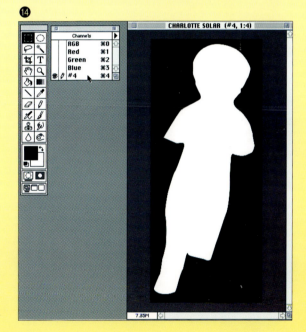

Step 8

The figure that appears in the upper right of Fenster's image was also scanned. However, while scanning, Fenster shifted the doll slightly, giving it red and blue ghost effects *(Fig. 11)*. Then she applied the Solarize filter in Photoshop. The effect of the Solarize filter was to invert the lightest tones of the image, flattening the contrast range. To boost the contrast, Fenster used the Levels dialog box *(Fig. 12)*. Fenster finished the doll by creating a path outline, which she converted to a selection *(Fig. 13)*. Then, she saved the selection as a mask in Channel #4 *(Fig. 14)*.

Step•by•Step — *Diane Fenster*

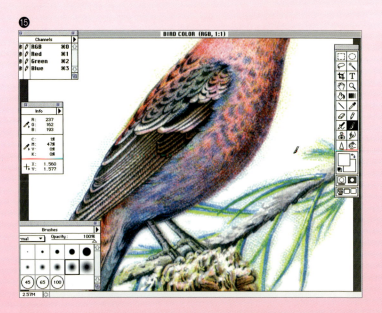

⑮

Step 9

Before importing a scan of a bird lithograph into Collage, Fenster prepared it in Photoshop by painting out the white background, except for the area adjacent to the bird *(Fig. 15)*. Then she created a mask to separate the bird from the white background and saved the file with the name Bird Color.

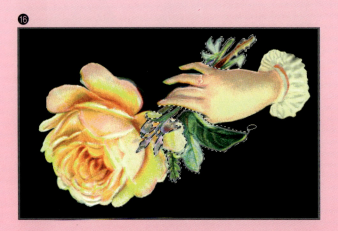

⑯

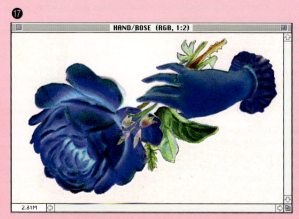

⑰

Step 10

Continuing in Photoshop, Fenster prepared the file Hand/Rose by selecting only the smaller flowers and leaves with the Lasso tool *(Fig. 16)*. Then, in order to select the background only, she inversed the selection. Next, she inverted the selected background, turning the yellow tones of the larger flower and hand to blue while leaving the tones of the smaller flowers and leaves unchanged *(Fig. 17)*.

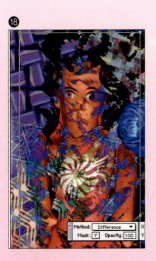

Step 11

After completing her source images, Fenster opened Collage and imported the files. Atop the background she'd created earlier, Fenster placed the file Nora 2.. Using the Information palette, she set the Method to Difference. This caused many of the underlying tones to appear through the scan of the doll *(Fig. 18)*. Then, she placed a duplicate of Nora 2 on top of, and slightly offset from, the underlying original. In the duplicate file's Method dialog box, she kept the default Copy mode, but this time used the Canvas slider to pull a range of underlying tones through the copy on top *(Fig. 19)*.

Step 12

Fenster imported the Bird Color file, placed it onto the canvas in default Copy mode and turned on its mask *(Fig. 20)*. Then, as in Step 11, she duplicated the file and placed the duplicate in a layer above, and offset to the right of the original. To blend the upper file into the background, Fenster not only chose the Difference setting of the Method dialog box, but also adjusted the Canvas slider. This adjustment resulted in a slightly ghosted bird superimposed over the original Bird Color file and background *(Fig. 21)*.

Diane Fenster 57

Step•by•Step *Diane Fenster*

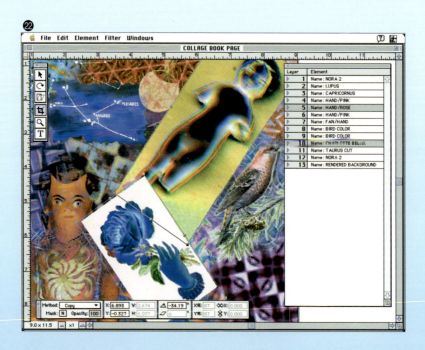

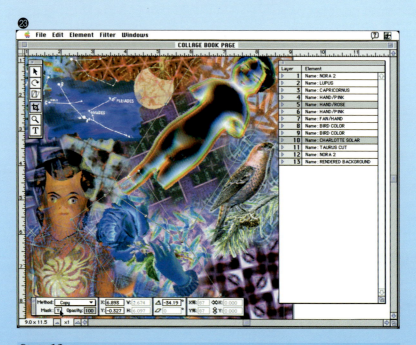

Step 13

Fenster added more elements to the image and rotated them *(Fig. 22)*. Then, she turned on their masks by using the Information palette's Mask option *(Fig. 23)*.

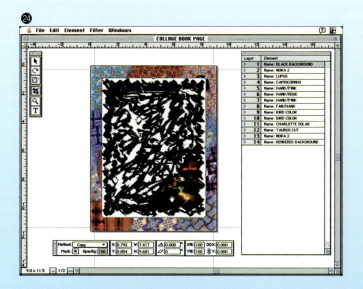
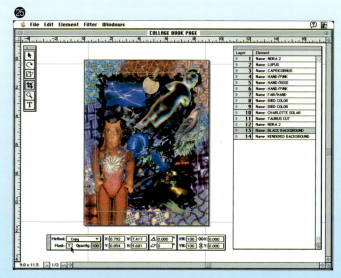

Step 14

The last element she added to the image was the black texture containing a scanned photograph, which appeared initially on the top layer *(Fig. 24)*. She then moved this element below all the others and turned on its mask *(Fig. 25)*.

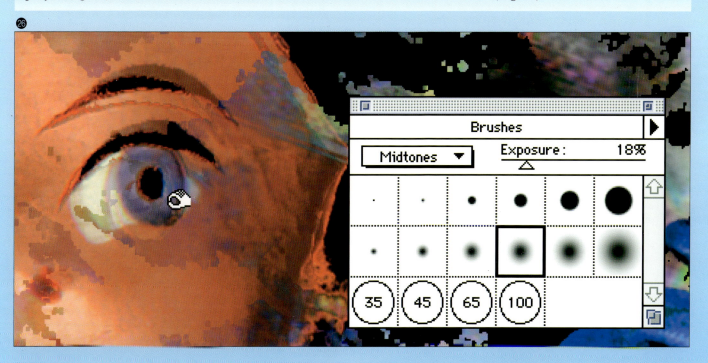

Step 15

After rendering the image in Collage, Fenster opened it in Photoshop and made minor changes. For instance, she intensified the color saturation of the eyes by burning them in a small amount using Photoshop's Burn tool *(Fig. 26)*.

Gallery — Diane Fenster

SYSTEM:
Radius Precision Color 17" monitor, Quadra 840AV, 40MB RAM, 230MB internal hard drive, 1.2GB external Fujitsu hard drive, internal CD/ROM drive, 128MB magneto-optical drive, MDS 44MB SyQuest drive, 6"x9" Wacom tablet, Microtek Scanmaker II scanner, Canon Xapshot still video camera, Sony Hi-8 camcorder, Agfa ProColor Premiere 35mm film recorder.

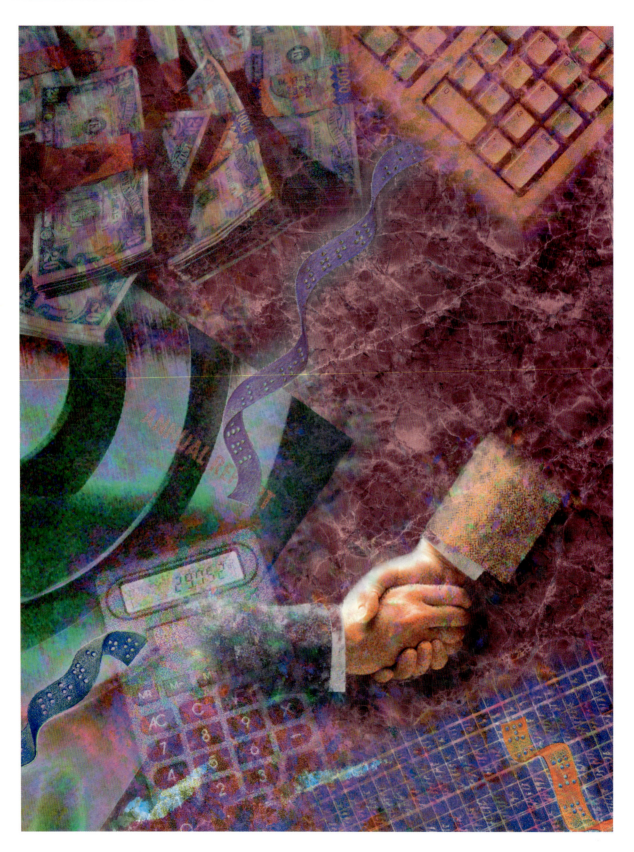

CIO Magazine Cover (Untitled)

1994 / Corporate Information Officer magazine : Cover Illustration
Software: Adobe Photoshop2.5.1, Xaos Tools Paint Alchemy1.0

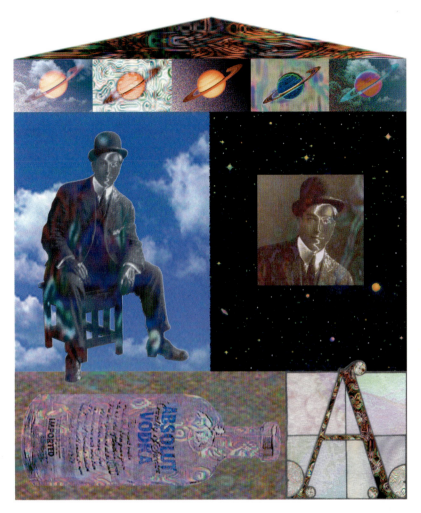

Absolut Ad/unpublished piece (Untitled)
1992 / Frisco magazine : Competition Entry
Software: Adobe Photoshop2.01

MACWORLD DSP boards illustration (Untitled)
1994 / Macworld magazine : Editorial Illustration
Software: Adobe Photoshop2.5.1

CIO Magazine Illustration (Untitled)
1993 / Corporate Information Officer magazine : Editorial Illustration
Software: Adobe Photoshop2.5.1

Diane Fenster

Gallery *Diane Fenster*

LCIII Shortage (Untitled)

1994 / Macworld magazine : Editorial Illustration
Software: Adobe Photoshop 2.5.1

Night Five
1992 / Personal : Point of
Emergence series
Software: Adobe Photoshop2.01

I Couldn't Stay in Miami
1994 / Personal : Ritual of Abandonment series
Software: Adobe Photoshop2.5.1

Night Six
1992 / Personal : Point of
Emergence series
Software: Adobe Photoshop2.01

Night Seven
1992 / Personal : Point of
Emergence series
Software: Adobe Photoshop2.01

Night Three
1992 / Personal : Point of
Emergence series
Software: Adobe Photoshop2.01

Diane Fenster

Gallery *Diane Fenster*

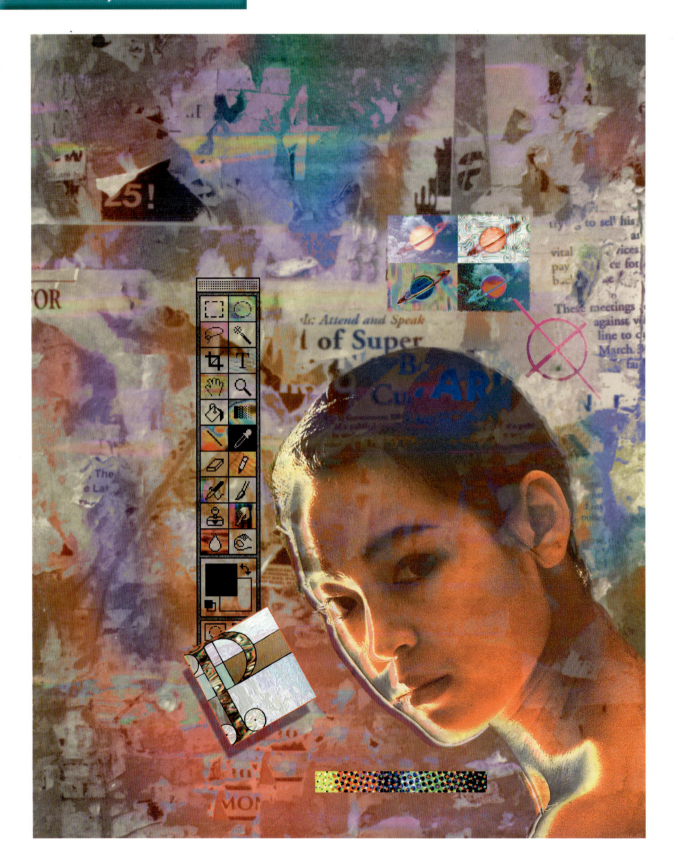

Photoshop 2.5 Bible bookcover (Untitled)
1993 / IDG Books : Bookcover Illustration
Software: Adobe Photoshop2.5.1

Odin's Initiation
1993 / Fractal Design Software : Advertising Illustration
Software: Fractal Design Painter2.0 and Painter X2

Macworld Collage Illustration (Untitled)
1994 / Macworld magazine : Editorial Illustration
Software: Specular Collage1.01, Adobe Photoshop2.5.1, Xaos Tools Paint Alchemy1.07b

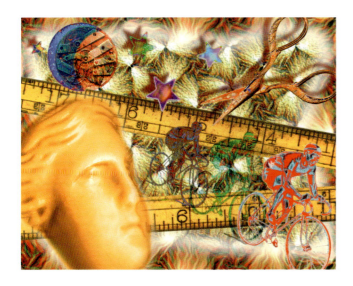

We Took the Train Together to My Apartment
1993 / Personal : Ritual of Abandonment series
Software: Adobe Photoshop2.5.1

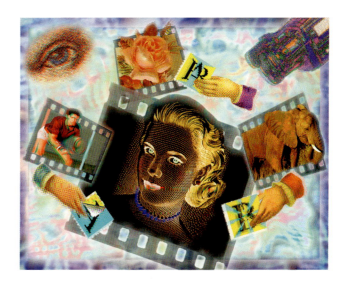

MACWORLD Premiere Illustration (Untitled)
1993 / Macworld magazine : Editorial Illustration
Software: Adobe Photoshop2.5.1

Diane Fenster

mycybermind
1994 / Personal
Software: Specular Collage1.01,
Ray Dream Designer3.0,
Adobe Illustrator5.0,
Adobe Photoshop2.5.1

Steve Lyons

Not long after graduating from the University of New Hampshire with a B.F.A. in printmaking, Steve Lyons realized he wasn't suited for a career in fine art. "I wasn't interested in pursuing the gallery route," he recalls, "and I knew it would be a struggle making a living that way."

So, he packed his bags, moved to Los Angeles and began experimenting with an illustration style using airbrush and colored pencils. "I did fake assignments, built up a portfolio and went around to magazines, book publishers, and places like that," he says. Almost immediately, he began receiving enough editorial illustration jobs to devote himself to freelancing fulltime. He soon quit his day job designing surfer T-shirts in a T-shirt factory.

Lyon's introduction to the Macintosh came in 1984 when Macworld magazine invited him to create an illustration on a loaned Mac Plus. At the time, the experience left Lyons unimpressed. "I never did like the image," he says, "and I thought computer illustration was a joke." But Lyons no longer belittles the Mac. Instead, he has embraced it as an art tool and has produced award-winning digital illustrations for clients that include AT&T, NBC, Apple Computer, and Adobe Systems.

According to Lyons, "mycybermind" emerged intuitively from a vague idea he had "of an image in which a person was immersed in a 3-D rendered world — a world where strange, familiar–looking objects hovered everywhere."

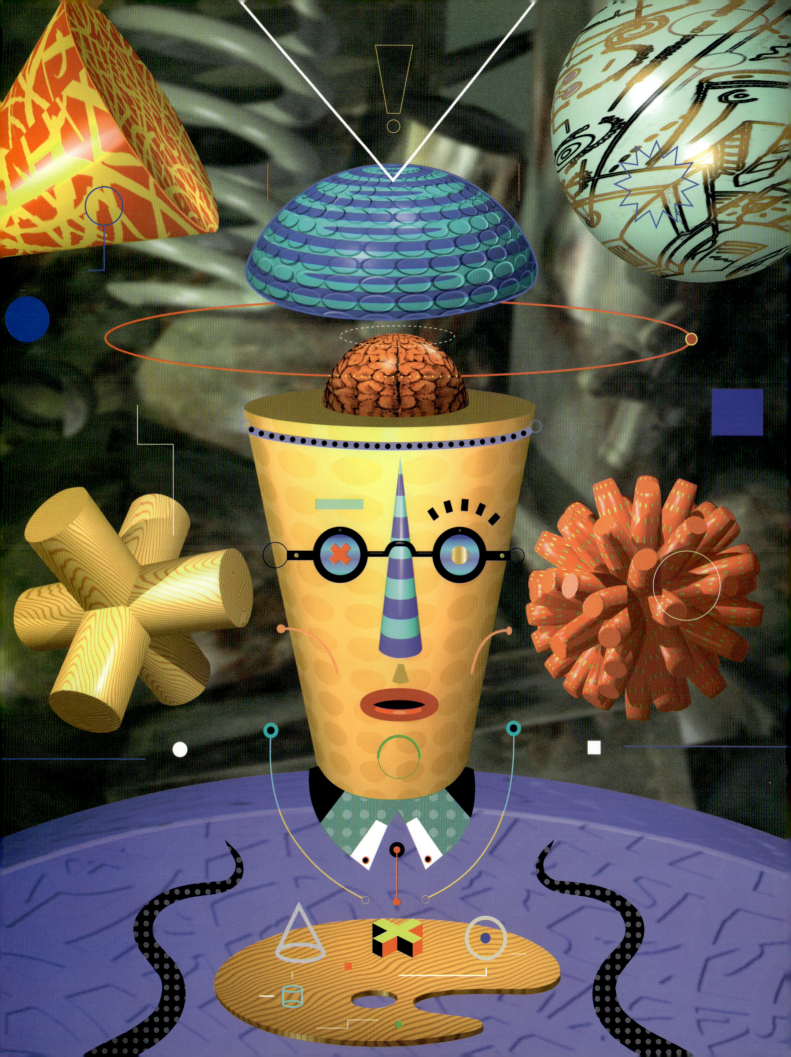

STEP BY STEP Steve Lyons

Step 1

Steve Lyons began "mycybermind" by creating a detailed sketch of his concept, including shape and placement of 2-D and 3-D elements.

Step 2

Moving from sketch pad to mouse pad, Lyons used Adobe Photoshop to create texture maps for use in Ray Dream Designer. For example, to create a brain texture map, he scanned a 19th century engraving of a brain and opened it in Photoshop. There, he blurred it to soften the linework and used the Hue/Saturation dialog box to colorize the image. The file was saved in the RGB PICT format.

Step 3

Next, Lyons opened Ray Dream Designer. In Designer, he imported the PICT file of the brain, mapped it onto a sphere lit with two light sources, and rendered it at 300 ppi.

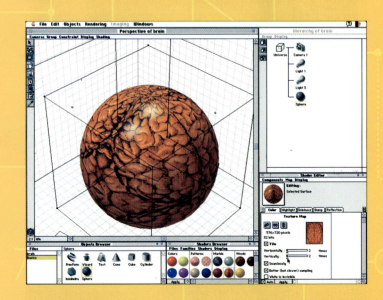

68 *Collage with Photoshop*

Step 4

Using the same basic procedures as in Steps 2 and 3, Lyons produced an assortment of 3-D objects to use in his final Collage image.

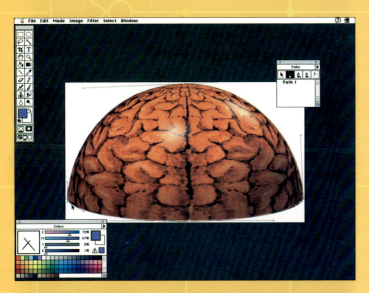

Step 5

After completing the modeling and texture mapping of all 3-D objects, Lyons needed to create masks to separate each object from its background. As with the brain scan, he created Pen tool paths of each object to create clean, well-defined masks.

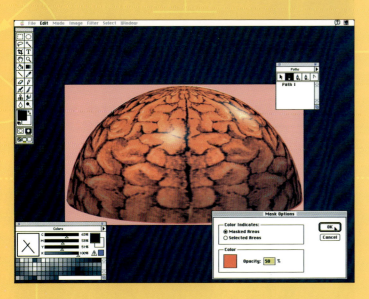

Step 6

Lyons next converted the Pen paths to selections and entered Photoshop's Quick Mask mode. By setting the mask color in the Mask Options dialog box to 50% red, Lyons was able to identify areas of the mask which needed to be tightened against the object. After final adjustments were made to the mask, he saved the selection into Channel #4, the mask channel used by Collage. Lyons repeated this process for all of the 3-D objects.

Steve Lyons

STEP BY STEP Steve Lyons

Step 7

Next, Lyons opened Collage and imported the objects he'd prepared in Photoshop and Designer. The background image was the first element placed onto the canvas.

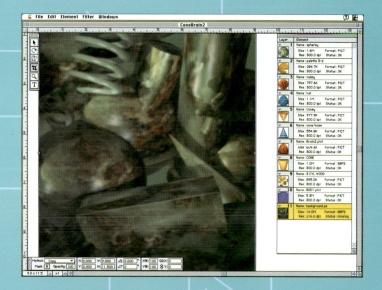

Step 8

Lyons placed the various pieces that represented the torso, head, nose, and brain onto the canvas. According to Lyons, the speed and flexibility of Collage's scaling and rotation features aided in assembling and fine-tuning the compositional relationships between these different elements.

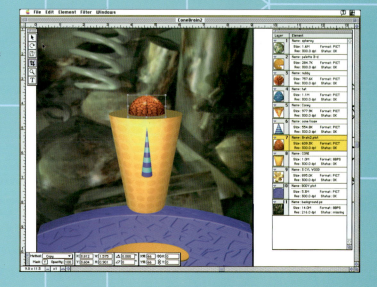

Step 9

After placing all the elements onto the canvas, Lyons played around with each piece's location until he was satisfied with the image. Having finished his edits in Collage, Lyons rendered his image at 300 ppi. Next, he opened the rendered image in Photoshop, converted it to CMYK and saved it as an EPS file for placement into Adobe Illustrator 5.0.

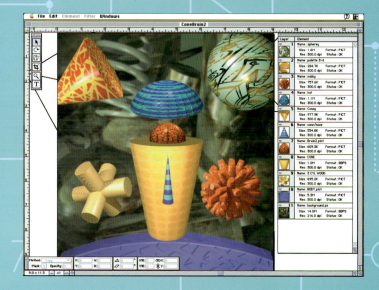

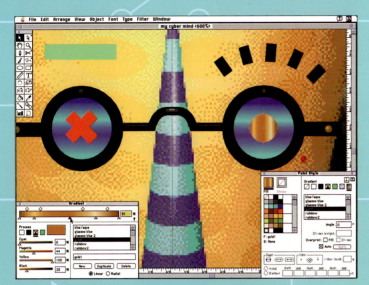

Step 10

In Illustrator, Lyons created a new document into which he placed the CMYK Photoshop file from the previous step. Then, he began creating 2-D shapes to further define facial features. For example, the eyeglasses were created with the Pen tool and then filled with blue and gold gradients using the gradient fill.

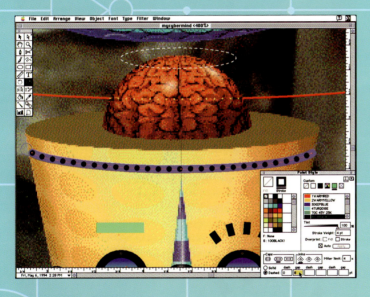

Step 11

Lyons customarily embellishes his illustrations with dashed lines and strokes, as he did with the string of black dots over the purple stroke along the top of the head in "Mycybermind." He created the dots by opening Illustrator's Paint Style dialog box and selecting the dashed line and rounded line cap style options. He formed the dots by entering 0 in the first Dash field and 8 in the first Gap field.

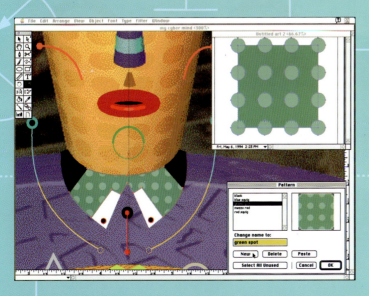

Step 12

To make the green polka dot pattern, Lyons began with a square of green to which he symmetrically added a pattern of lighter green circles. After selecting the square and circles, he opened the Pattern dialog box, named the pattern green spot and clicked New. Then, Lyons selected the shirt collar and filled it with the polka dot pattern. The final image was an Illustrator file containing the placed Photoshop file which Lyons had composited in Collage.

Gallery
Steve Lyons

SYSTEM:
Supermac 20" Trinitron monitor, E-Machines Ultra LX video card, Quadra 840AV, 4MB RAM, 230MB internal hard drive, APS 325MB external hard drive, Mitak 270MB Syquest drive, PLI 44 MB SyQuest drive, Microtek Scanmaker II color scanner, Wacom ArtZ tablet.

DatabaseDyno
1993 / MacWorld magazine : Editorial Illustration
Software: Ray Dream Designer2.0, Adobe Illustrator3.2, Adobe Photoshop2.5.1

Net Freak
1993 / San Jose Mercury News : Newspaper Illustration
Software: Adobe Illustrator3.2

Digital World
1994 / Digital World Expo : Poster Illustration
Software: Adobe Illustrator5.0, Adobe Photoshop 2.5.1

72 *Collage with Photoshop*

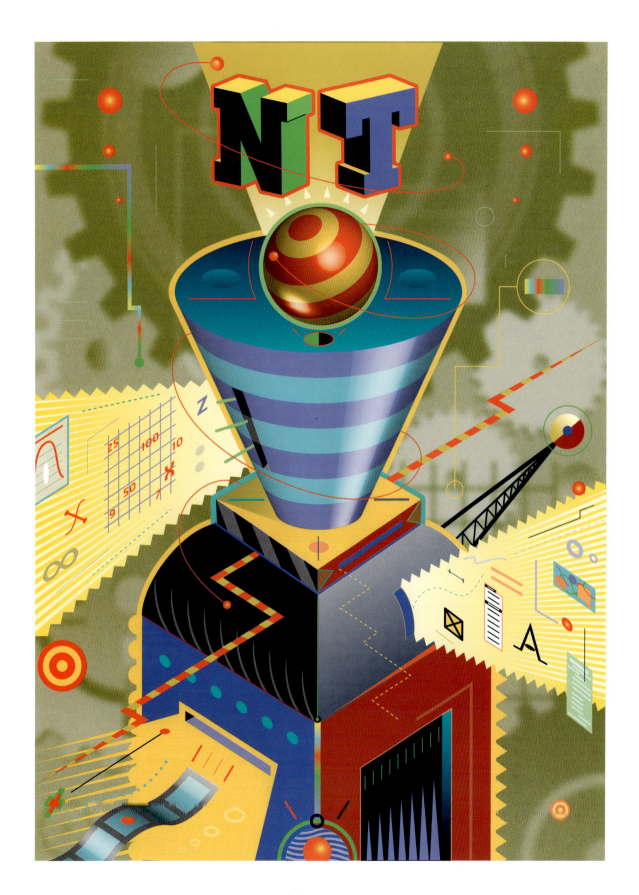

Windows

1993 / PC World magazine : Editorial Illustration
Software: Adobe Dimensions1.0, Adobe Illustrator3.2, Adobe Photoshop2.5.1

Gallery
Steve Lyons

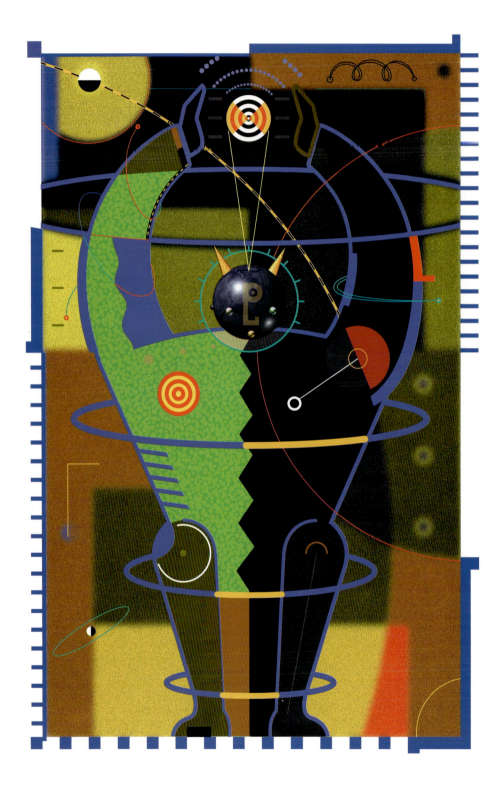

Pluto

1992 / Monadnock Paper Co. : Poster Illustration
Software: Adobe Illustrator3.2, Adobe Photoshop2.01, Swivel 3-D

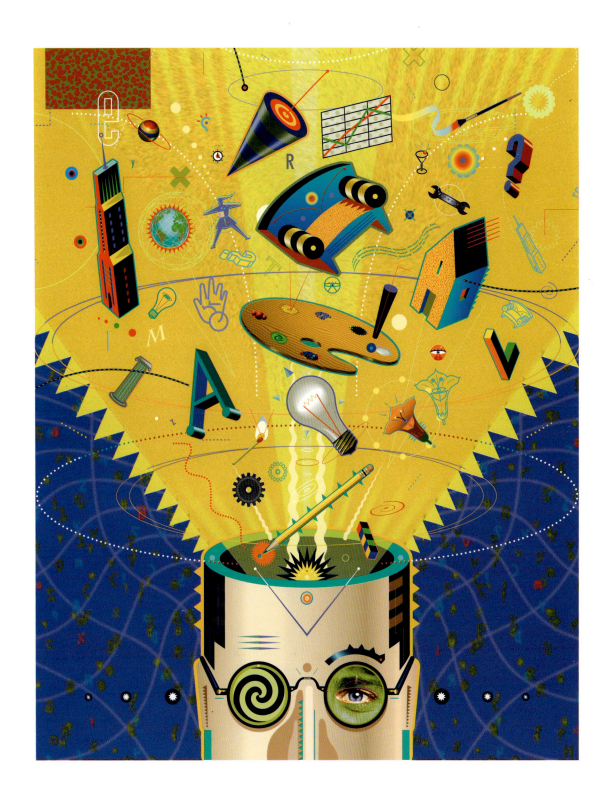

IllustratorMan

1994 / Adobe Systems : Advertisement Illustration
Software: Adobe Illustrator5.0, Adobe Photoshop2.5.1

Gallery
Steve Lyons

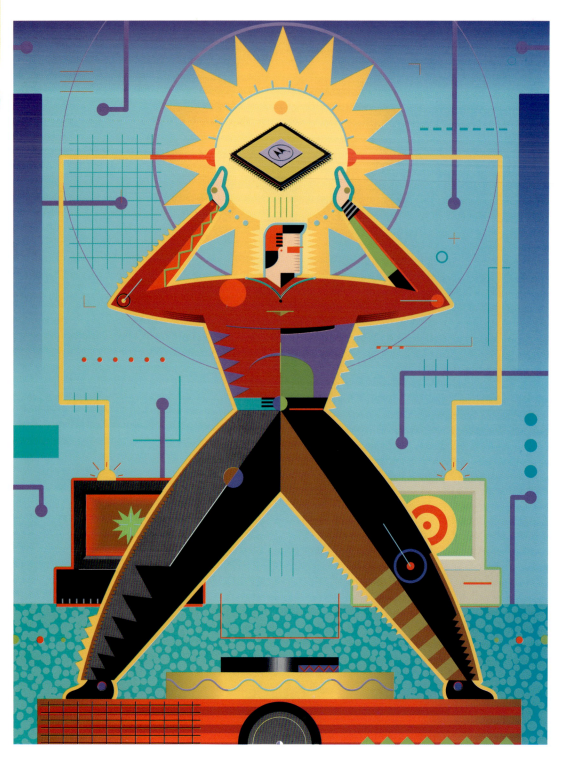

PowerPC
1993 / Motorola, Inc. : Brochure Illustration
Software: Adobe Illustrator3.2

ComputerMan
1993 / PC World magazine : Editorial Illustration
Software: Adobe Illustrator3.2, Adobe Photoshop2.5.1

Jeff BRICE

Illustrator Jeff Brice started art school at Parsons School of Design in New York City before moving on to Carnegie Mellon University in Pittsburgh. While attending Carnegie Mellon in 1978, Brice began experimenting with video technology as an art form. "That's how I got into computer art," explains Brice, "I ended up graduating with a B.F.A. in painting only because they didn't have a category for video art at the time."

Brice later returned to New York City where, in the pursuit of a masters degree in communications at New York Institute of Technology, he used the Institute's high-resolution imaging system called Images. Brice, a Fine Arts major with a taste for the technical, had a natural affinity for the system. Brice attributes his comfort with the technology to a strong science background that helps him to think logically. His talent with the Images system eventually led to work teaching computer imaging and consulting for the Institute when they began selling Images commercially.

In 1989, Brice moved to Seattle, where he combines his painting and computer imaging skills to produce photomontage images on the Macintosh for clients that include Microsoft, Nintendo, and Monadnock Paper Company.

Semiotic

1994 / Self-Promotion
Software: Adobe Photoshop2.5.1, Specular Collage1.0

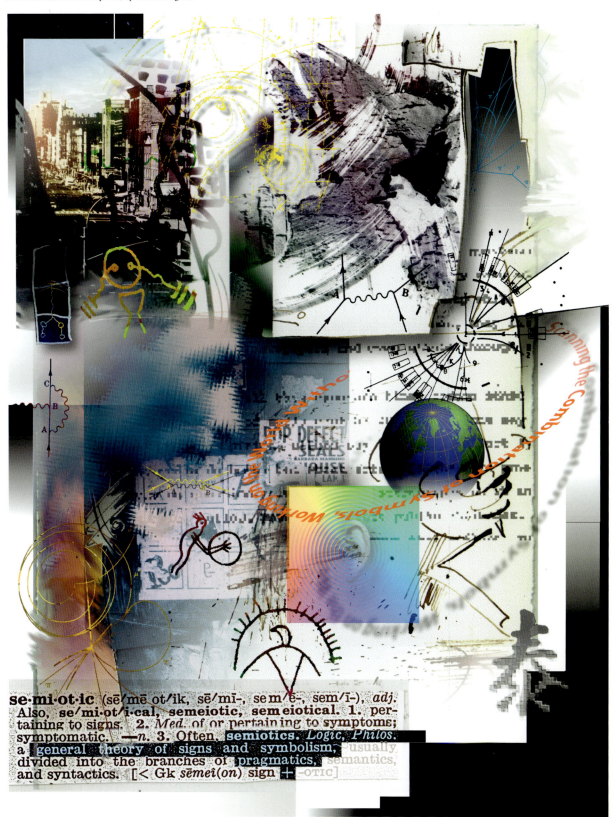

According to Brice, "Semiotic" is about the symbols used in language and communication.
"With this piece I wanted to create an image that felt like symbols were coming off the page, emerging from marks on the paper," says Brice.

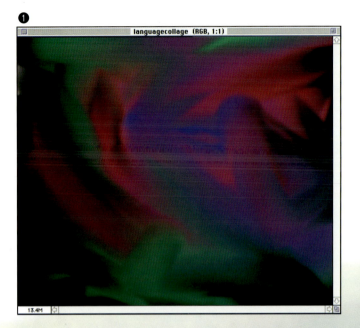

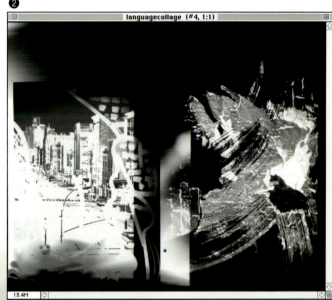

Step 1

Jeff Brice's first step in creating "Semiotic" was to use Adobe Photoshop, Aldus FreeHand and Adobe Dimensions to prepare source images for compositing in Specular Collage. Beginning in Photoshop, Brice created an RGB file containing a random blend of colors and saved it as languagecollage *(Fig. 1)*. Then, into Channel #4 of this file, Brice pasted a grayscale composite of photographs, textures, and scanned paintbrush strokes *(Fig. 2)*. He used the channel to mask out portions of the random colors he created in the RGB composite channel of the languagecollage file.

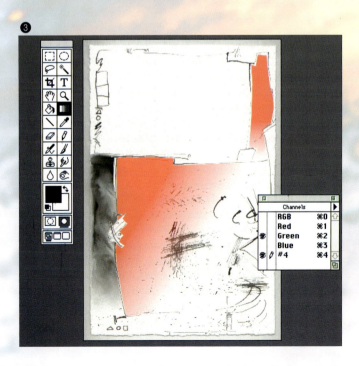

Step 2

To create the main background image for "Semiotic," Brice applied lines, scribbles and paint to a piece of paper. After scanning the paper and opening the scanned image in Photoshop, he used the Quick Mask mode to create a graduated mask for use in Collage *(Fig. 3)*.

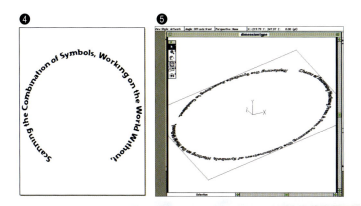

Step 3

Next, Brice created a line of circular type in FreeHand *(Fig. 4)*. Then, he opened the FreeHand type in Dimensions and altered its perspective *(Fig. 5)*. In order to use the Dimension's type in Photoshop, Brice rendered it and exported it in Illustrator 3.0 format. Back in Photoshop, Brice created a new RGB file, selected all, and filled it with red. Into Channel #4 of this file he placed the circular line of type from Dimensions to use as a mask in Collage.

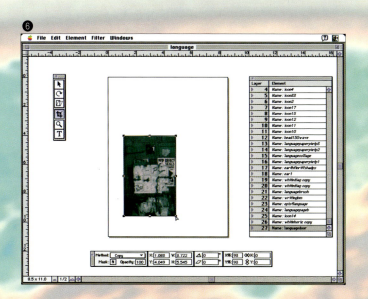

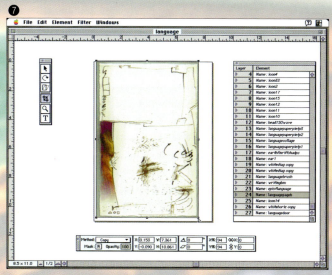

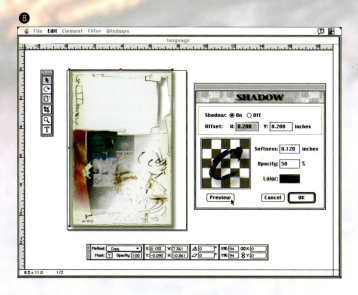

Step 4

After he was finished preparing source images, Brice opened Collage, created a new project and imported all of the elements he intended to use. The first file he placed onto the canvas was a scanned photograph of a door *(Fig. 6)*. Brice placed the paper image from Step 2 over the door *(Fig. 7)*. Next, he turned on the mask for the image in the Information palette and applied a shadow to it using the controls in the Shadow dialog box *(Fig. 8)*.

Jeff Brice 81

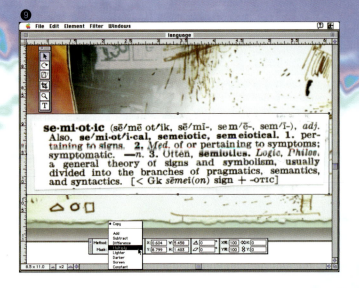

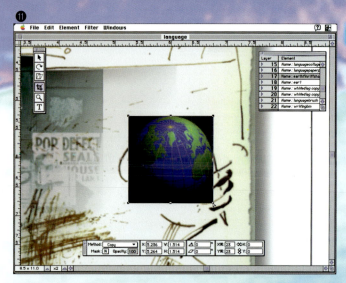

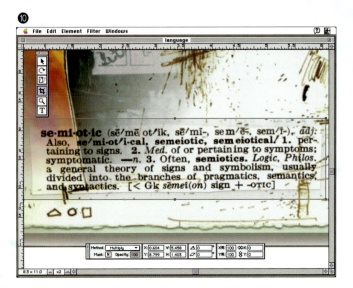

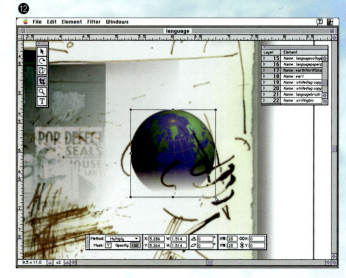

Step 5

Many elements that were added to "Semiotic" were blended into the image using the Multiply method. The scanned dictionary description of the word "Semiotic" was added using this method *(Fig. 9)*. This image first appeared on the canvas with a white background, but, after applying the Multiply method, only the darker tones of the type remained *(Fig. 10)*. Next, a scanned image of a globe was placed onto the canvas *(Fig. 11)*. To blend it into the image, Brice used not only the Multiply method, but also turned on a mask created in Photoshop *(Fig. 12)*.

Step 6

Brice used Collage to create in "Semiotic" many layers of depth, some of which are not immediately recognizable. For example, in the upper left corner of the image, Brice placed a differently cropped version of the original background paper image *(Fig. 13)*. Then, he turned on the image's mask and applied a shadow using the controls in the Shadow dialog box *(Fig. 14)*. (Note that in Fig. 13 through Fig. 22, elements on the canvas have been hidden in order to clearly demonstrate the following.)

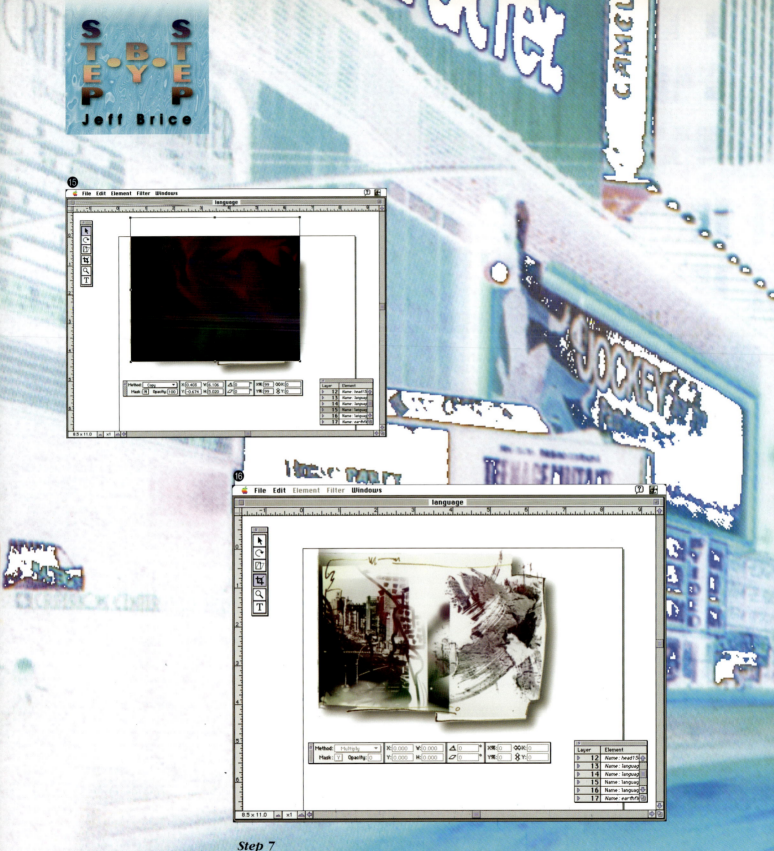

Step 7

On top of the paper image in the upper left corner, Brice placed the image languagecollage *(Fig. 15)* and turned on its mask *(Fig. 16)*.

84 *Collage with Photoshop*

Step 8

The next layer was the same scanned image of paper from Step 6, but with a different mask *(Fig. 17)*. When the mask was turned on, and a shadow applied, the image languagecollage became framed by the shadows cast by the layers above and below it *(Fig. 18)*.

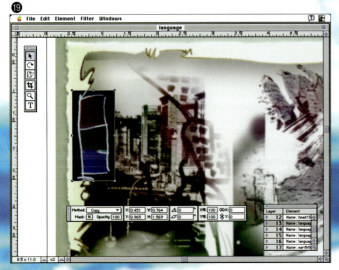

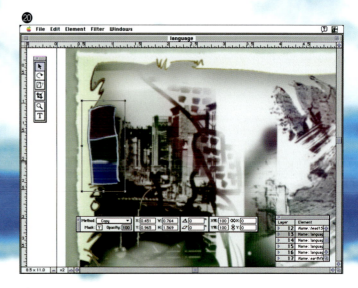

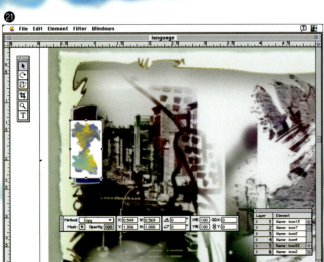

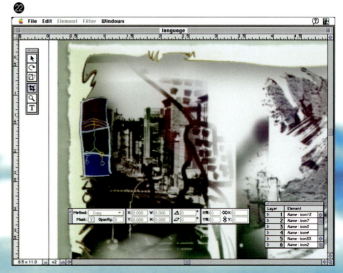

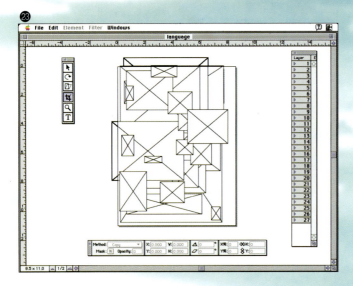

Step 9

Brice used Collage to compose even the smallest details of "Semiotic" using several layers. For example, he placed a small image containing three boxes of color onto the canvas, lined it up with the paper image from Step 8 *(Fig. 19)* and then turned on its mask *(Fig. 20)*. Over this color bar, Brice placed an image of smeared paints *(Fig. 21)* and turned on its mask, revealing one of many hand-drawn icons he used throughout the image *(Fig. 22)*. Brice, at this point, had assembled 27 different elements into his image using a variety of masks created in Photoshop and transfer methods applied in Collage. Looking at the image in Draft view, the reader can see how the elements were distributed *(Fig. 23)*.

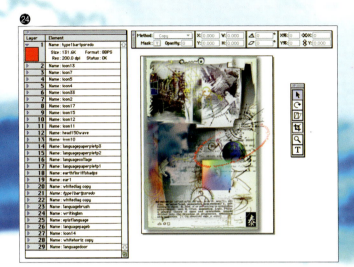

Step 10

Brice then added the circular type generated in FreeHand and Dimensions. He did this by dragging onto the canvas a solid red element containing a mask of the type. After the mask was turned on, only the red type remained *(Fig. 24)*.

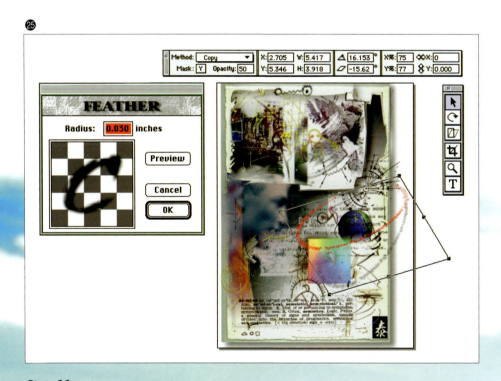

Step 11

Brice wanted the red type to cast a skewed shadow. However, he could not achieve this effect by using the choices in Collage's Shadow dialog box. To create the skewed effect, Brice duplicated the red type and skewed the copy. Then, choosing Filter Channel from the Filter menu, he selected only the Red channel and applied the Invert filter. By inverting the Red channel, he produced black type instead of red type. Finally, he softened the black type by using the Feather dialog box and by setting the opacity of the type to 50% in the Information palette *(Fig. 25)*.

GALLERY Jeff Brice

SYSTEM:
Sony 17" monitor, Apple 13" monitor, Quadra650, 40MB RAM, 1.5GB Micropolis internal hard drive, 44MB Micronet Syquest drive, APS DAT drive, NuDesign 128MB magneto-optical drive, Wacom tablet, Umax UC630 flatbed scanner, HP 550c color printer.

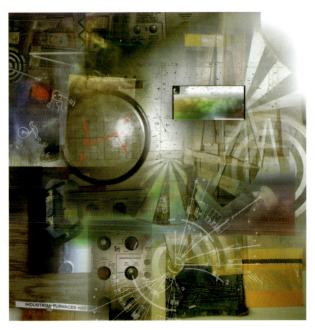

Windmachine
1994 / Self-Promotion
Software: Adobe Photoshop2.5.1, Specular Collage1.0

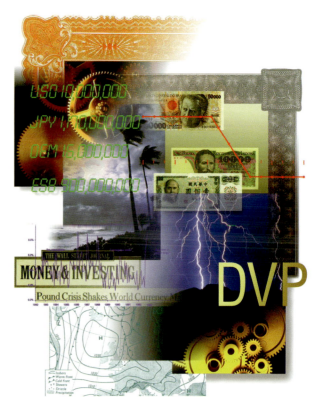

Risk
1993 / J. P. Morgan Co, Inc. : Annual Report Illustration
Software: Fractal Design Colorstudio1.5

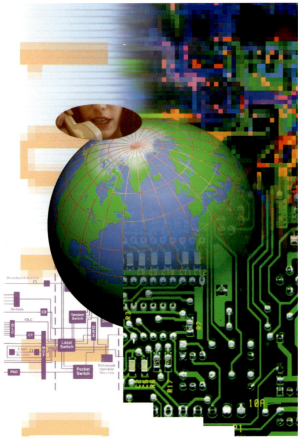

F.G.I.
1992 / F.G.I. : Annual Report Cover
Software: Fractal Design Colorstudio1.5

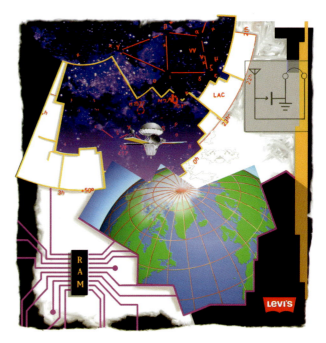

Levi's
1992 / Levis International : Annual Report Cover
Software: Aldus FreeHand3.0, Fractal Design Colorstudio1.5

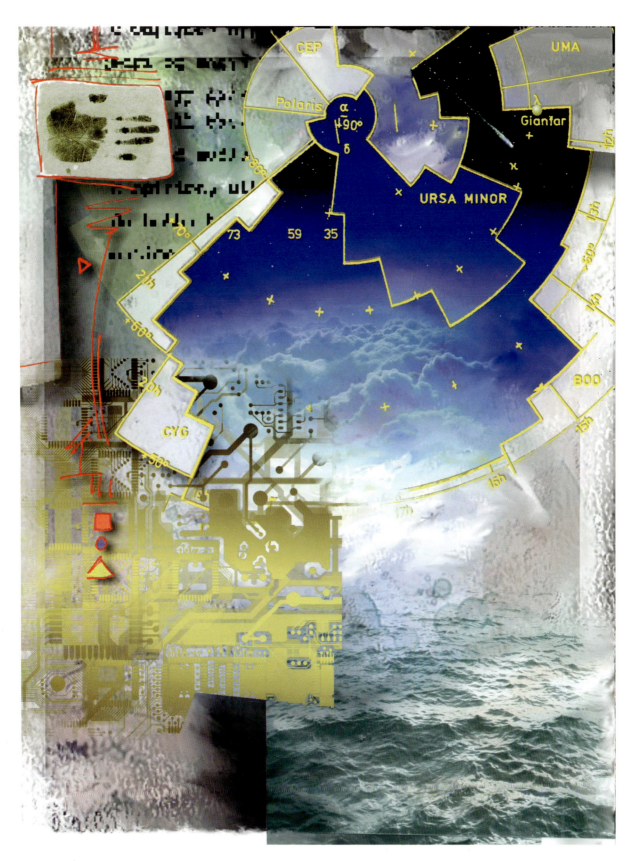

I.D.E.A.

1993 / I.D.E.A.
Software: Fractal Design Painter 2.0, Fractal Design Colorstudio 1.5

GALLERY Jeff Brice

Mercury
1992 / Mohawk Paper Co. : Paper Promotion Illustration
Software: Fractal Design Colorstudio1.5, Aldus FreeHand3.0

Health Promo
1993 / Self-Promotion
Software: Adobe Photoshop2.5.1, Fractal Design Colorstudio1.5

Microphone
1993 / Microsoft Corporation : Package Design
Software: Adobe Photoshop2.5.1, Fractal Design Colorstudio1.5

Compuserve Mural
1992 / Compuserve : Trade Show Mural
Software: Fractal Design Colorstudio1.5

Collage with Photoshop

Fountain
1994 / Self-Promotion
Software: Adobe Photoshop2.5.1, Specular Collage1.0

Photo CD
1992 / Macworld magazine : Editorial Illustration
Software: Fractal Design Colorstudio1.5, Aldus FreeHand2.0

Communications
1993 / Microsoft Corporation : Point of Purchase Display Illustration
Software: Fractal Design Colorstudio1.5

Life Sciences
1992 / Research Technologies Corporation : Annual Report Illustration
Software: Fractal Design Colorstudio1.5

Holy War
1994 / Personal
Software: Adobe Photoshop 2.5.1, Adobe Illustrator 5.0, Specular Collage 1.01, Ray Dream Designer 3.0.4, Aldus FreeHand 4.0, Altsys Fontographer 4.0

When designer Rick Valicenti of Chicago began *Thirst* in 1988, it marked the rebirth of his design firm, R. Valicenti Design, in which he shed a safe corporate approach of placating clients in favor of an approach which emphasized artistic self-expression. In so doing, Valicenti assumed a stance whereby he risked alienating customers. That is exactly what happened—he lost all but one of his clients.

"You know, it gets blown out of proportion," recalls Valicenti. "It wasn't that big of a deal. It was just a decision to try to do things my own way and not anybody else's and to hope it would all be OK." Doing things his own way included bringing designer, photographer, and computer artist Mark Ratten on board at *Thirst*.

According to Valicenti, his experience with the Macintosh computer prior to working with Ratten "was probably like everyone else's—as a spectator trying to catch up." Since joining forces, they have made an effort to use the Macintosh not just for solving production problems, but also to push its limits as a means of artistic expression. This approach has resulted in award-winning design projects for a wide range of clients including Gilbert Paper Company, Scitex Corporation, and Warner Brothers Records.

"When war is waged because of religious belief or affiliation, we undermine the basic essence of humanity," explains Thirst's Mark Ratten, "Holy War is a comment on the abusive politics of power and religion."

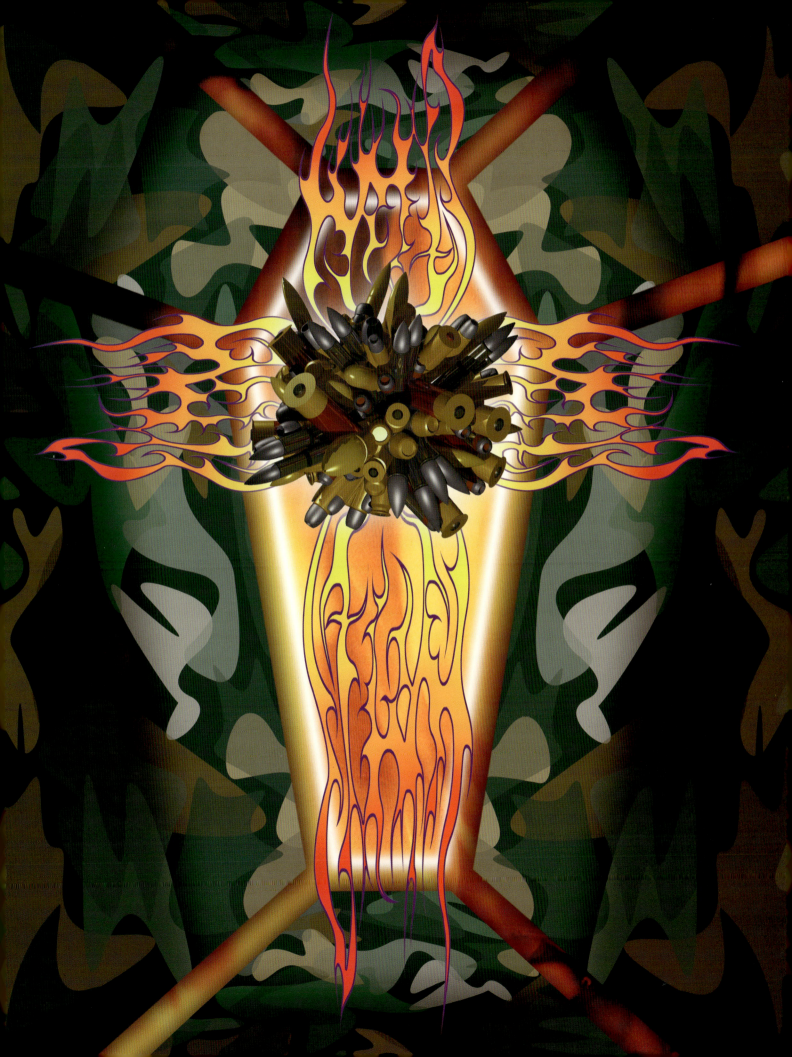

STEP BY STEP
TH1RST

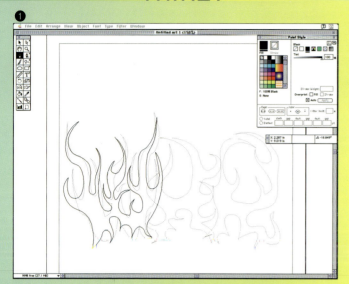

Step 1

"Holy War," by Thirst's Rick Valicenti and Mark Ratten, was started in Adobe Illustrator 5.0 by creating curved paths with the Pen tool to make a stylized, flame-like graphic of the word "war" *(Fig. 1)*.

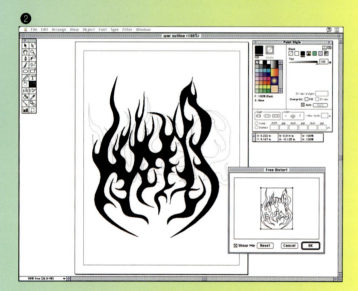

Step 2

In order to give the graphic a more imposing and ominous presence, the Thirst team stretched it upward using Illustrator's Free Distort filter *(Fig. 2)* and then adjusted its perspective *(Fig. 3)*.

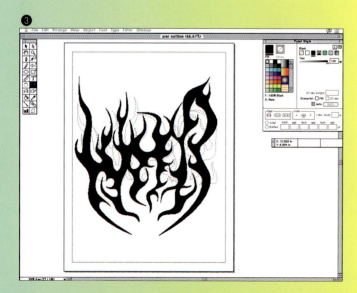

94 Collage with Photoshop

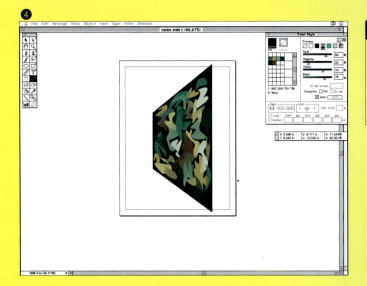

Step 3

In another Illustrator file, the team created a camouflage texture and reshaped it with the Free Distort filter *(Fig. 4)*. They repeated this process to create several different shapes of camouflage panels before saving the file.

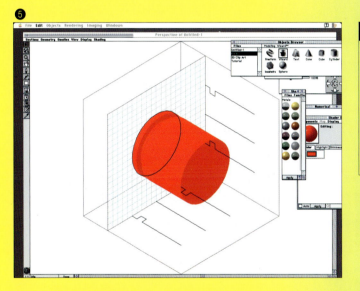

Step 4

Valicenti and Ratten envisioned a sphere of bullets as strongly symbolic of their view of war and of ethnic cleansing in Bosnia. To illustrate this concept, they used Ray Dream Designer 3.0 to create 3-D bullets. First, they created a shape for the bullet shell *(Fig. 5)*. Then, using Designer's Lathe Object operation, they made a tapered bullet which they added to the shell *(Fig. 6)*.

STEP BY STEP
TH1RST

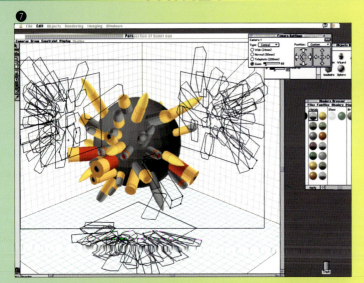
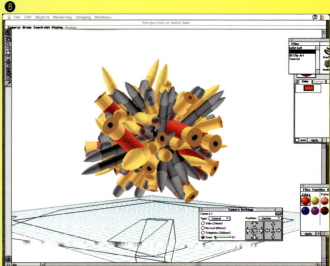

Step 5

After they created a variety of bullet shapes in Designer, the Thirst team formed them into a ball. This was accomplished by creating a sphere as a template around which the bullets were arranged *(Fig. 7)*.

Step 6

The result of tightly packing the varied bullet shapes, sizes and colors around the template was the creation of a globe bristling with bullets. The team of artists was now able to delete the sphere which had served as a template, and they rendered the file *(Fig. 8)*.

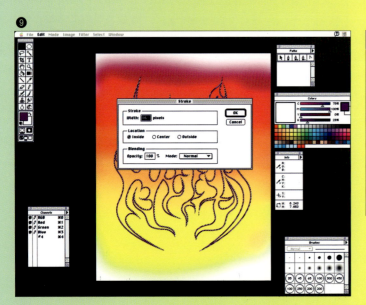

Step 7

While the 3-D image was being rendered on one computer, Valicenti and Ratten used another computer to create the remaining source images for "Holy War." They began in Adobe Photoshop 2.5 by creating an airbrushed red-to-yellow gradation in a blank RGB file. Then they placed the black-and-white Illustrator file of the "war" flames into Channel #4 to use as a mask. Next, they loaded the selection from Channel #4 and applied a 16-pixel stroke to better define the shape of the flames *(Fig. 9)*.

Step 8

When the flames were finished, the artists worked on the camouflage background. After opening the Illustrator file in Photoshop, they shaded the camouflage panel so it would appear that a light source was glowing along one side. Before saving the file, a mask was made to separate the panel from its background when used in Collage *(Fig. 10)*. The artists prepared several more panels following this procedure.

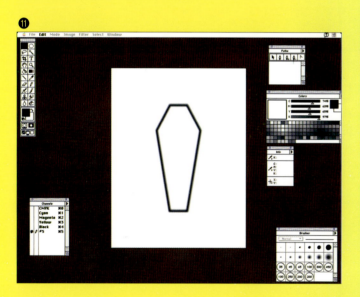

Step 9

After finishing the camouflage panels, Valicenti and Ratten scanned a photograph of a fire and created an outline form of a coffin in the image. First, the Thirst team created the coffin as a black outline against a white background and softened it using the Gaussian Blur filter *(Fig. 11)*. Second, they copied and pasted the black-and-white file of the coffin into Channel #4 of the fire image. Third, after inverting the channel, they loaded the selection and filled the selected area of the RGB channel with white *(Fig. 12)*.

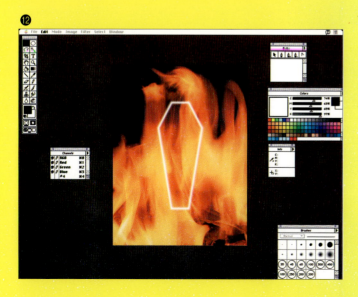

STEP BY STEP
TH1RST

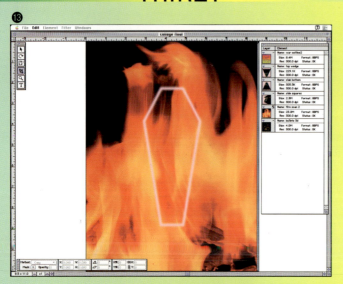

Step 10

After they completed their work in Designer, Illustrator, and Photoshop, the Thirst team opened Collage and imported all of the elements. Working methodically, they began building the final image layer by layer, starting from the bottom. The first layer added was the image of the flames and the coffin *(Fig. 13)*.

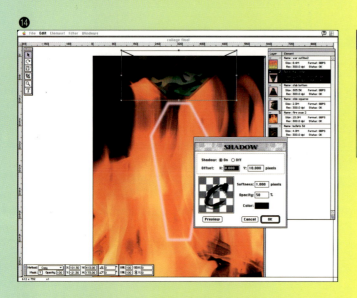

Step 11

The next layer was assembled using the camouflage panels, starting with a panel at the top of the image. Here, Valicenti and Ratten used the Shadow dialog box to create the illusion that the panel is floating above the fire background *(Fig. 14)*. They repeated this process until all the camouflage pieces were in place *(Fig. 15)*.

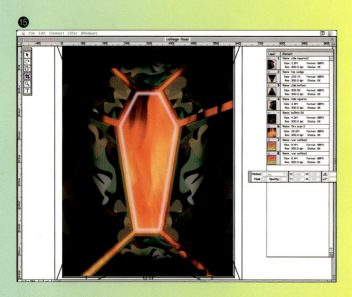

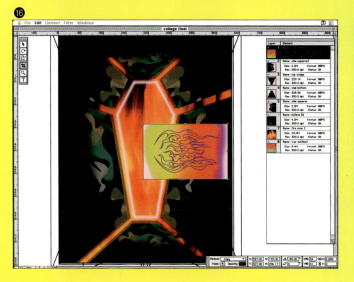

Step 12

Only one copy of the flames was imported into Collage. After it was placed onto the canvas, the artists rotated it until it was in a horizontal position *(Fig. 16)* and turned on its mask. Then, using Collage's Duplicate command, they easily added three more copies of the flames. After moving the flames into position, the team rotated the copies by entering values into the Rotation field of the Information palette *(Fig. 17)*.

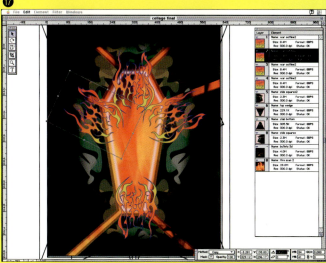

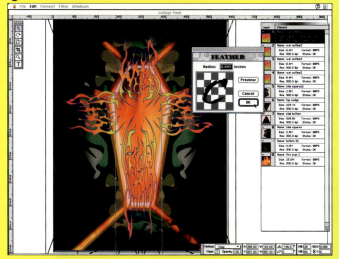

Step 13

Using the Arrow tool, the Thirst team selected points along the frame of the lower flame image and stretched it to fill the bottom half of the image. Then, using the controls in the Feather dialog box, they subtly softened the flames *(Fig. 18)*.

Thirst 99

STEP BY STEP
TH1RST

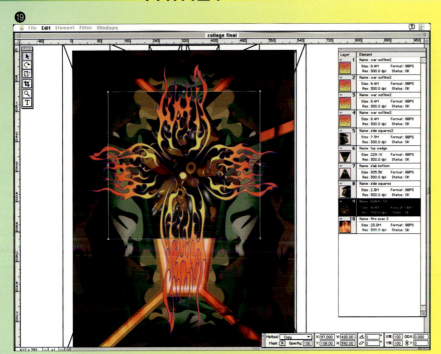

Step 14

The bullet sphere, when placed onto the canvas from its original position on the Element palette, appeared below the other elements *(Fig. 19)*. To correct this, the bullet entry on the Element palette was moved from Layer 9 to Layer 1, and its mask was turned on *(Fig. 20)*.

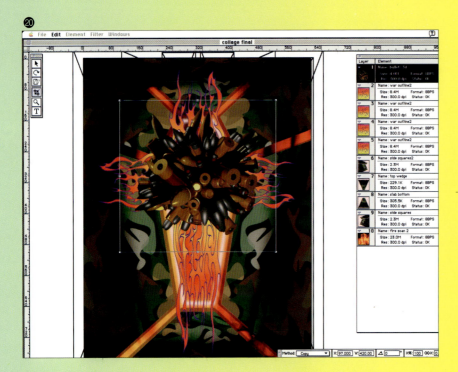

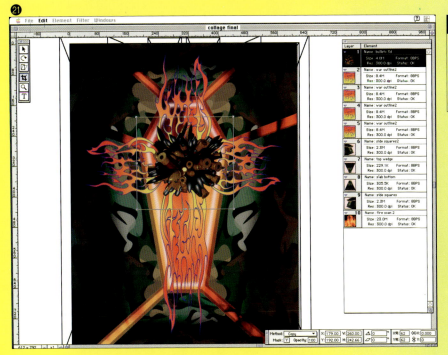

Step 15

Before the final rendering of the image, the Thirst team reduced the size of the bullet sphere *(Fig. 21)* and then rotated it *(Fig. 22)*.

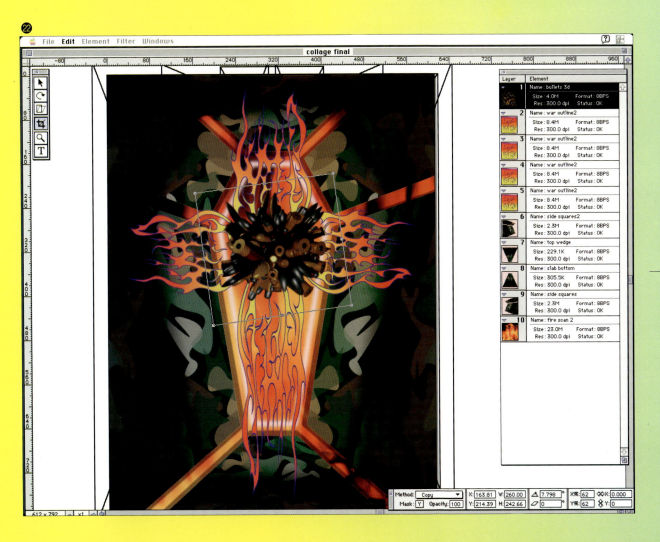

GALLERY
TH1RST

System:
19" SuperMac monitor, Quadra 950, 140MB RAM, 1.2GB internal Raven Twin hard drive, Thunder Pro 24, Tahiti 1 GB removable magneto-optical drive.

Ideas
1993 / Scitex (Thomas Munroe, Inc.) : Brochure Illustration
Software: Adobe Photoshop2.5.1, Adobe Illustrator3.2, Ray Dream Designer 2.0, Altsys Fontographer

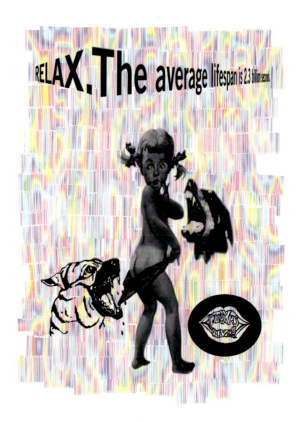

Fluxus Back Side
1993 / Art Club of Chicago : Poster
Software: Adobe Photoshop2.5.1

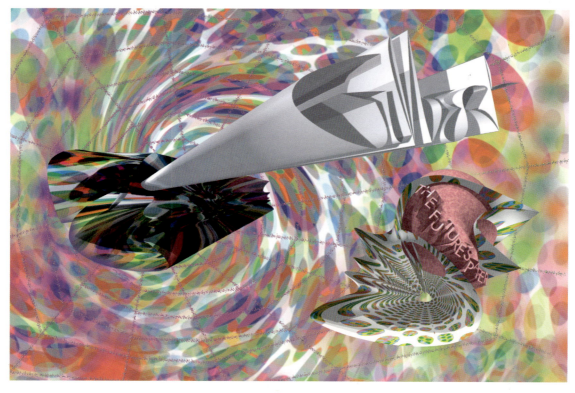

The Cyberweb
1994 / Gilbert Paper Co. : Advertisement Illustration
Software: Adobe Illustrator5.0, Adobe Photoshop2.5.1, Ray Dream Designer2.0

102 *Collage with Photoshop*

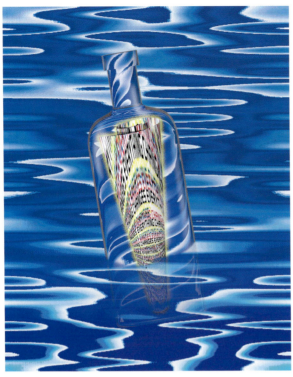

Absolut Paradigm

1994 / I.D. magazine (Carillon Importers, Ltd.) : Advertisement Illustration
Software: Adobe Illustrator5.0, Adobe Photoshop2.5.1, Ray Dream Designer2.0

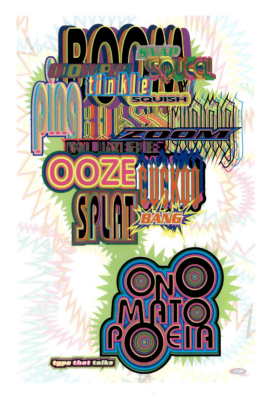

Onomatopoeia

1994 / AGFA : Book Illustration
Software: Adobe Illustrator5.0

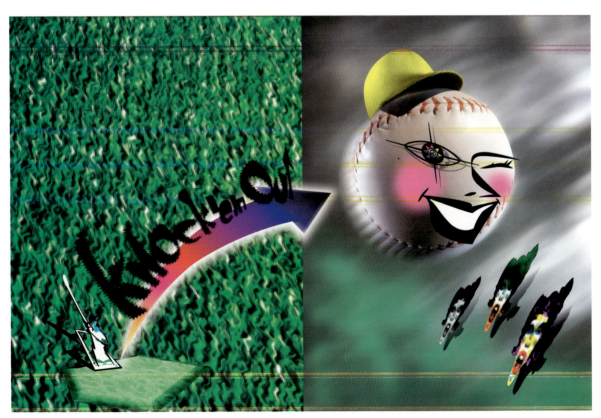

The Color Center

1992 / Scitex (Thomas Munroe, Inc.) : Brochure Illustration
Software: Adobe Illustrator3.2, Adobe Photoshop2.01, Fractal Design Painter1.0, Aldus FreeHand3.1
Cameras: Toyo4×5, Hasselblad2 1/4

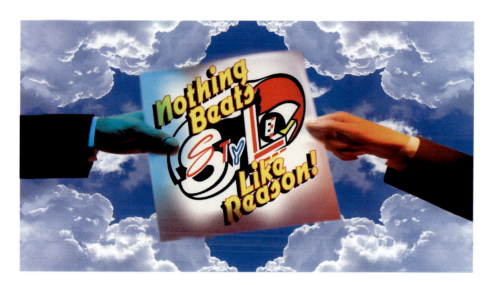

Nothing Beats Style Like Reason

1993 / Gilbert Paper Co. : Advertisement Illustration
Software: Aldus FreeHand 3.1, Adobe Photoshop2.5.1
Camera: Hasselblad2 1/4

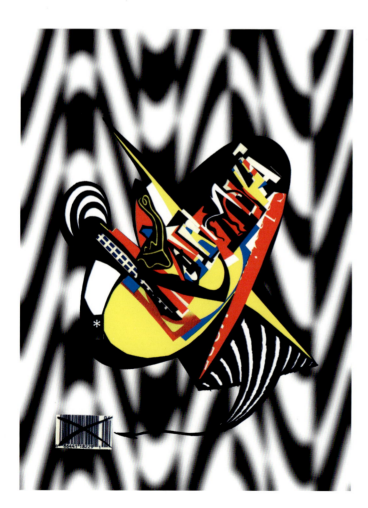

Karma

1993 / Creativity magazine : Cover Illustration
Software: Adobe Photoshop2.5.1, Aldus FreeHand3.1

Pique Touch

1994 / Gilbert Paper : Advertisement
Camera: Hasselblad2 1/4

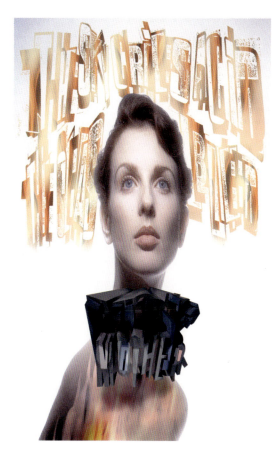

Earth Mother

1994 / World Conservation Union Conference : Poster
Software: Adobe Illustrator5.0, Aldus FreeHand 4.0, Altsys Fontographer4.0,
Adobe Photoshop2.5.1, Ray Dream Designer3.0.4
Camera: Hasselblad2 1/4

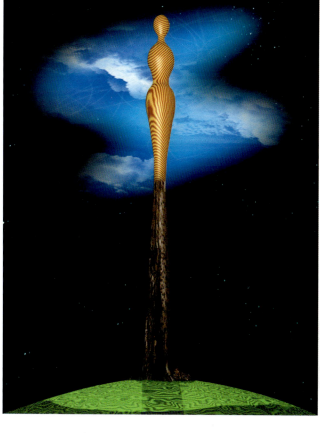

Livingwood Venus

1993 / Livingwood : Television Graphic
Software: Adobe Photoshop2.5.1, Ray Dream Designer2.0

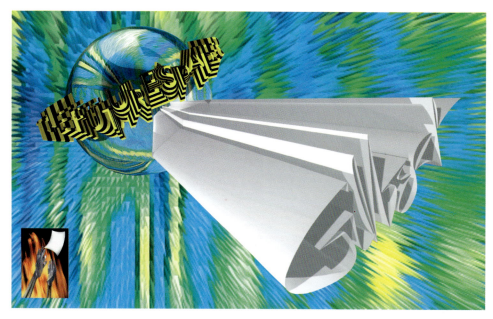

Brave New World

1994 / Gilbert Paper Co. : Advertisement Illustration
Software: Adobe Photoshop2.5.1, Aldus FreeHand4.0, Adobe Illustrator5.0, Altsys
Fontographer 4.0, Ray Dream Designer2.0

TH1RST

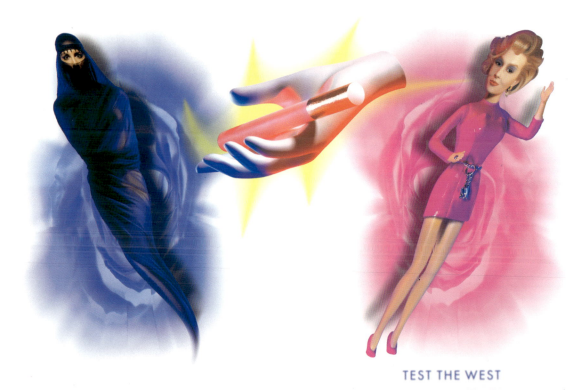

Test the West

1994 / Scholz & Friends, Germany : Billboard
Software: Adobe Photoshop2.5.1, Aldus FreeHand4.0

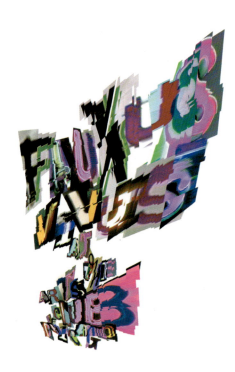

Fluxus Poster Type

1993 / Art Club of Chicago : Poster
Software: Adobe Photoshop2.5.1
Cameras: Color Snap32, Sony Hi-8 video

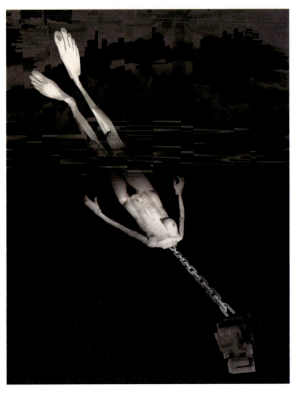

You Are a Prisoner of Your Own Conventions

1993 / Confetti magazine : Editorial Illustration
Software: Adobe Photoshop2.5.1
Cameras: Color Snap32, Sony Hi-8 Camera

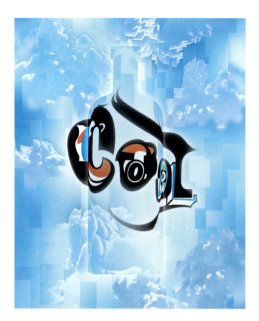

Absolut Attitude
1994 / I.D. magazine (Carillon Importers Ltd.) : Advertisement Illustration
Software: Adobe Illustrator3.2, Ray Dream Designer2.0, Adobe Photoshop2.5.1

Romeo &
1993 / Elektra Music : Record Cover
Software: Adobe Photoshop2.5.1, Adobe Illustrator3.2
Camera: Sony Hi-8 video

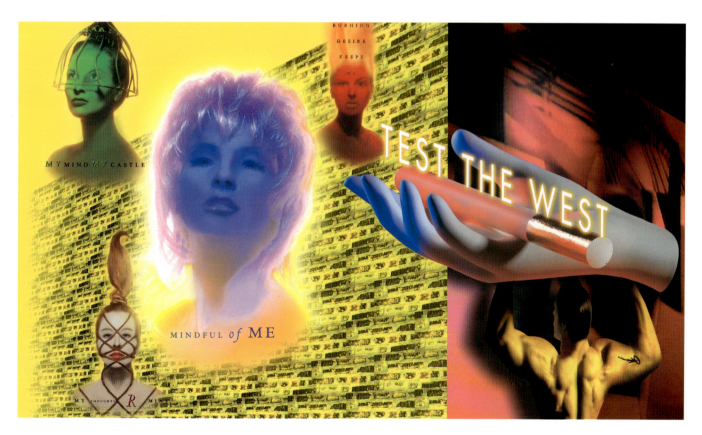

Esoterica
1994 / Scholz & Friends, Germany : Billboard
Software: Aldus FreeHand 4.0, Adobe Photoshop2.5.1, Ray Dream Designer2.0
Cameras: Sony Hi-8 video camera, Hasselblad2 1/4 camera, Color Snap32

Pamela Hobbs

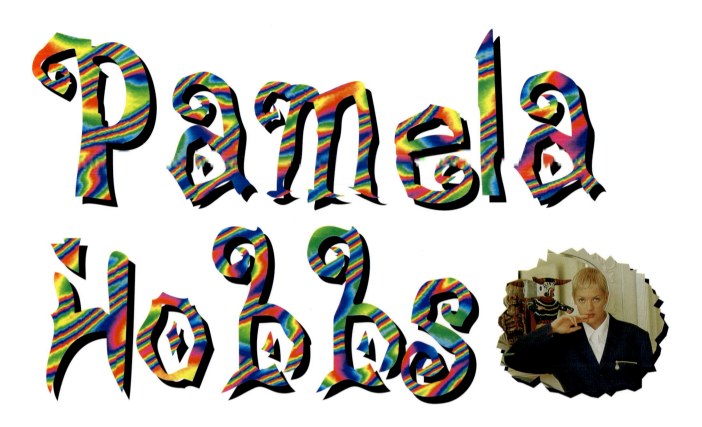

 Pamela Hobbs has lived and worked as a computer artist in several cities around the globe, including London, Washington, DC, New York City, Tokyo and San Francisco.

 Hobbs' journey began, after graduation from the Maryland Art Institute, when she was hired as a technician on a Lightspeed workstation for a Washington, DC computer graphics firm. In between projects for clients, she used the system to build a portfolio of computer art of her own. Soon after moving to New York City, she began showing her portfolio around town. One early stop, at Psychology Today, resulted in an immediate assignment. "The art director said, 'Great, we like your stuff. Here's a job, finish it in a week,'" Hobbs remembers with a laugh, "I don't know what I was thinking, because I didn't have a computer at the time."

 Hobbs persevered, gained access to a leased IBM computer and completed the assignment successfully. Since then, Hobbs has completed many illustration assignments for clients including the New York Times, CBS, MTV, Absolut Vodka, Condé Nast, and Polygram Records. Her artwork has been widely exhibited in the United States and Japan and she has been featured in publications including Verbum magazine, How magazine, Step-by-Step Graphics, Mac Life (Tokyo) and Aldus magazine.

Evince

1994
Software：Adobe Photoshop2.5.1、Specular Collage1.0.1、
Pantechnicon TextureSynth1.2.1

"I just wanted to make a really cool looking image and I love Jean Paul Gaultier's new line of clothing which had that Indian look to it so I thought, hey, that's a direction," Hobbs explains about the making of Evince.

Step By Step
Pamela Hobbs

Step 1

For her illustration entitled "Evince," Pamela Hobbs wanted to create an image that juxtaposed traditional values with modern day kitsch. She selected about 30 different elements to demonstrate this concept, ranging from a 3-D charm bracelet Buddha *(Fig. 1)* to a photograph of a drag queen *(Fig. 2)*.

Step 2

To prepare files for use in Specular Collage, Hobbs started by using a flatbed scanner to scan the many objects and photographs she'd collected. Then, in Adobe Photoshop, she opened the scans, selected the objects and created masks employing varying degrees of feathering.

Step 3

To create the frame, Hobbs scanned a real frame on her flatbed scanner. Then, she scanned a photograph of a different frame and composited the two together. To further enhance the appearance of the composited frame, she applied the Twirl filter to various areas, such as the inside corners, and used the Dodge tool to add highlights.

Step 4

In TextureSynth, Hobbs created two textures (one blue and one red) which she saved as 24-bit, 640 × 480-pixel TIFF files.

Step By Step
Pamela Hobbs

Step 5

Hobbs created the figure that appears inside the frame by first creating a line art drawing of the head and face on paper. Next, she scanned the line art, selected and deleted its background, and then saved the grayscale file.

Step 6

Once the different elements were completed in Photoshop, Hobbs imported them into Collage using the More feature of the Import dialog box to import multiple files. After all the elements were imported, she dragged them onto the canvas beginning with the blue texture created in TextureSynth.

Step 7

Hobbs continued placing elements onto the canvas, taking full advantage of the fact that Collage treats bitmapped images as objects to get just the right juxtaposition of images. She freely experimented with different positions, layers, and blending methods until she was satisfied with what she saw on the screen.

112 **Collage with Photoshop**

Step 8

Up to this point, Hobbs had experimented with her image extensively in Collage. But when she added the figure of the head into the frame, she decided that it needed to be worked on in Photoshop. Since the black-and-white line artwork appeared against a colored background only in Collage, she selected and rendered only that portion of the image.

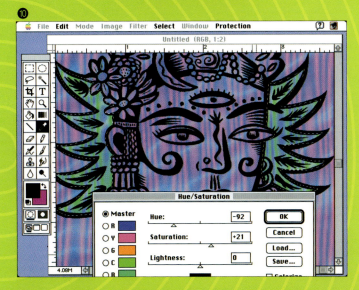

Step 9

In Photoshop, Hobbs opened the portion of the image she rendered in Step 8. Then, using the Hue/Saturation dialog box, she selectively began adjusting colors and boosting the saturation of the image. Before saving the file, she used Kai's Power Tools (KPT) filters to create spheres over the background texture.

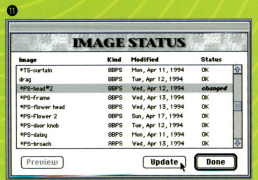

Step 10

Back in Collage, Hobbs used the Image Status dialog box to update the file named *PS-head#2 with the newer version containing more saturated colors and the KPT filter glass spheres.

Step by Step
Pamela Hobbs

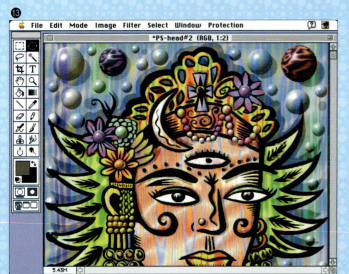
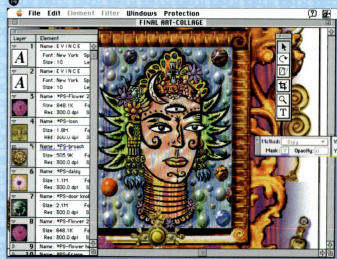

Step 11

Hobbs made one final adjustment to the head in Photoshop, this time adding color and shadows to the spheres. She used the same procedure in Step 10 to update the Collage file.

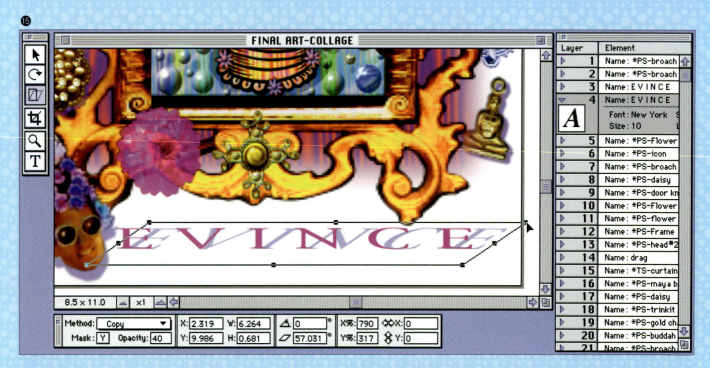

Step 12

To create added dimension, Hobbs placed a shadow behind the text, "Evince," by duplicating the type, placing it behind the original, and then skewing the duplicate.

114 Collage with Photoshop

SYSTEM:
Macintosh IIci with cache card, 20MB RAM, Daystar 040 accelerator board, 240MB internal hard drive, 44MB SyQuest, Umax 630 600dpi scanner

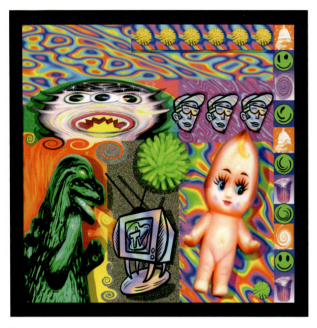

House
1994 / Polygram Records : CD Cover
Software: Adobe Photoshop2.5.1, Pantechnicon TextureSynth1.21

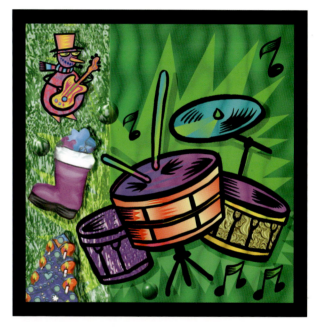

Rockin at Christmastime
1994 / Polygram Records : CD Cover
Software: Adobe Photoshop2.5.1, Pantechnicon TextureSynth1.21

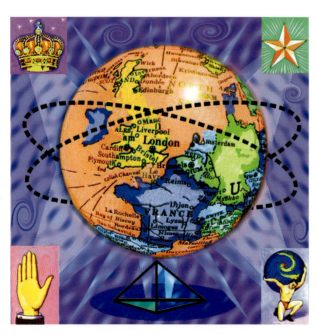

Euro
1994 / Polygram Records : CD Cover
Software: Adobe Photoshop2.5.1, Pantechnicon TextureSynth1.2.1

Pamela Hobbs

Gallery
Pamela Hobbs

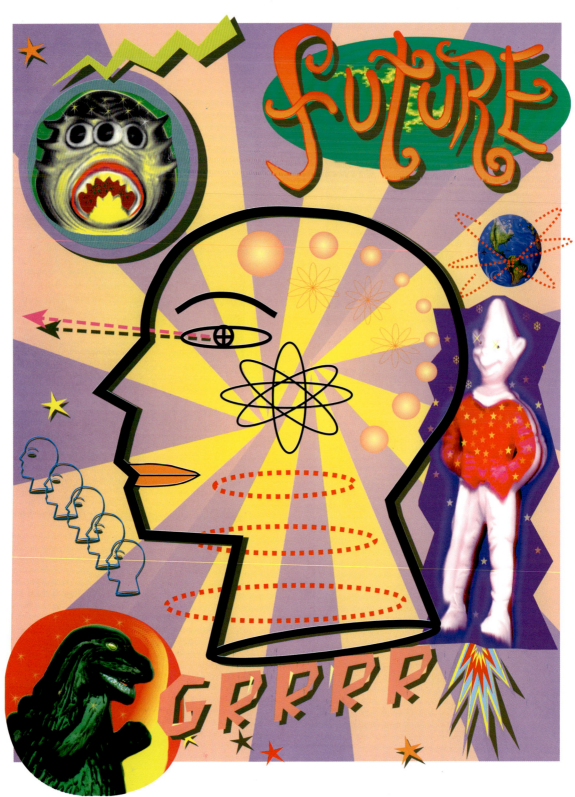

Virtual Worlds
1993 / ACM Siggraph magazine : Editorial Illustration
Software: Adobe Photoshop2.5.1, Aldus FreeHand4.0

Disco Hits
1994 / Polygram Records : CD Cover
Software: Adobe Photoshop2.5.1, Pantechnicon TextureSynth1.21

Soulful Xmas
1994 / Polygram Records : CD Cover
Software: Adobe Photoshop2.5.1, Pantechnicon TextureSynth1.2.1

Disco Divas
1994 / Polygram Records : CD Cover
Software: Adobe Photoshop2.5.1, Pantechnicon TextureSynth1.21

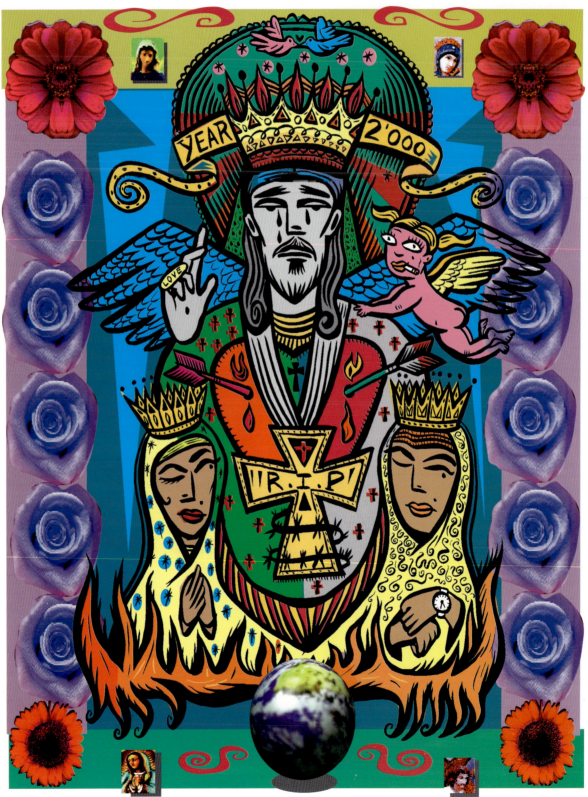

Into the Millennium

1993 / Mercer Gallery : Art Trading Card
Software：Adobe Photoshop2.5.1、Aldus FreeHand4.0

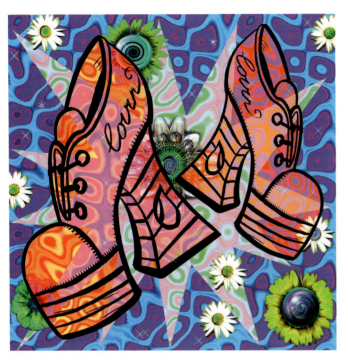

Disco Funk
1994 / Polygram Records : CD Cover
Software：Adobe Photoshop2.5.1、Pantechnicon TextureSynth1.21

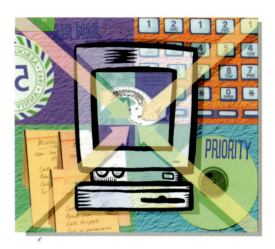

Networking
1993 / MacWeek : Editorial Illustration
Software: Adobe Photoshop2.5.1

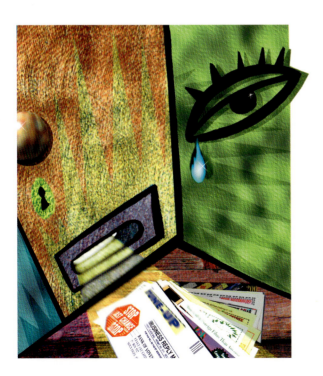

Assembling the Pieces of a Power Mac System
1994 / MacWeek : Editorial Illustration
Software：Adobe Photoshop2.5.1、Pantechnicon TextureSynth1.2.1

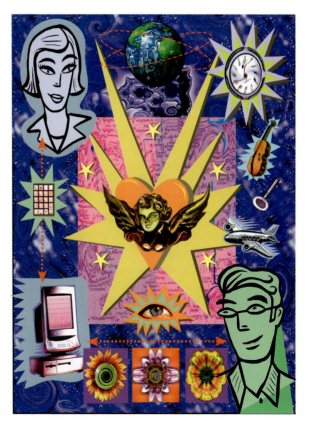

Love at First Link-up
1993 / New Woman magazine : Editorial Illustration
Software：Adobe Photoshop2.5.1、Aldus FreeHand3.1

Lance Hidy

During his twenty-five year career as a fine artist and illustrator, Massachusetts-based artist Lance Hidy has received accolades for his work in traditional media such as etching, wood engraving, letterpress, and silk-screen. "I think that I've done work in every historic printing medium," reflects Hidy, "including pre-printing things like calligraphy and painting."

Hidy's early artistic pursuits during his college years at Yale University and shortly after graduation, involved publishing handmade books as an art form. But starting in the mid-1970s he became interested in creating poster illustrations as a means of communication. "I spent a lot of time learning about early posters and related art forms including Matisse's paper cut-outs, Greek vase paintings, and Japanese woodblock printing," Hidy says.

It was during that period of study that Hidy discovered the photomontage artwork of Tadanori Yokoo and longed to work with similar techniques. "But technically," says Hidy, "his approach was something that was out of reach for me." That changed for Hidy when he began using the Macintosh and Adobe Photoshop for the first time in 1989. "It was like I had been waiting 12 years for that moment," Hidy recalls, "I'd never had a creative experience as intense as that."

Two Fences
1994 / Personal
Software: Adobe Photoshop2.5.1, Specular Collage1.01

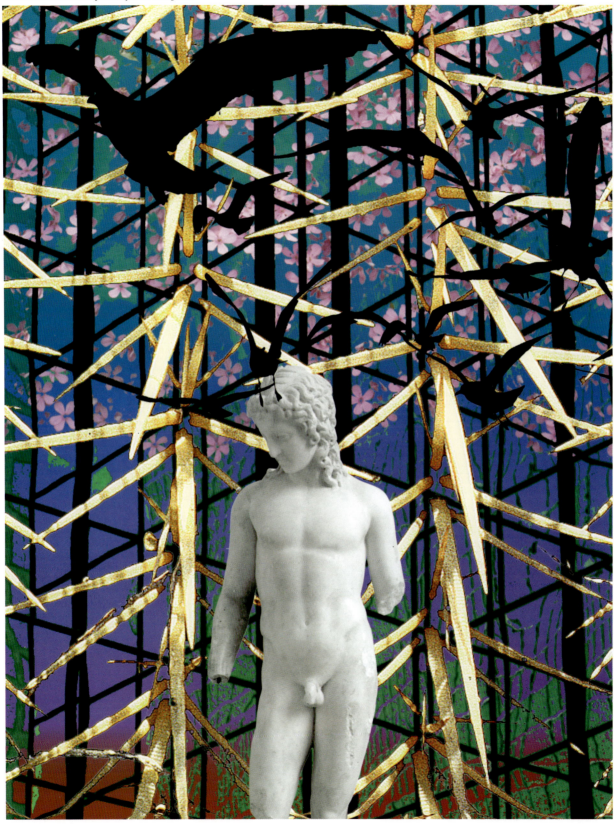

Hidy created "Two Fences" by letting his subconscious thoughts be his guide. "I try not to think about what I am making," he explains, "Sometimes I do not understand what the work is about until months later."

Step by Step Lance Hidy

Step 1

Lance Hidy started work on his image "Two Fences" by creating a number of source files in Adobe Photoshop to use in Specular Collage. He began by creating a background image using a scanned photograph of reflections in the side of a glass building *(Fig. 1)*. Using the Magic Wand tool, he made a selection of the blue areas of the reflection, deleted these areas to white and saved the selection as a mask in Channel #4 *(Fig. 2)*. Then, he returned to the RGB channel and used the Hue/Saturation dialog box to tint the image green *(Fig. 3)*.

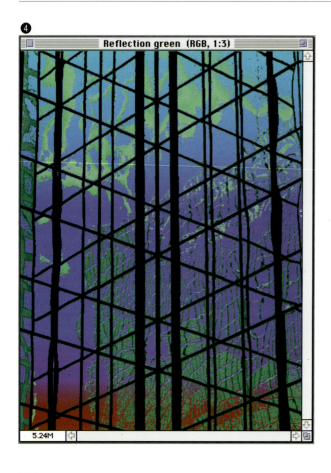

Step 2

Next, Hidy loaded the selection from Channel #4 and applied a gradation to the image using the Gradient tool *(Fig. 4)*. Hidy wasn't pleased with the lighter tone at the top of the image. To correct this, he returned to the mask in Channel #4. Then, he selected the Gradient tool and the Multiply mode from the Brushes palette. These selections allowed him to apply a black-to-white gradation in only the white portions of the mask *(Fig. 5)*. To darken the upper portion of the RGB image using this mask, Hidy loaded the selection and applied a 50% fill with black *(Fig. 6)*.

Step 3

Another element Hidy included in his background image was a scan of pink flowers *(Fig. 7)*. Hidy used the Magic Wand tool to select the dark areas of the scan. He then inverted the selection and copied the pink flowers to the clipboard. Next, he selected the black lines of the image he created in Step 2 and used the Paste Behind command from the Edit menu to add the pink flowers to the background *(Fig. 8)*.

Step 4

Additional elements Hidy incorporated into "Two Fences" were from an archive of scanned images that he'd used in previous compositions. These images included the thorns *(Fig. 9)*, the Greek statue *(Fig. 10)*, and the high-contrast scan of seagulls *(Fig. 11)*. For use in Specular Collage, Hidy created a mask in Channel #4 of each image.

Step by Step Lance Hidy

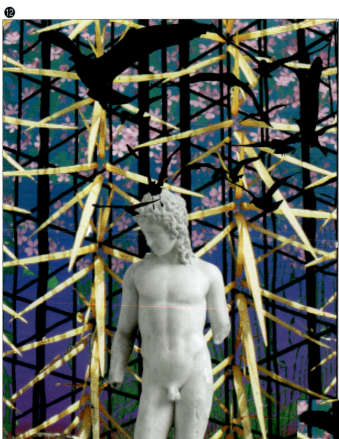

Step 5

After opening Collage, Hidy imported the various elements he'd created in Photoshop. According to Hidy, Collage benefits his style of working by allowing him to make as many subtle back-and-forth changes of position and size of elements as he needs. For example, after placing all the components onto the canvas *(Fig. 12)*, Hidy toyed with the position of the seagulls and the size of the statue until he was satisfied with the final results *(Fig. 13)*.

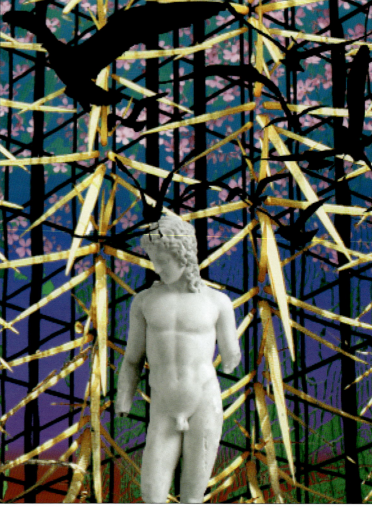

Gallery Lance Hidy

SYSTEM:
Radius 19" monitor, Radius 24-bit DirectColor video card, Mac II, 8MB RAM, 170 MB Quantum internal drive, Syquest 44MB drive, 600MB magneto-optical drive, Nikon LS-3500 slide scanner, Microtek 300z flatbed scanner.

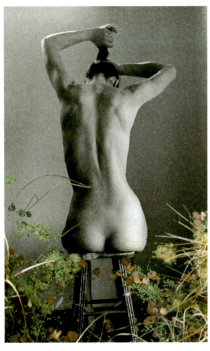

Libby
1991 / Personal
Software: Adobe Photoshop1.01

Splinters
1992 / Personal
Software: Adobe Photoshop2.01

Neptune
1992 / Personal
Software: Adobe Photoshop2.01

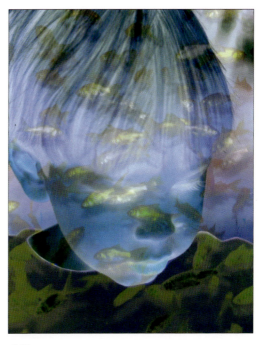

Fishboy
1991 / Personal : Portrait of Hidy's Son
Software: Adobe Photoshop1.01

Gallery Lance Hidy

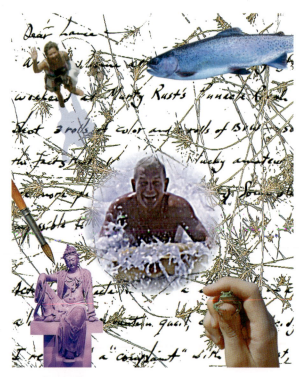

My Father Surfing
1992 / Personal
Software: Adobe Photoshop2.01

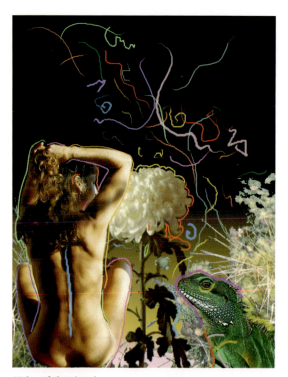

Voice of the Lizard
1991 / Personal
Software: Adobe Photoshop1.01

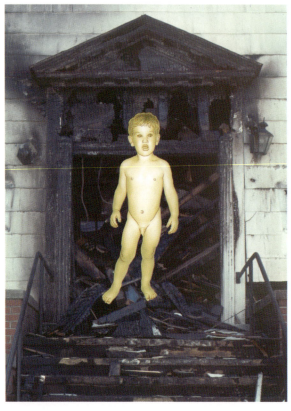

Boy Rising
1994 / Personal
Software: Adobe Photoshop2.5.1

Tadanori Yokoo Learns Photoshop
1992 / Print magazine : Editorial Illustration
Software: Adobe Photoshop2.01

Untitled
1990 / The American Foundation for Surgery of the Hand : Poster
Software: Adobe Photoshop1.01, Adobe Illustrator

Temple
1989 / Personal : Birth Announcement for Hidy's Son
Software: Adobe Photoshop beta

Swimming
1989 / Art Director's Club of Metropolitan Washington : Lecture Announcement
Software: Adobe Photoshop beta, Adobe Illustrator

SKOLOS/WEDELL

Nancy Skolos and Tom Wedell are a husband and wife design duo based in Charlestown, MA. Skolos says that she and Wedell were "fated to meet each other" while attending Cranbrook Academy of Art in 1979. Since then, Skolos' design skill and Wedell's photographic wizardry have blended into a singular style of design and illustration exemplified by complex layering, ethereal lighting, and surreal shadowing.

The fact that their illustrations are so complex has led many to believe that Skolos and Wedell's early images were created on computers. "For example," Wedell recalls, "we did a cover for ID magazine back in 1983. Everything was done in camera—there were very bright colors and geometric shapes." Soon after the magazine was published, Wedell explains, he received a call from someone wondering what computer the artist had used. "I told him that you can't do that on a computer," Wedell remembers, "you can only do it in camera."

Just as fate linked the two artists to each other, it seems also to have played a role in linking them to the computer. They have integrated not only the Macintosh computer into their work method, but also high-end digital imaging systems such as the Quantel Paintbox and the Kodak Premier System.

Electronic Imaging
1994 / Personal
Software: Aldus FreeHand4.0, Adobe Photoshop2.5.1, Specular Collage1.01

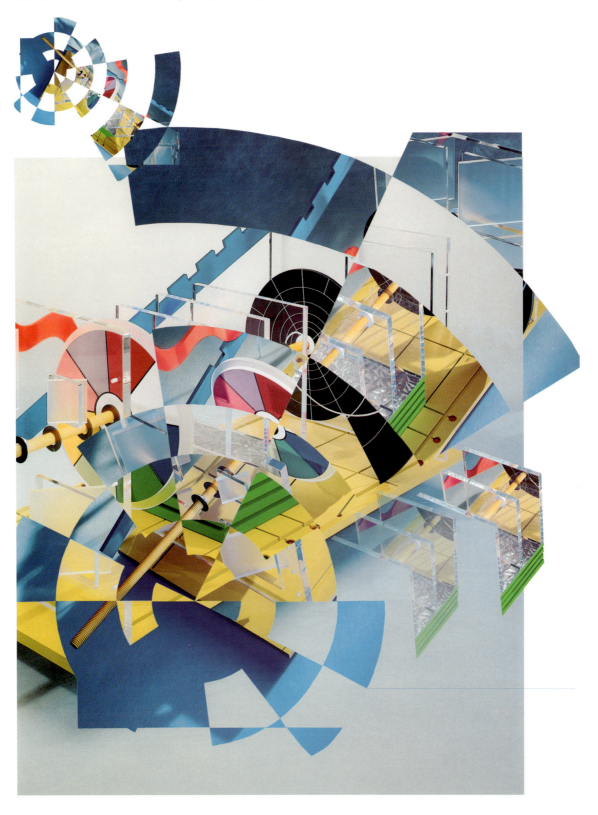

According to Nancy Skolos, the image is designed to conceptually convey the characteristics of electronic imaging, such as data processing, special effects, and image compositing.

STEP BY STEP

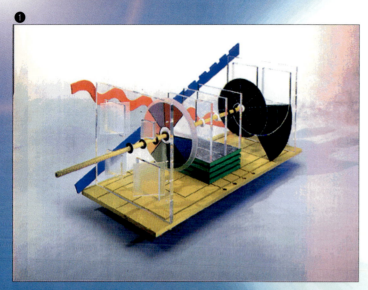

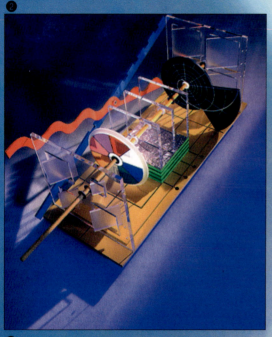

Step 1

Photographing a model made with acrylic plastic sheets in two different views was the first step for Nancy Skolos and Tom Wedells' Specular Collage image project. After they finished the photography, the artists scanned the photos of both views so that they could create a digital composite. One scan was saved as Skolos1.tiff *(Fig. 1)* and the other was saved as Image 1 *(Fig. 2)*.

Step 2

Next, in Aldus FreeHand, they created outlines of concentric circles and a pie-shaped wedge to use as the basis for a mask in Adobe Photoshop *(Fig. 3)*.

Step 3

After saving the FreeHand file in Illustrator 3.0 format, they opened the file in Photoshop where they copied and pasted it into Channel #4 of the file named Image 1 *(Fig. 4)*. Next, they loaded the selection from the mask in Channel #4 and Fill was chosen from the Edit menu to fill portions of the image with white. This process turned the scanned photograph into an abstract of geometric shapes *(Fig. 5)*. The new image was saved as Cut 1.

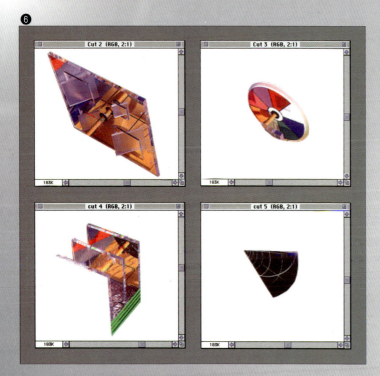

Step 4

Continuing in Photoshop, the artists next selected and copied small portions of the image Skolos1.tiff. They then pasted the copied portions into new files *(Fig. 6)* and made a mask for each object. The files were named Cut 2, Cut 3, Cut 4, and Cut 5.

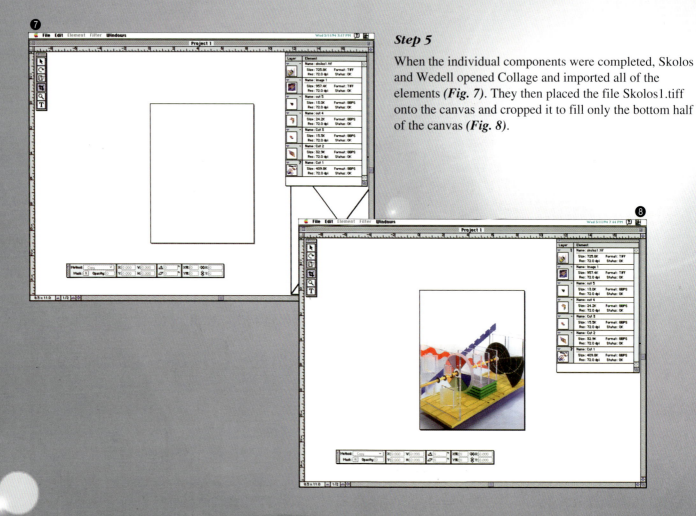

Step 5

When the individual components were completed, Skolos and Wedell opened Collage and imported all of the elements *(Fig. 7)*. They then placed the file Skolos1.tiff onto the canvas and cropped it to fill only the bottom half of the canvas *(Fig. 8)*.

Step 6

Choosing Layering from the Element menu and Bring Forward from the submenu, Skolos and Wedell moved the Cut 1 image from the bottom layer to the top layer *(Fig. 9)* and adjusted its position relative to the background image *(Fig. 10)*. At this point they determined the background was too large, so they trimmed it with the Crop tool *(Fig. 11)*.

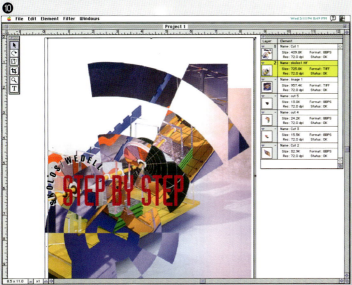

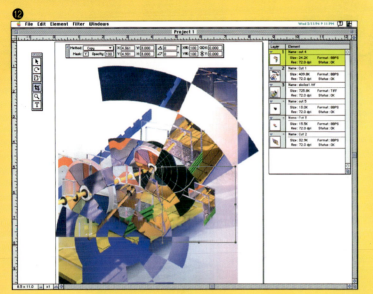

Step 7

The next element added to the image was from the file named Cut 4 *(Fig. 12)*. After placing it on the canvas and turning on its mask, they duplicated the file. Then, using the Information palette, they adjusted the opacity of the duplicate file *(Fig. 13)*.

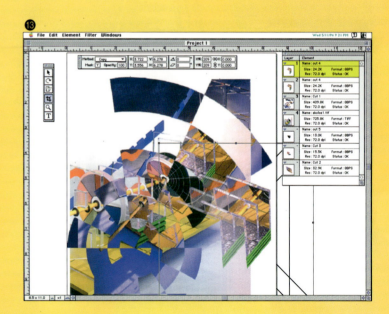

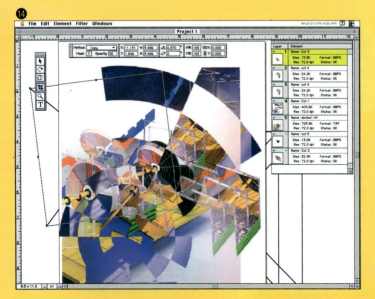

Step 8

The team placed the file Cut 3 next, and gave it an opacity of 50% to blend it into the background *(Fig. 14)*.

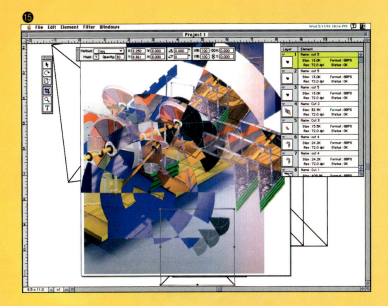

Step 9

Three copies of Cut 5 were positioned on the canvas, and varying degrees of opacity were applied to them *(Fig. 15)*.

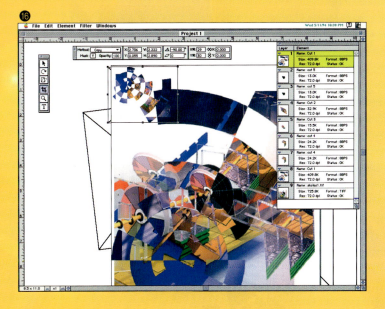

Step 10

As a final step before rendering the image, Skolos and Wedell duplicated the Cut 1 file, rotated it, scaled it down and placed it in the upper left corner of the image *(Fig. 16)*.

SKOLOS/WEDELL GALLERY

SYSTEM:
Radius Intellicolor 20" monitor, Power Macintosh 8100, 32MB RAM, 500MB internal hard drive, internal CD/ROM drive, 88MB SyQuest drive, Microtek Scanmaker IIXE.

Lyceum Fellowship Competition 1994
1994 / Lyceum Fellowship Committee : Poster
Software: Aldus FreeHand
Camera: Sinar View Camera

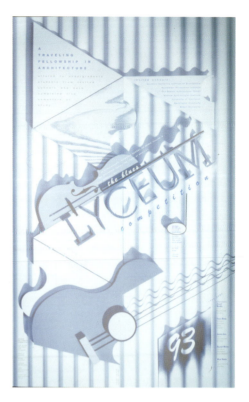

Lyceum Fellowship Competition 1993
1993 / Lyceum Fellowship Committee : Poster
Software: Aldus FreeHand
Camera: Sinar View Camera

Delphax Fonts Poster
1987 / Delphax
Camera: Sinar View Camera

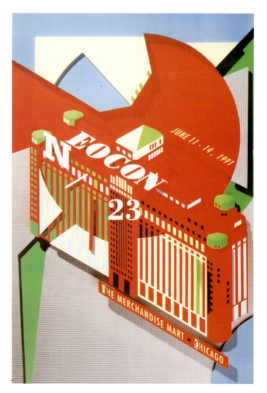

Neocon
1991 / The Merchandise Mart : Furniture Promotion
Software: Aldus FreeHand
Camera: Sinar View Camera

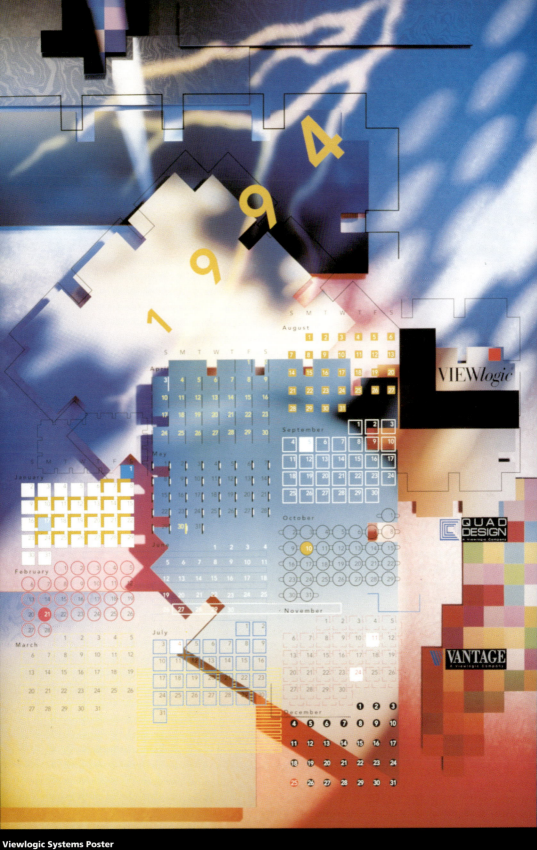

Viewlogic Systems Poster
1994 / VIEWlogic Systems, Inc. : Calendar
Software: Aldus FreeHand
Camera: Sinar View Camera

Man and Nature

1992 / Design Rio : Poster
Camera: Sinar View Camera

Creative Spirit Poster
1990 / WCVB : TV
Camera: Sinar View Camera

Lyceum Fellowship Competition 1992
1992 / Lyceum Fellowship Committee : Poster
Software: Aldus FreeHand
Camera: Sinar View Camera

EMI Music Publishing
1991 / EMI Music Publishing : Catalog Promotion
Camera: Sinar View Camera

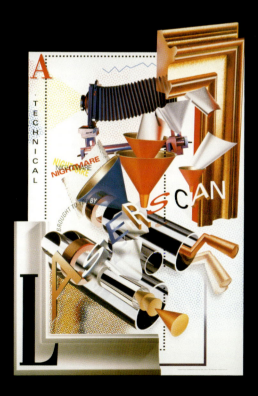

Laserscan Poster
1989 / Laserscan, Inc.
Software: Quantel Paintbox

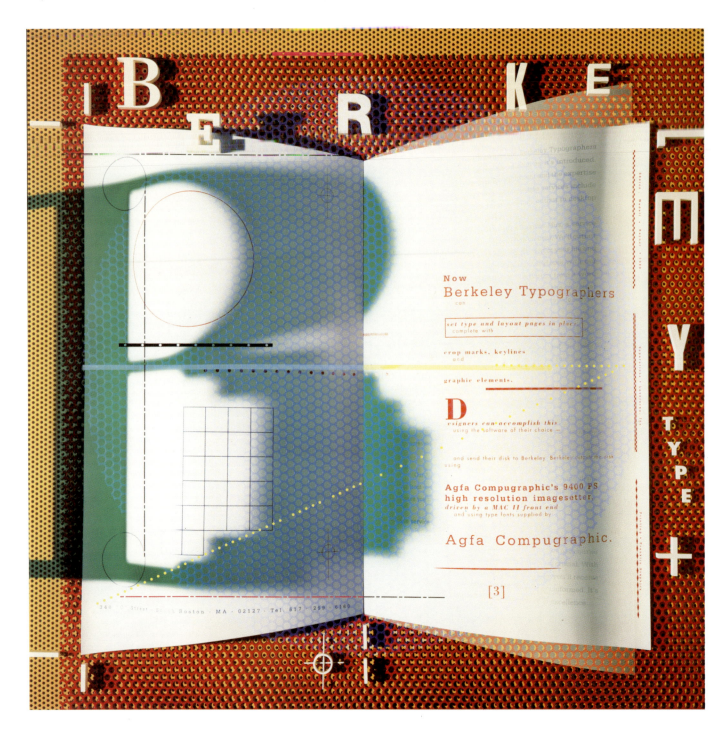

Berkeley Typographers Poster

1989 / Berkeley Typographers
Camera: Sinar View Camera

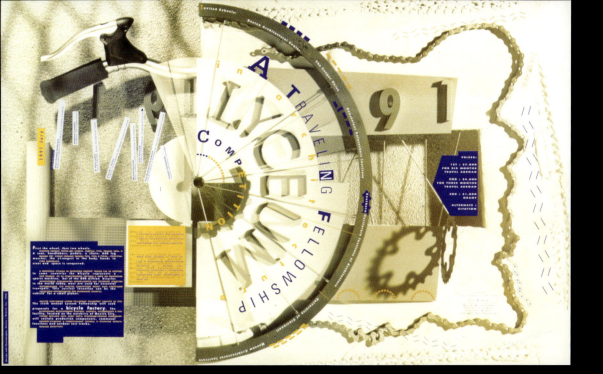

Lyceum Fellowship Competition 1991

1991 / Lyceum Fellowship Committee : Poster
Software: Aldus FreeHand
Camera: Sinar View Camera

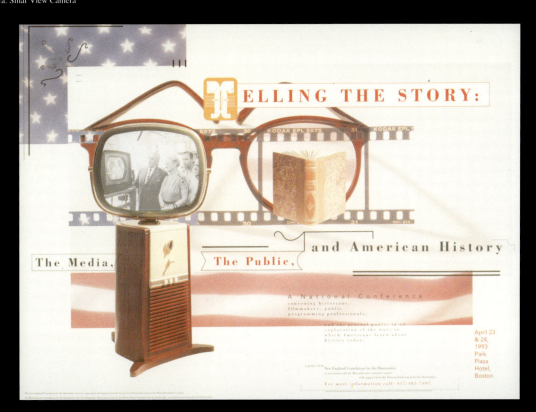

The Media, The Public and American History

1993 / New England Foundation for the Humanities : Poster
Software: Kodak Premier

Dan Marcolina

Designer and photographer Dan Marcolina and his wife, Denise, founded Marcolina Design, Inc. in Conshohocken, PA in October 1990 as a design firm specializing in electronic design on the Macintosh. According to Marcolina, the impetus to form this type of company came from several different directions.

Marcolina explains that he had the opportunity to dabble in Adobe Photoshop in early 1990. "I became very excited about the possibilities that the Macintosh computer could provide," he says. However, the design firm where he was employed didn't share the excitement. "My boss at the time had never touched a computer, didn't understand it, didn't have the same vision and didn't want to spend the money on the technology," Marcolina recalls.

To prepare for launching his own firm, Marcolina bought a Mac IIci for home "so that when I got home from work I could figure things out." In the process of figuring things out, he created a number of sample illustrations to show to prospective clients. One sample caught the attention of people at Letraset USA, who, according to Marcolina, has become "our biggest client." Other major clients include GTE, Kodak and BF Goodrich. Marcolina's illustrations have been featured in Communication Arts, Step-by-Step Graphics, Macworld and Macweek.

WaterMusic

1994 / Letraset : Brochure Illustration
Software; Specular Collage1.01, Adobe Photoshop2.5.1, Fractal Design Painter2.0

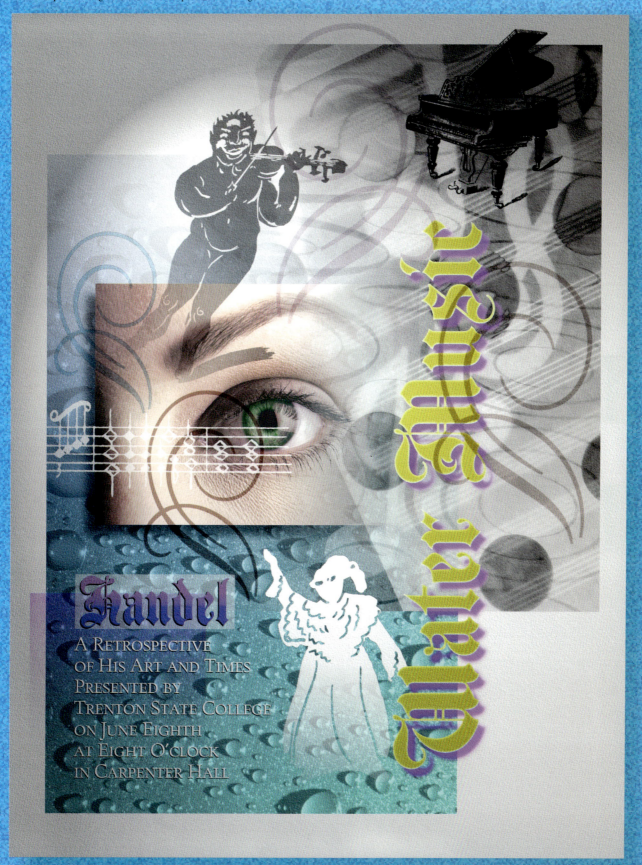

According to Marcolina, graphic elements of the poster were chosen to try to illustrate the playful, slightly religious overtones of Georg Friedrich Handel's (1685–1759) orchestral composition, Water Music.

STEP BY STEP
Dan Marcolina

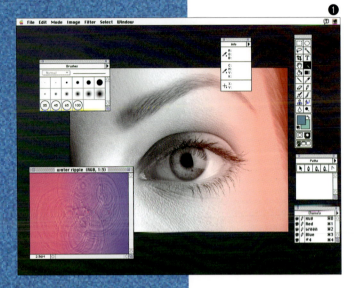

Step 1

Dan Marcolina wanted to design a poster with the theme based on Haydn's Water Music. He initiated the process by collecting a number of images related to water and music. He opened the images in Adobe Photoshop and began preparing them for use in Specular Collage. For example, using the Quick Mask mode, he created separate gradation masks for the images of the eye and the water ripples *(Fig. 1)*.

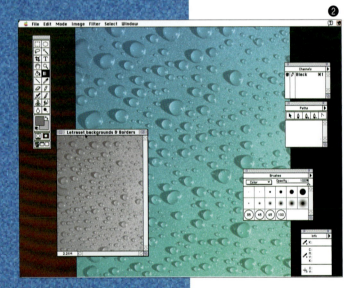

Step 2

Marcolina then opened a grayscale image of water droplets that he copied from Letraset's Backgrounds and Borders CD-ROM for use as a background image. After converting the file from grayscale to RGB, he used the Gradient tool, with Brush palette settings of Color mode and 80% opacity, to add a blue-to-green gradation over the grayscale tones *(Fig. 2)*.

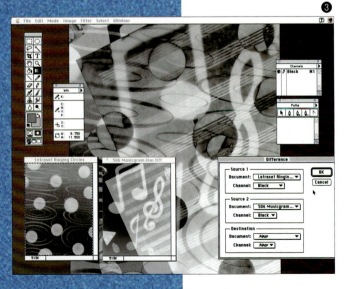

Step 3

Marcolina then selected two additional black-and-white texture images from the Backgrounds and Borders CD-ROM and combined them into one image in Photoshop by choosing Calculate from the Image menu, and Difference from the submenu *(Fig. 3)*.

Collage with Photoshop

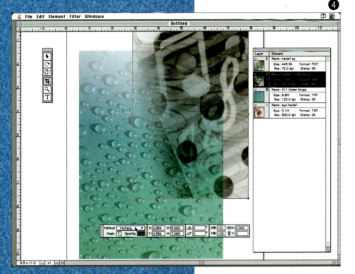

Step 4

His Photoshop preparations completed, Marcolina opened Collage, created a new project and assembled the components into a final image. The first images he placed on the Collage canvas created the background. After overlapping the blue-and-green water droplets image with the image from Step 3, he faded one into the other using the Multiply method in the Information palette *(Fig. 4)*.

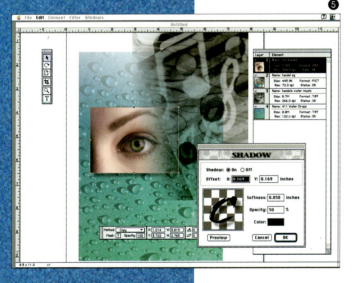

Step 5

When Marcolina was satisfied with the background, he began adding the other elements. He placed the eye onto the canvas and turned on its mask to blend it into the background. Then, he created a shadow under the eye, using selections in the Shadow dialog box *(Fig. 5)*.

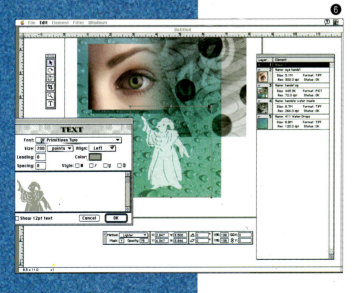

Step 6

Using Collage's Text dialog box, Marcolina selected a medieval character from the Primitives collection of Letraset's Design Fonts. After he placed the character on the canvas, Marcolina decreased its opacity to 75% using the Information Palette *(Fig. 6)*. At this point, Marcolina switched from High to Low Detail mode. In Low Detail mode, Collage turned off such effects as soft shadows to speed screen redraw. (Compare the shadow under the eye shown in Figure 5 to the shadow under the eye shown in Figure 6.)

STEP BY STEP
Dan Marcolina

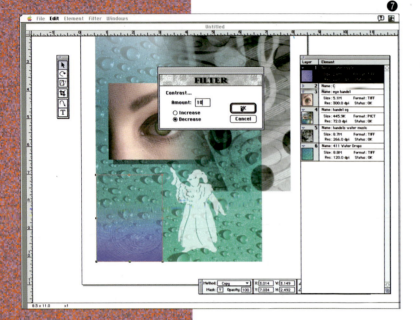

Step 7

Next, Marcolina added the image of water ripples. However, after turning on the mask he had made in Photoshop, he realized the image was not sufficiently translucent. To modify the mask in Collage, Marcolina selected Filter Channel from the Filter menu and Alpha from the submenu. He then applied the Contrast filter. He was able to increase the translucency of the water ripples by decreasing the contrast in the mask (changing the white portions of the mask to gray) *(Fig. 7)*.

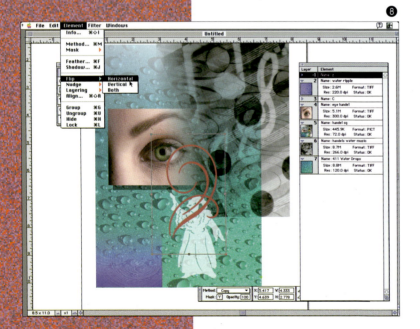

Step 8

Using Collage's Text dialog box, Marcolina selected a calligraphic embellishment from the Letraset Fontek font collection. After the character appeared on the canvas, he flipped it horizontally by selecting Flip from the Element menu *(Fig. 8)*.

146 *Collage with Photoshop*

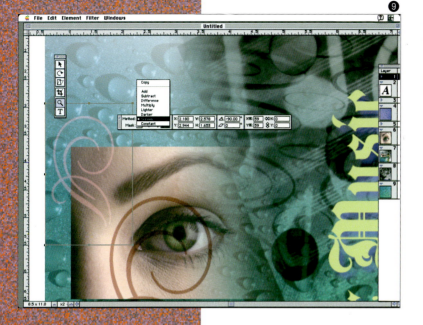

Step 9

Marcolina duplicated the character from Step 8 several times and blended the duplicates into the image by choosing the Screen method from the Information palette *(Fig. 9)*.

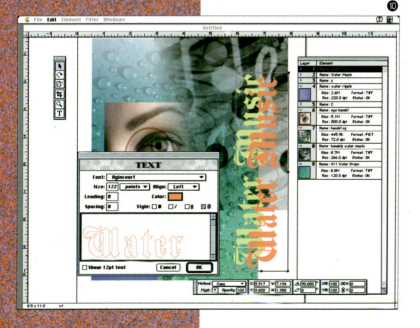

Step 10

Adding the yellow "Water Music" text to the poster using Collage's Text tool was the artist's next step. He then chose Duplicate from the Edit menu to create a second copy of the same text. After double-clicking on the duplicate text with the Arrow tool, the Text dialog box opened and Marcolina changed the duplicate text's color to red and its style to outline *(Fig. 10)*.

STEP BY STEP
Dan Marcolina

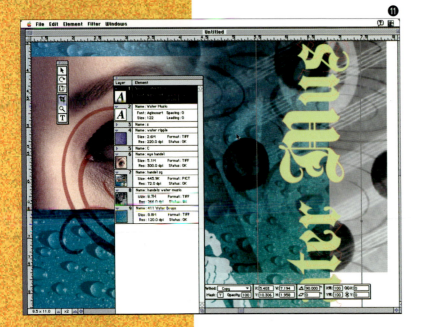

Step 11

The outline type, when aligned over the solid type, created a red stroke *(Fig. 11)*. He then added a soft purple shadow under the type. (Note: The red was changed to light yellow for the final image).

Step 12

Using Letraset's Character Chooser utility to pick another icon from the Primitives collection, Marcolina selected a medieval fiddler for the top of the image *(Fig. 12)*. He combined the fiddler with the main image by choosing the Multiply method and changing the opacity to 50%.

148 *Collage with Photoshop*

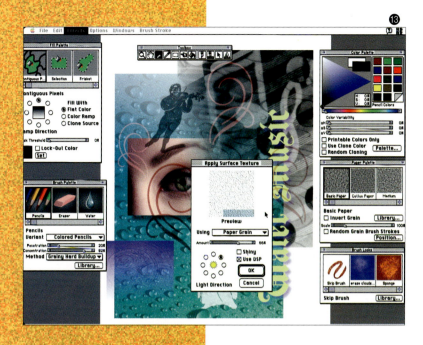

Step 13

Marcolina applied finishing touches in Fractal Design Painter. This process included adding a paper texture by using Painter's Apply Surface Texture dialog box *(Fig. 13)* and a theatrical spotlight by using Painter's Apply Lighting dialog box *(Fig. 14)*.

GALLERY
Dan Marcolina

SYSTEM:
Supermac 19" monitor, 24-bit Thunder 24, Mac 840AV, 64MB RAM, 1GB hard drive, 128MB magneto-optical drive, triple speed CD/ROM drive, 88MB SyQuest drive, Epson flatbed scanner, Canon Hi-8 video camera.

GTE Luminarie
1994 / GTE : Brochure Illustration
Software: Specular Collage 1.01, Adobe Photoshop 2.5.1, Adobe Dimensions 1.0

Collage with Photoshop

It's Amazing What We Can Do Together
1994 / GTE : Magazine Cover
Software: Specular Collage1.01, Adobe Photoshop2.5.1, Adobe Illustrator5.0
Art Direction: Dermot MacCormic

GALLERY
Dan Marcolina

Self-Portrait
1991 / Self-Promotion
Software: Raster Ops Frame Grabber, Adobe Photoshop1.01

Time is Money
1993 / Dean Witter : Brochure Cover
Software: Adobe Photoshop2.5.1, Adobe Illustrator3.2,
Fractal Design Painter2.0

Time is Money
1993 / Dean Witter : Brochure Cover
Software: Adobe Photoshop2.5.1, Adobe Illustrator3.2

New Ventures
1992 / GTE : Magazine Illustration
Software: Specular Infini-D2.5.1, Adobe Photoshop2.5.1, Adobe Illustrator3.2

152 Collage with Photoshop

GTE—75 Years of Service

1993 / GTE : Magazine Cover Illustration
Software: Adobe Photoshop2.5.1

GALLERY
Dan Marcolina

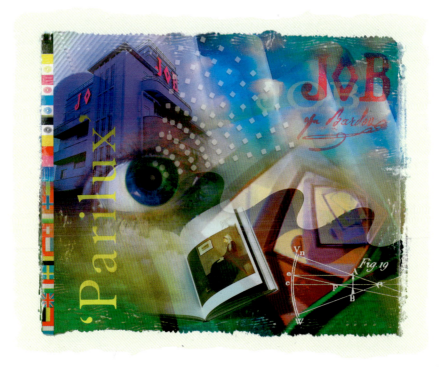

Vision in Transition

1992 / Job Papers : Brochure Cover
Software: Adobe Photoshop2.01, Adobe Illustrator3.2

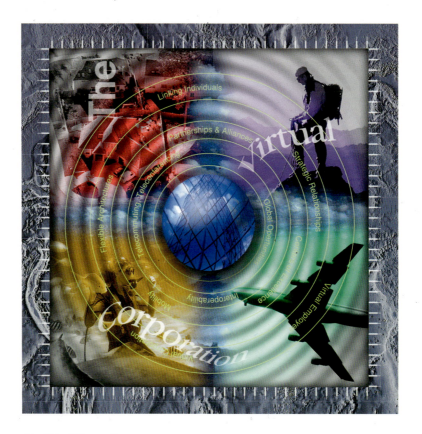

The Virtual Corporation

1993 / UNIX Systems Labs : Magazine Cover Illustration
Software: Specular Infini-D2.5.1, Adobe Photoshop2.5.1, Adobe Illustrator3.2

154 Collage with Photoshop

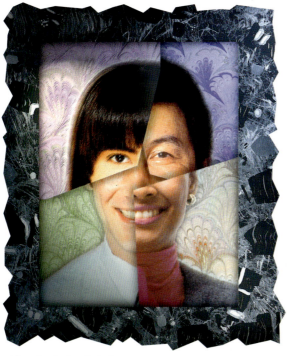

Diversity in the Workplace

1994 / GTE : Magazine Illustration
Software: Specular Collage1.01, Adobe Photoshop2.5.1

Seasons Greetings

1994 / Letraset : Christmas Card
Software: Specular Infini-D2.5.1, Adobe Photoshop2.5.1, Adobe Illustrator5.0, Letraset Fontek

Home Health Care

1994 / Shared Medical Systems : Brochure Illustration
Software: Specular Collage1.01, Adobe Photoshop2.5.1

Dan Marcolina

JOHN HERSEY

$\Delta\mu \quad \leq\Theta \quad © \quad f \; \Delta \quad ⚛ \; ⛓$

San Anselmo, California-based illustrator John Hersey was one of the first artists to have a computer-generated illustration published in Macworld magazine. That was ten years ago. Since that time, he has created a huge portfolio of digital illustrations for clients such as the Boston Globe, the Chicago Tribune, US News & World Report, IBM, MCI, Esprit, and Benetton.

Hersey doesn't consider his early use of the computer as an art tool as pioneering or groundbreaking. "I don't think about it in those terms," Hersey reflects, "I had a feeling I could make a little money doing illustration with the computer but I wan't any kind of visionary." Nonetheless, Hersey did value the computer as an art tool when other artists remained skeptical. "I really liked doing the pictures on the computer," he says, "I never thought it was crass."

Hersey also appreciates the ability of many computer graphics applications to create highly innovative, unique pop art. Since most computer images appear in print for the first time when they are reproduced in a magazine, observes Hersey, "that makes hundreds of thousands of first editions. It's true pop art!"

Thingface
1994 / Personal
Software: Aldus FreeHand3.11, Ray Dream Designer2.0,
Adobe Photoshop2.5, Specular Collage1.01

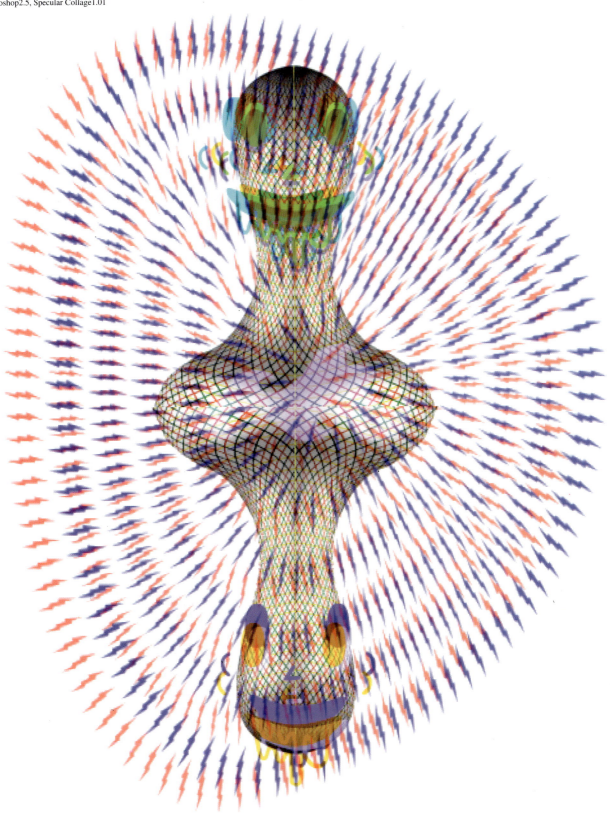

Hersey started "Thingface" as an attempt to create a sculptural shape that would look like the handle of a tool.
The final image, says Hersey, looked like a nipple which was made more human by adding an icon of a face.

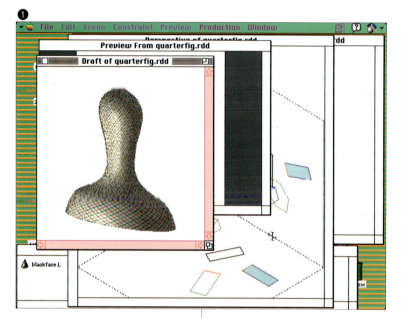

Step 1

To make the image "Thingface." in Specular Collage, John Hersey prepared files in Ray Dream Designer, Adobe Photoshop, and Aldus FreeHand. He began in Designer, where he explored many variations of a shape reminiscent of a head and shoulders. When the shape was completed, Hersey mapped a detailed pattern to its surface *(Fig. 1)*. Then he rendered the shape and saved it as a PICT file.

Step 2

The original rendered image had elements in the background which Hersey decided he didn't like. In Photoshop, Hersey opened the image, selected the head-and-shoulders object with the Pen tool, turned it into a selection, inverted the selection and filled the background with white *(Fig. 2)*.

158 *Collage with Photoshop*

Step 3

Several of the elements that Hersey used in his image were characters from a font, called Thingbat, which he designed in Altsys Fontographer. These included a lightning bolt *(Fig. 3)*, a flame *(Fig. 4)*, and a drooling baby face *(Fig. 5)*.

Step 4

To create the red and blue circles of lightning bolts that he used in his final Collage image, Hersey used FreeHand. He began by creating a circular path and then, choosing the Bind to Path option from FreeHand's Text menu, wrapped a series of lightning bolt characters around the path. Then, he cloned the shape, scaled it down and blended the two circles together with four steps (*Fig. 6*). He then converted the text characters to outlines and saved the file in Adobe Illustrator 3 format so the file could be opened in Photoshop.

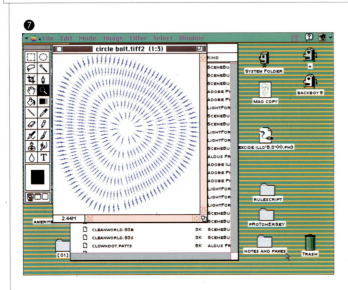

Step 5

In Photoshop, Hersey opened the lightning bolt circles created in FreeHand and colorized the artwork blue (*Fig. 7*). He also made a duplicate of the file which he colorized red.

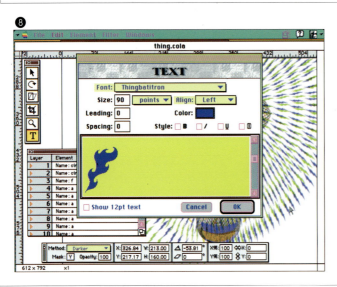

Step 6

After completing the source images, Hersey opened Collage. Using Collage's Text tool, Hersey added more of his Thingbat characters, including the drooling baby and the flame (*Fig. 8*).

SYSTEM:
13" Apple monitor, Macintosh IIfx, 20MB RAM, 200MB hard drive, 44MB SyQuest drive, Sharp JX 300 color scanner

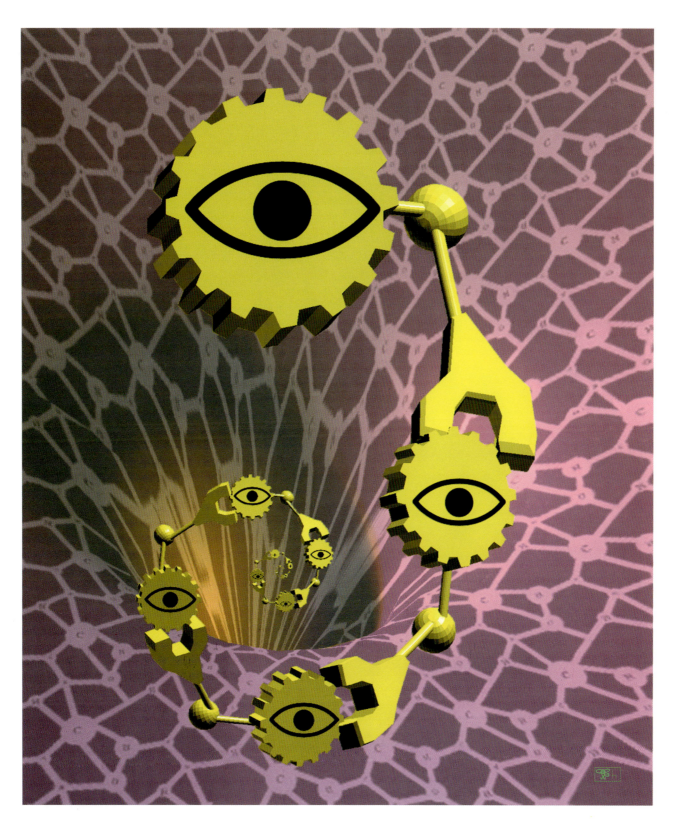

Wired Nanoworld
1993 / Wired magazine : Editorial Illustration
Software: Ray Dream Designer2.0, Adobe Photoshop2.0.1

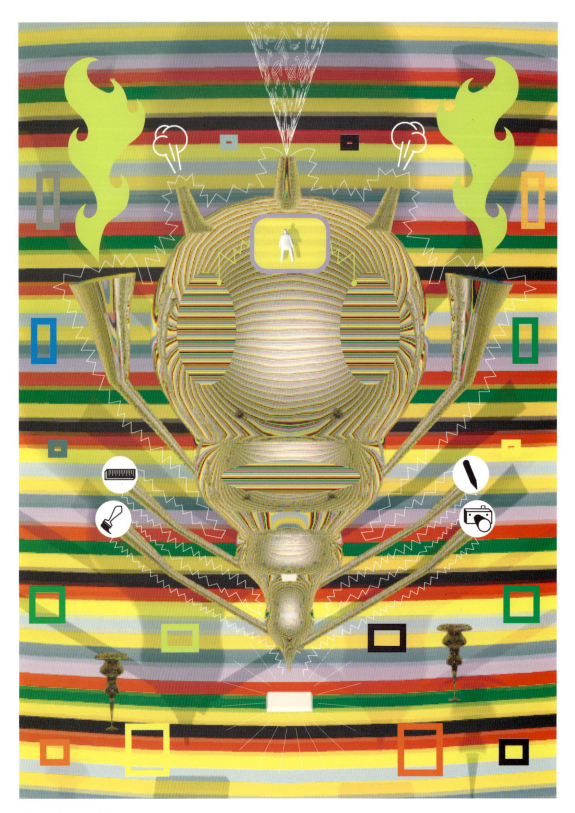

Illustration Overdrive
1994 / Aldus Magazine : Editorial Illustration
Software: Aldus FreeHand3.11, Ray Dream Designer2.0

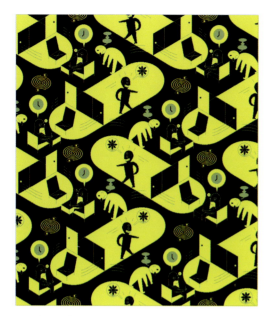

Go Glo Psycho
1992 / Boston Globe Magazine : Editorial Illustration
Software: Superpaint2.0, Adobe Photoshop2.0

Drawman 2
1990 / Macworld : Feature Illustration
Software: Aldus FreeHand2.0

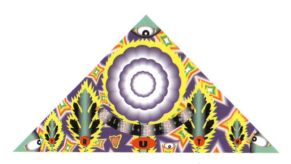

Aldus Flower
1990 / Aldus Corp. : FreeHand Brochure
Software: Aldus FreeHand2.0

Bozofilter
1993 / Wired magazine : Editorial Illustration
Software: Swivel 3D Pro3.0, Aldus FreeHand3.11

S.F.A.E.F. Logo
1989 / SFAEF : Logo Design
Software: Aldus FreeHand2.0

John Hersey

Ultraduck Font
Softwear: Fontographer

Collage with Photoshop

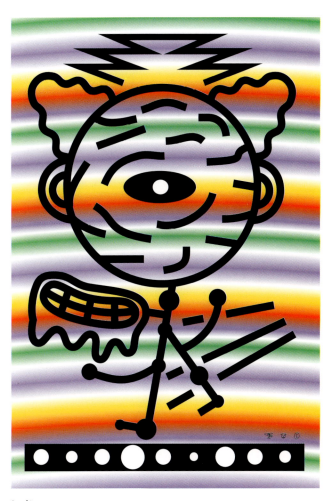

Jupiter
1992 / Monadnock Paper Co. : Paper Promotion
Software: Aldus FreeHand3.11

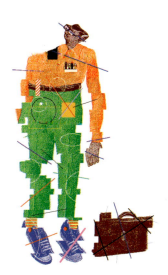

Personal Nerd
1988 / Psychology Today magazine : Editorial Illustration
Software: Pixelpaint2.0

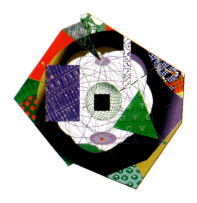

MCI Worldnet Spot
1988 / Pentagram : Corporate Brochure
Software: Adobe Photoshop2.0

SciFi Channel
1993 / SciFi Channel : Poster
Software: Adobe Photoshop2.0

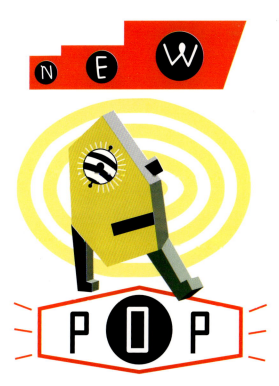

New Pop
1992 / Museo Fortuny : Logo Design
Software: Aldus FreeHand3.0

David Carson

Del Mar, CA resident David Carson was a 26-year-old high school sociology teacher, a profession chosen partly because it freed up his summers for surfing, when he discovered graphic design. "I didn't even know there was a term called 'graphic design,'" says Carson. But during a two-week summer workshop in graphic design at the University of Arizona, Carson became convinced that he'd found his second career.

Since then Carson has won awards and accolades for his 'hang loose' art direction and kinetic use of type in magazines such as Beach Culture, Surfer and more recently, Ray Gun. Carson says his style is not the result of deliberately setting out to break design rules. Instead, he maintains, he never really learned the rules in the first place. This explains why, for example, his use of type is influenced less by a master typographer such as Paul Rand, and more by spray-painted signage and graffiti.

The fact that Carson's style seems to have struck a chord with a generation which has grown up with video games and MTV is not lost on some of America's bigger advertisers. Not very long ago, says Carson, MTV advertisers began bringing issues of Ray Gun magazine to people at MTV saying, "We want our ad to look something like this." Soon after, Carson began getting calls from companies like Nike and Pepsi to design print ads and TV commercials.

Untitled
1994 / Raygun #17 : Magazine Cover
Software: Adobe Photoshop, Specular Collage, Quark XPress

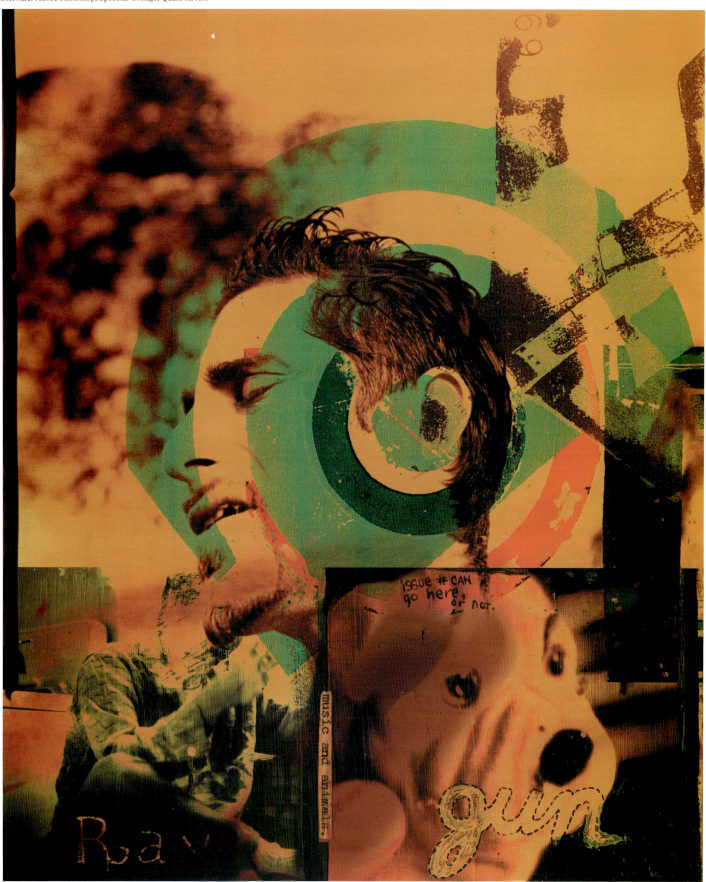

Carson created the cover image for Raygun #17 by compositing various images from inside the issue with unsolicited artwork sent to him by readers.

Step-By-Step David Carson

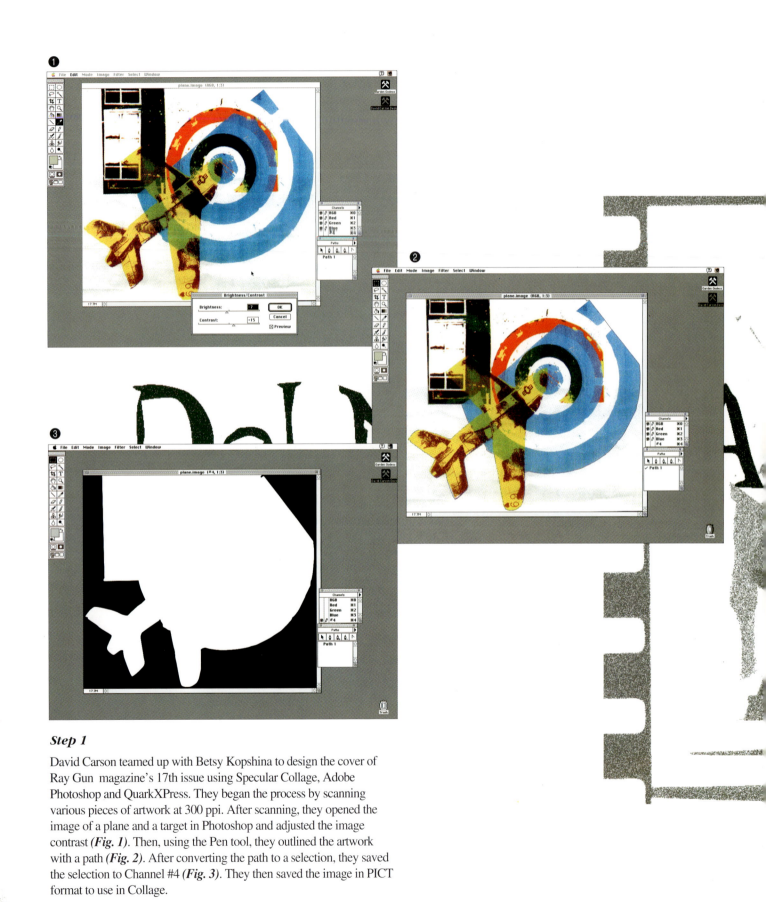

Step 1

David Carson teamed up with Betsy Kopshina to design the cover of Ray Gun magazine's 17th issue using Specular Collage, Adobe Photoshop and QuarkXPress. They began the process by scanning various pieces of artwork at 300 ppi. After scanning, they opened the image of a plane and a target in Photoshop and adjusted the image contrast *(Fig. 1)*. Then, using the Pen tool, they outlined the artwork with a path *(Fig. 2)*. After converting the path to a selection, they saved the selection to Channel #4 *(Fig. 3)*. They then saved the image in PICT format to use in Collage.

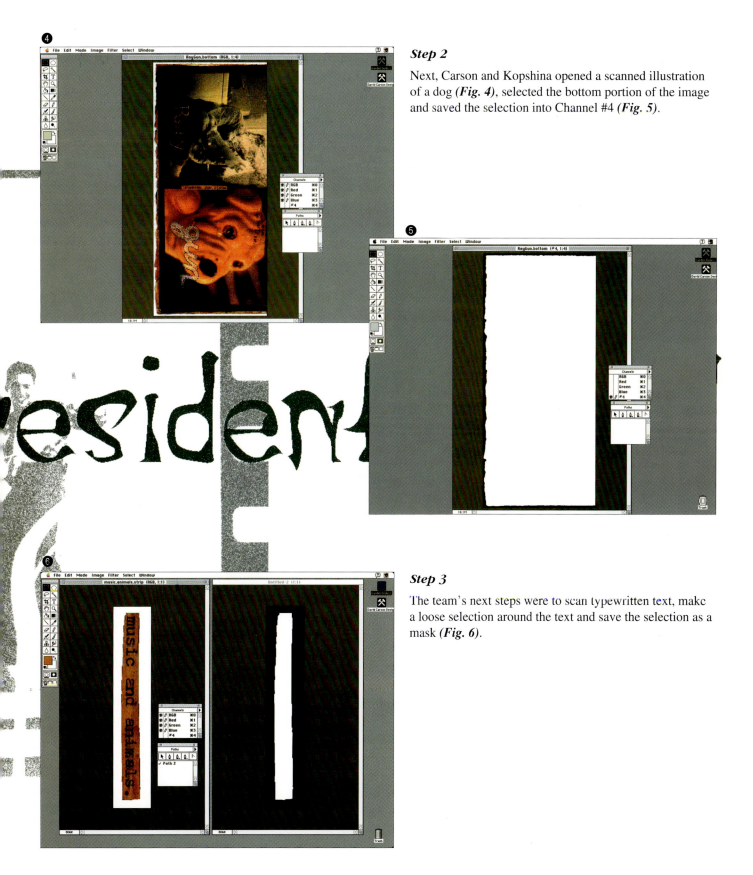

Step 2

Next, Carson and Kopshina opened a scanned illustration of a dog *(Fig. 4)*, selected the bottom portion of the image and saved the selection into Channel #4 *(Fig. 5)*.

Step 3

The team's next steps were to scan typewritten text, make a loose selection around the text and save the selection as a mask *(Fig. 6)*.

Step-By-Step David Carson

Step 4

Carson and Kopshina scanned a photograph of singer Perry Farrell as the background for the Collage image. After opening this image in Photoshop, they used controls in the Color Balance dialog box to give the image an orange tint *(Fig. 7)*.

Step 5

After they finished preparing the Photoshop files, Carson and Kopshina opened Collage and created a new project. They imported all the component images and then placed the image of Perry Farrell onto the canvas *(Fig. 8)*.

Step 6

The next element placed onto the canvas was the image of the dog. Since the original Photoshop file was vertical, the artists rotated it to a horizontal position with the Rotate tool *(Fig. 9)*. By turning on the mask from the Information palette *(Fig. 10)*, the white strip along the bottom of the dog scan was removed *(Fig. 11)*.

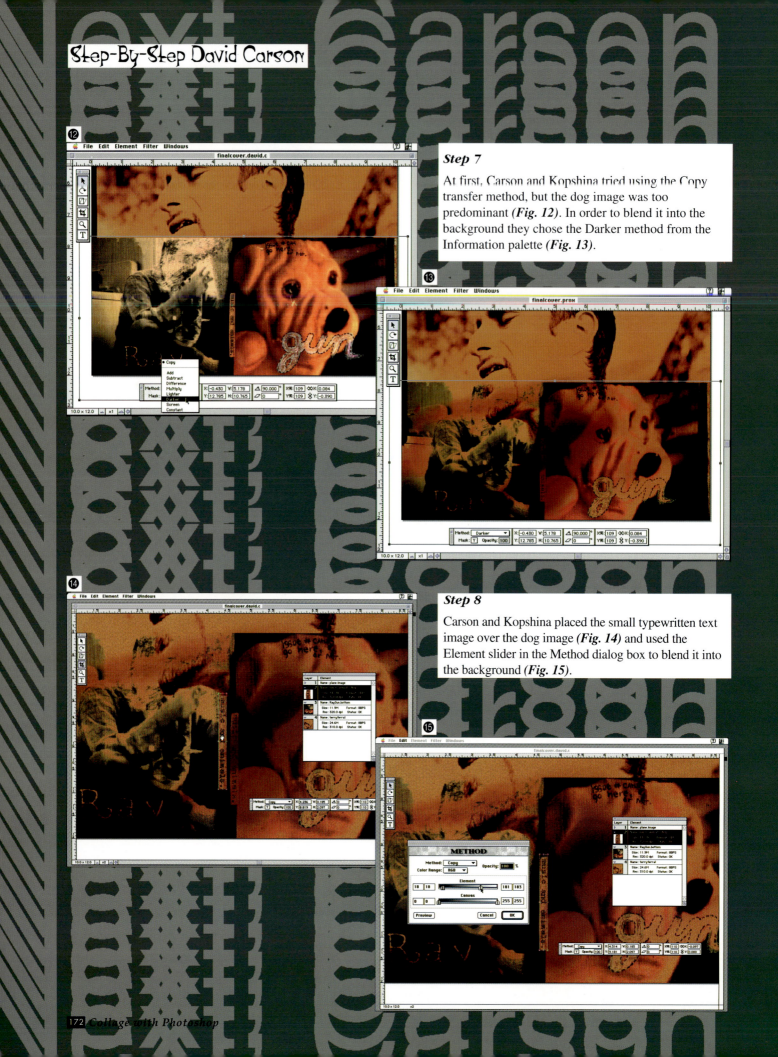

Step-By-Step David Carson

Step 7

At first, Carson and Kopshina tried using the Copy transfer method, but the dog image was too predominant **(Fig. 12)**. In order to blend it into the background they chose the Darker method from the Information palette **(Fig. 13)**.

Step 8

Carson and Kopshina placed the small typewritten text image over the dog image **(Fig. 14)** and used the Element slider in the Method dialog box to blend it into the background **(Fig. 15)**.

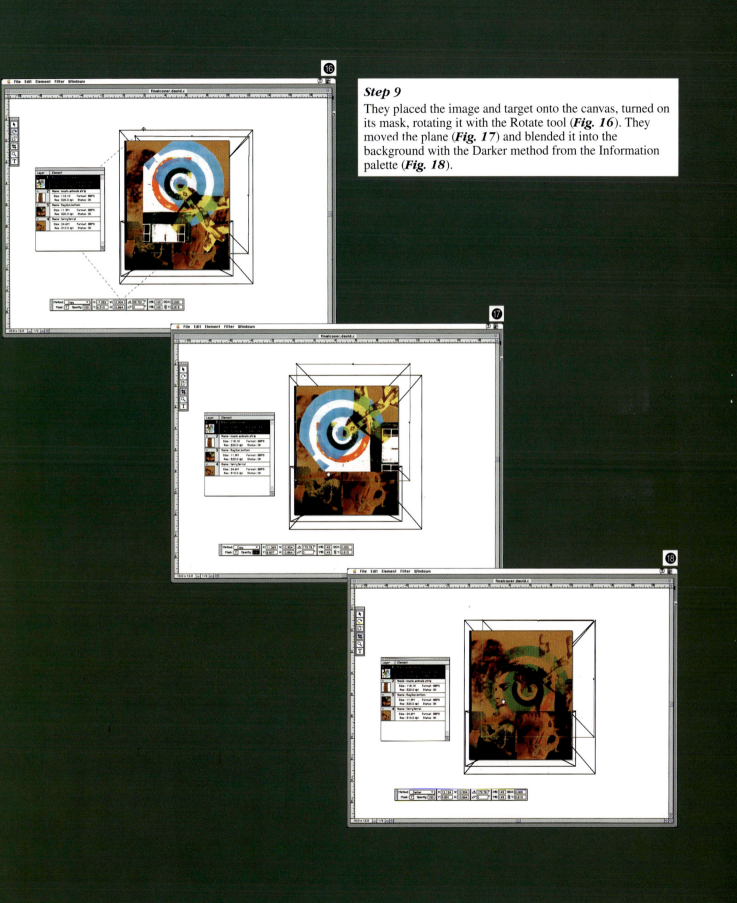

Step 9
They placed the image and target onto the canvas, turned on its mask, rotating it with the Rotate tool (*Fig. 16*). They moved the plane (*Fig. 17*) and blended it into the background with the Darker method from the Information palette (*Fig. 18*).

Step-By-Step David Carson

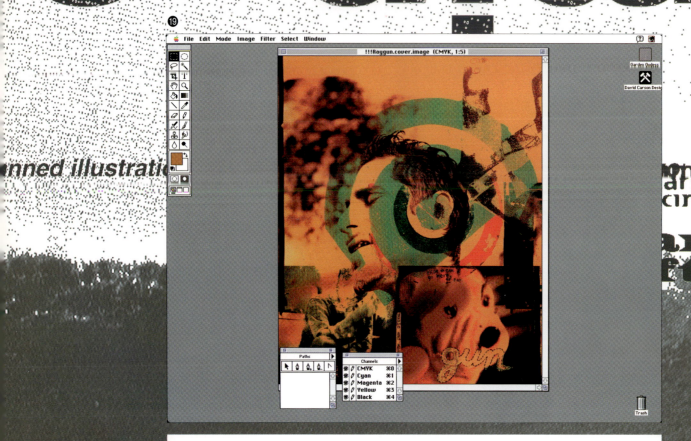

Step 10

Carson and Kopshina finished the Collage portion of their project and rendered the final image at 10" × 12" at 300 ppi. They then opened the rendered image in Photoshop and converted it to CMYK mode *(Fig. 19)*.

Step 11

The final image was imported into XPress *(Fig. 20)*. Here, Carson and Kopshina finished the project by adding the magazine title and cover text *(Fig. 21)*.

Gallery David Carson

SYSTEM:
21" NEC Multisync monitor, Macintosh IIci, 20MB RAM, 1 GB internal drive, 44MB SyQuest drive, Relisys flatbed scanner, Laserwriter Pro 600.

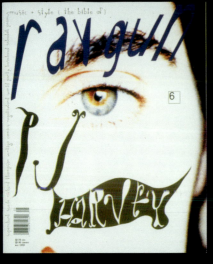

Untitled
1993 / Raygun #6 : Magazine Cover
Software: Aldus PageMaker

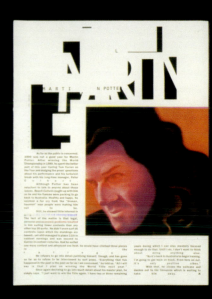

Untitled
1991 / Beach Culture #6 : Magazine Page
Software: Aldus PageMaker
Illustration by: Hans Henderson

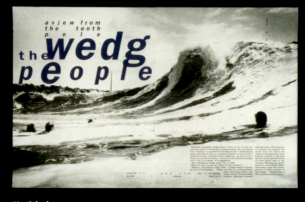

Untitled
1991 / Beach Culture #3 : Magazine Spread
Software: Aldus PageMaker

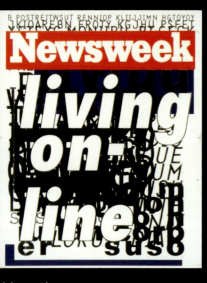

Living on Line
1993 / Newsweek magazine : Cover (design proposal; not used)
Software: Quark XPress, Adobe Photoshop

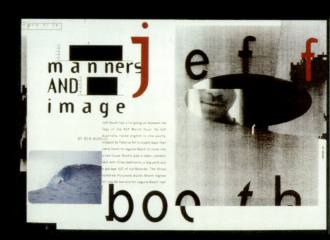

Untitled
1993 / Surfer magazine : Magazine Spread
Software: Quark XPress, Adobe Photoshop

Collage with Photoshop

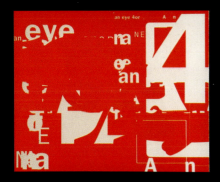

Untitled
1992 / Eye magazine : Promotion
Software: Aldus PageMaker

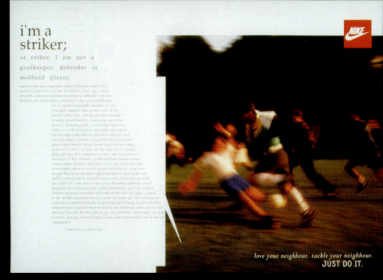

I'm a Striker
1993 / Nike : Advertisement
Software: Aldus PageMaker

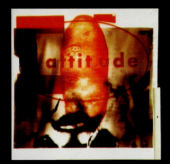

Untitled
1992 / Vans Tennis Shoes : Advertisement
Software: Aldus PageMaker

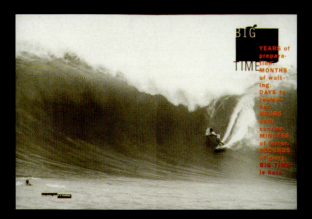

Untitled
1993 / Surfer magazine : Magazine Spread
Software: Quark XPress

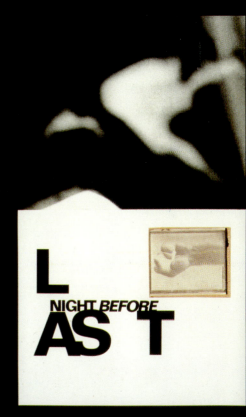

Night Before Last
1991 / Beach Culture #5 : Magazine Spread
Software: Aldus PageMaker

Gallery David Carson

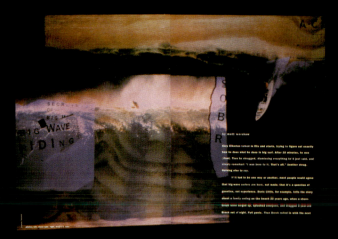

Untitled
1993 / Surfer magazine : Magazine Spread
Software: Quark XPress, Adobe Photoshop

Untitled
1991 / Beach Culture #5 : Magazine Cover
Software: Aldus PageMaker
Illustration by: Gary Baseman

Untitled
1992 / How magazine #14 : Magazine Cover
Software: Aldus PageMaker

Untitled
1992 / Raygun #1 : Magazine Page
Software: Aldus PageMaker

Bikini Kill
1992 / Raygun #2 : Magazine Page
Software: Aldus PageMaker

Untitled
1992 / How magazine : Magazine Cover
Software: Aldus PageMaker

Mr. Damage
1993 / Surfer magazine : Magazine Spread
Software: Quark XPress

Untitled
1992 / Vans Tennis Shoes : Advertisement
Software: Aldus PageMaker

Untitled
1993 / Surfer magazine : Magazine Spread
Software: Quark XPress, Adobe Photoshop

Untitled
1993 / Pepsi Co. : Advertisement
Software: Adobe Photoshop

Bert Monroy

Albany, California-based artist Bert Monroy has been around the Macintosh design and imaging world since its beginning in the mid-1980s. A digital imaging teacher and lecturer, Monroy frequently refers to the "good ol' days" of Macintosh imaging in his presentations. According to Monroy, those were the days when the only programs were MacWrite, MacPaint, and MacDraw and the 128KB Macintosh was not just the system of choice—it was the only choice.

"My original machine was a 128KB Mac with no external drive," Monroy recalls, "just a single floppy drive, which meant you had to swap disks back and forth." Back then, says Monroy, the system and the application were both on a single-sided floppy and file sizes were only 21 or 22KB. And for those of us who whine about the slowness of current computers, Monroy's recollection of the introduction of the 512KB Mac is sobering. At the time, he says, it was an incredible increase of power.

According to Monroy, the Macintosh has taken him in unexpected artistic directions. For example, he produced multimedia projects before there was even a term for the concept. Currently, Monroy is busy with diverse projects that employ his detailed photorealistic illustration style, including the creation of matte paintings for Hollywood movies.

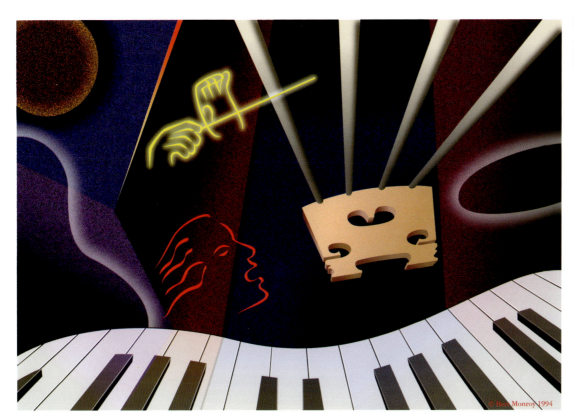

Music Theme 1
1994 / Macmillan Publishing Co. :
Book Cover
Software: Adobe Photoshop2.5.1,
Specular Collage1.01

Music Theme 2
1994 / Macmillan Publishing Co. :
Book Cover
Software: Adobe Photoshop2.5.1,
Adobe Illustrator5.5, Specular
Collage1.01

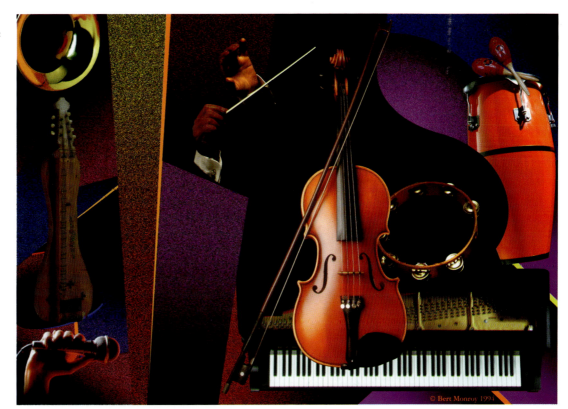

Monroy produced illustrations based on a musical theme for the cover of music instruction books published by Macmillan.

Step By Step — BERT MONROY

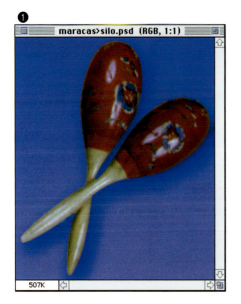

Step 1

For his Specular Collage project, Bert Monroy created two images, both based on a music theme. The source images he prepared for use in Collage included scanned photographs and images created in Adobe Illustrator. To create the first image, Monroy collected and scanned a series of photographs of musical instruments, such as the photo of a pair of maracas *(Fig. 1)*.

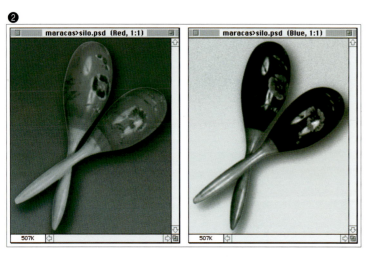

Step 2

Beginning with the image of the maracas, Monroy analyzed each image's file for the best selection and masking strategy to use in Adobe Photoshop. After studying the Red and the Blue channels of the maracas *(Fig. 2)*, Monroy determined that he would produce the best mask by first choosing Calculate from the Image menu and Difference from the submenu. In the Difference dialog box, he set Source 1 to be the Red channel and Source 2 to be the Blue channel, and he selected New for the Destination *(Fig. 3)*. These choices produced a flat-toned grayscale version of the maracas in Channel #4 *(Fig. 4)*.

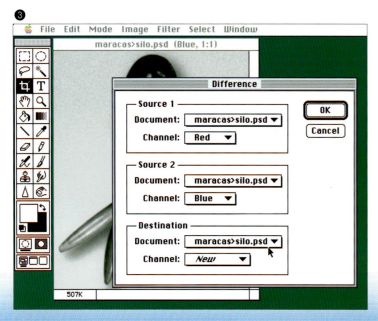
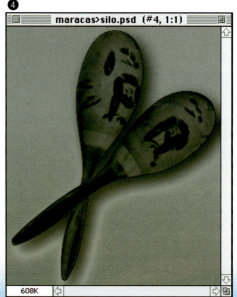

182 Collage with Photoshop

Step 3

Monroy then used controls in the Levels dialog box to change the gray tones of the background to white *(Fig. 5)*. Then, using the Paint Bucket tool, Monroy filled in most of the interior of the maracas with black *(Fig. 6)*. Because the Difference command had created a fringe of solid black pixels along the border of the maracas and their background, the black fill didn't bleed into the surrounding white background.

Step 4

At this stage, the mask was nearly completed. Monroy's fourth step was to clean up the remaining light gray pixels in the background. To accomplish this, Monroy used the controls in the Curves dialog box *(Fig. 7)*. Then, he retouched the rest of the mask using the Paintbrush tool. Monroy prepared the mask for use in Collage by inverting it so it would separate the instrument from its background *(Fig. 8)*. The other musical instruments were masked by a similar process and their backgrounds were selected and filled with white *(Fig. 9)*.

 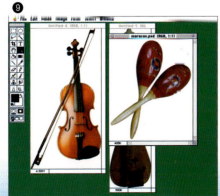

Step 5

Next, Monroy prepared backgrounds for the two images. First, he created a new file in Lab Color mode. Second, using a variety of selection tools, he created individual geometric shapes and filled them with solid colors. Third, with the Channels palette set to edit only the Lightness channel, he applied the Add Noise filter. This step generated black noise in the colored shapes, instead of the rainbow-like colors this filter generates when applied to an RGB file. Fourth, he shaded the geometric shapes with a black-to-white gradation, using the Multiply mode on the Brushes palette. When he was finished, he converted the image back to RGB and saved the file *(Fig. 10)*.

Step 6

To create components for the second image, Monroy used Adobe Illustrator. He created outlines of a piano keyboard *(Fig. 11)* and a violin bridge *(Fig. 12)* and filled them with solid colors. (Note: the remaining steps refer to the second image only.)

Step 7

Rather than opening the Illustrator files in Photoshop, Monroy placed them one at a time into individual Photoshop files. He prefers this method because, when an Illustrator file such as the violin bridge image is placed into a new Photoshop file, it appears as an active selection *(Fig. 13)*. This selection can then easily be saved as a mask *(Fig. 14)*.

Step 8

In Photoshop, Monroy used the Magic Wand tool to select areas of solid color in the violin bridge, and he added texture by applying the Add Noise filter *(Fig. 15)*. Then, using paintbrushes and masks, he shaded the illustrations to add dimension *(Fig. 16)*.

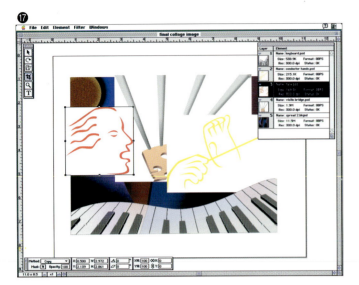

Step 9

After Monroy finished creating various elements, he imported them into a new Collage project. Next, he placed the textured background from Step 5 onto the canvas, followed by the keyboard, face, hands and violin bridge elements *(Fig. 17)*. Then, choosing Mask from the Element menu *(Fig. 18)*, he turned the masks on *(Fig. 19)*.

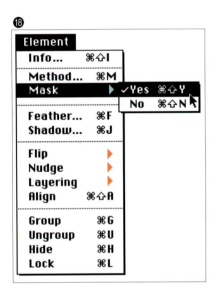

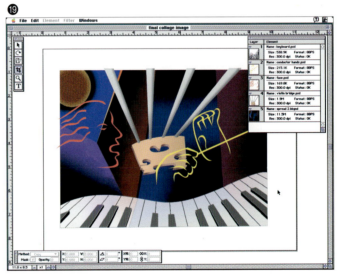

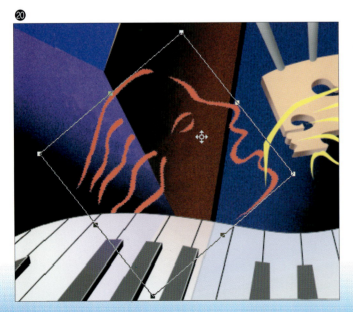

Step 10

Monroy then worked with the compositional arrangement of the elements, such as rotating the face with the Rotate tool *(Fig. 20)*.

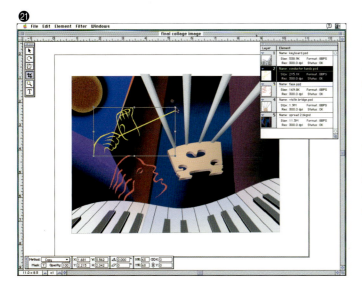

Step 11

Continuing in Collage, Monroy decided to place a neon glow effect under the hands. Rather than create a mask in Photoshop to produce the effect, he devised a method to achieve the same result in Collage. His first action was to select the hands *(Fig. 21)* and to copy them by choosing Duplicate from the Edit menu *(Fig. 22)*. He then placed the copy of the hands underneath the original image *(Fig. 23)* and blurred the image using Collage's Gaussian Blur filter *(Fig. 24)*. Finally, before rendering the image, Monroy used the controls in the Align dialog box to position the original hands image directly over the blurred hands, creating the neon glow effect.

Gallery BERT MONROY

SYSTEM:
SuperMac 19" monitor, Apple 13" monitor, PowerMac 8100, 96MB RAM, internal CD/ROM, 250MB internal hard drive, 1.3GB PLI external hard drive, 44MB SyQuest drive, 650MB PLI magneto-optical drive.

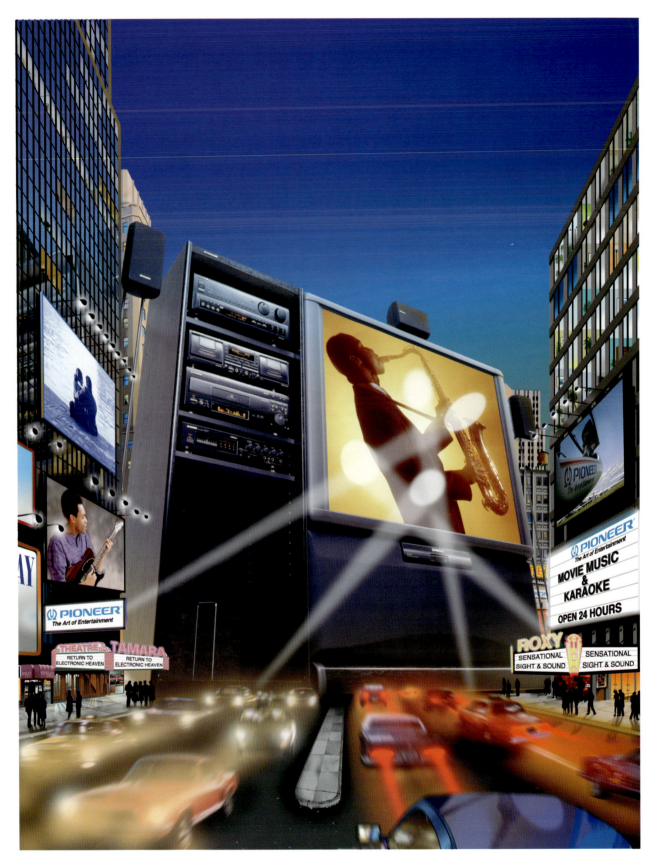

Pioneer 1994 Merchandise Catalog
1994 / Axxi (Pioneer) : Catalog Cover
Software: Adobe Photoshop3.0, Adobe Illustrator5.5
Art Direction: Kazumoto Yokouchi (AXXi)

The Orbital World
1993 / Step-By-Step Electronic Design (Japan) : Magazine Cover
Software: Adobe Illustrator3.0, Adobe Photoshop2.5, Ray Dream Designer

Gallery — BERT MONROY

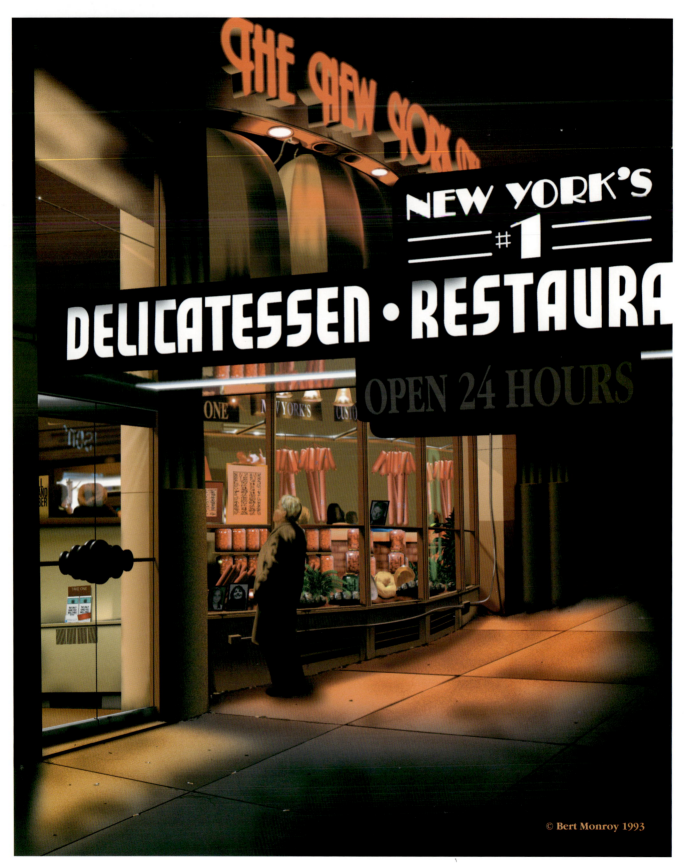

New York Deli
1993 / Step-By-Step Electronic Design (Japan) : Magazine Cover
Software: Adobe Illustrator5.0, Adobe Photoshop2.5.1

190 *Collage with Photoshop*

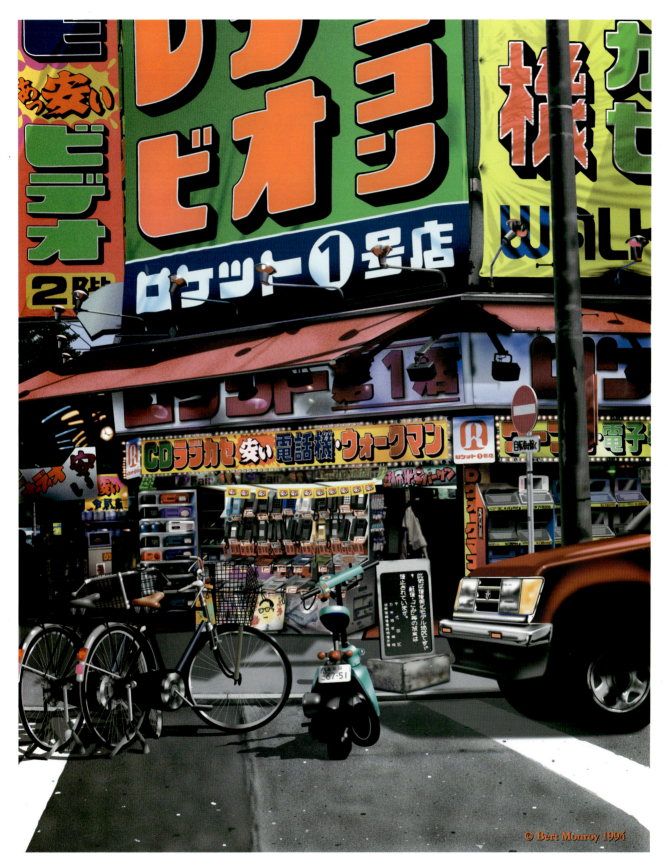

Akihabara

1994 / Personal
Software：Adobe Illustrator5.5、Adobe Photoshop2.5.1

Pioneer Car Stereo Promo
1993 / Pioneer (Japan) : Brochure Cover
Software: Electric Image1.5, Adobe Photoshop2.5.1,
Specular Collage1.01
Art Direction:Kazumoto Yokouchi (AXXi)

Jack Davis had attended a half-dozen art schools and was working as a creative director at a Los Angeles advertising firm when the Macintosh computer first appeared in 1984. At that time, Davis found himself facing a career choice. "My next step was to either move to New York City to get more experience in advertising," he explains, "or to look into this new field of computer graphics."

Since choosing the latter option, Davis has become very involved with interactive CD-ROM projects, working first as the art director for Verbum Interactive and then as art director on The Journeyman Project CD-ROM game. He finds interactive work to be particularly exciting because it is similar to how people have communicated since the beginning of civilization. "The history of communication," explains Davis, "is storytelling. This means face-to-face, interactive, visual communication. I think that in that sense, multimedia has the potential to be much more like a gather-around-the-campfire form of storytelling than print, TV, or radio."

Currently, Davis is busy re-creating The Journeyman Project from scratch for TV-based CD-ROM platforms such as Panasonic 3DO and Sega Saturn. And following the success of the Photoshop WOW Book which he co-wrote, he has begun work on the Multimedia WOW Book.

"My idea for this particular version of a brochure cover," says Davis, "was to create a somewhat surreal image of a very 'sexy' car to convey the quality and power of the Pioneer car stereo, but without looking like a car advertisement."

PIONEER CAR AUDIO

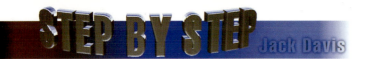

STEP BY STEP
Jack Davis

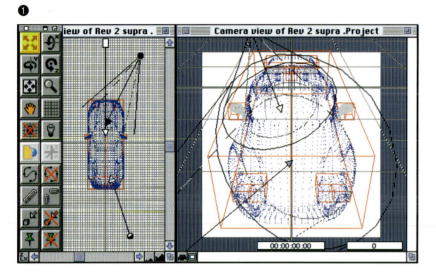

Step 1

Jack Davis began his Specular Collage project by using a 3-D scanner to scan a physical model of a Toyota Supra. The scanning process created a digital wire-frame model which, when saved in DXF format, could be opened in Electric Image *(Fig. 1)*.

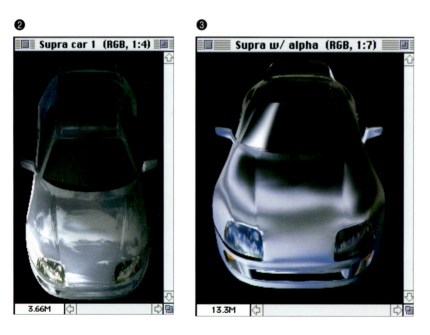

Step 2

In Electric Image, Davis experimented by mapping several types of surfaces to the model. In his first test, he rendered the model with a highly reflective surface mapped with a photograph of clouds *(Fig. 2)*. In his second test he rendered it using a matte finish and a very diffused surface map of clouds *(Fig. 3)*. Davis selected the latter rendering to use in his project.

Step 3

When Davis opened the rendered image of the Supra in Adobe Photoshop the file already contained, in Channel #4, a mask generated by Electric Image *(Fig. 4)*. Using a duplicate of this mask he made another mask for applying a glow around the car *(Fig. 5)*. Then, using the Image-Calculate-Add command, he combined these two masks into one to use in Collage for separating the car and the glow from the background. *(Fig. 6)*.

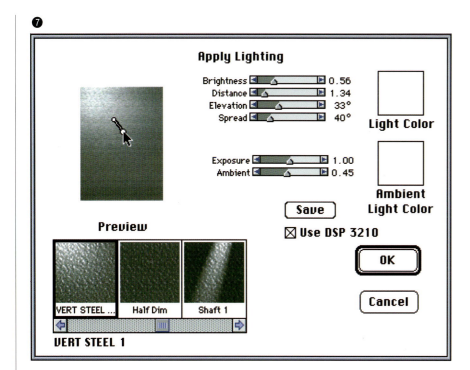

Step 4

For a background image, Davis began with a scan of brushed steel, and after applying a combination of Blur and Motion Blur filters in Photoshop to soften the image, he saved the file. Then, he opened the softened image in Fractal Design Painter and used the Surface Controls-Apply Lighting feature to cast a glow on the background *(Fig. 7)*.

Step 5

The next image Davis prepared was an image of Pioneer car stereo components. Starting with a drum scan of a 4" × 5" transparency *(Fig. 8)*, Davis extended the bottom of the image by selecting and stretching it *(Fig. 9)*. Then, he used the Pen tool to outline the stereo components with a path *(Fig. 10)*, turned the path into a selection and saved the selection as a mask.

Jack Davis

STEP BY STEP
Jack Davis

⓫

Step 6

Through his prior experimentation in Collage, Davis knew he couldn't create the glow effect he wanted above and behind the stereo components using only the controls in Collage's Shadow or Feather dialog boxes. To produce the desired effect, Davis created a white glow against a black background in a separate RGB image in Photoshop. Then, in Channel #4, he made a mask to separate the glow from the background *(Fig. 11)*.

⓬

Step 7

Davis created another source image in Photoshop containing the word "Pioneer" in blue chrome type and saved the file with a mask *(Fig. 12)*.

⓭

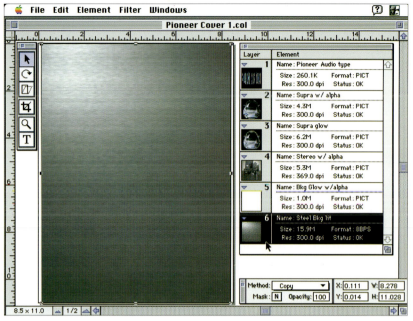

Step 8

Next, Davis opened Collage and imported his source images. He began the process of creating the Collage image by placing the brushed steel background onto the canvas *(Fig. 13)*.

⓮

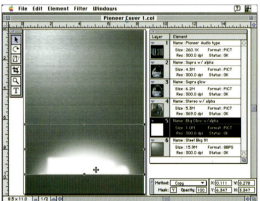

Step 9

Davis then placed the glow behind the stereo onto the background, and turned on its mask *(Fig. 14)*. His next task was to place the stereo components onto the layer above the glow *(Fig. 15)*.

⓯

196 Collage with Photoshop

Step 10

Next, Davis placed the car element with glow onto the background, turned on its mask, and chose the Add method in the Information palette to remove the darker tones of the car. Only the car body's lighter tones and a white glow remained visible *(Fig. 16)*. At this point, Davis realized that the overall effect he wanted to achieve wouldn't be possible as long as the white portions of the car body remained visible. In order to remove the car body, but retain the glow, Davis decided to invert the mask he'd created in Figure 6 of Step 3. He began by selecting Filter Channel from the Filter menu and choosing only the Alpha channel *(Fig. 17)* for the car image. After applying the Invert filter *(Fig. 18)*, the portion of the mask which had been 100 percent white became 100 percent black. However, when inverted, the gray pixels changed very little. The result was that the white car body disappeared, exposing the bottom brushed steel layer and leaving the glow virtually unchanged *(Fig. 19)*.

⓴

Step 11

Next, Davis placed a 100 percent opaque copy of the original car within the glow *(Fig. 20)*. Then, using the Difference method, he blended the car into the brushed steel background *(Fig. 21)*. Since he had removed the white bodied copy of the car in Step 10, the Difference calculation took place between the tones of the original car and the brushed steel background.

㉑

Step 12

Davis' final touch was adding the blue chrome type he'd created in Photoshop. After placing the type and turning on its mask *(Fig. 22)*, he opened the Shadow dialog box. To create a deep shadow directly under the type, he set the X and Y offset values to zero in this dialog box and set a fairly high degree of softness and 100 percent opacity *(Fig. 23)*. The result was a shadow effect directly under the letters *(Fig. 24)*. However, Davis wanted darker shadows. Since the maximum opacity setting in the Shadow dialog box is 100 percent, Davis solved the problem by stacking several layers of the type, including shadows, on top of each other. This increased the opacity of the shadow, giving him the dark shadow effect *(Fig. 25)*.

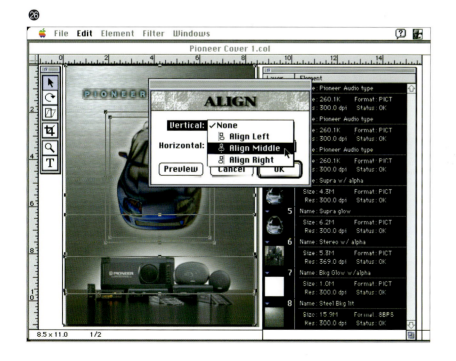

Step 13

During the process of creating his source files in Photoshop, Davis was careful to keep objects centered within their backgrounds. He was therefore able, as a final step, to precisely align all the components along their centers by making selections in the Align dialog box *(Fig. 26)*.

GALLERY Jack Davis

SYSTEM:
NEC 19" monitor, Quadra 840AV, 82MB RAM, 3GB of hard disk space, 128MB magneto-optical drive, 88MB SyQuest drive, DAT drive, Microtek scanner.

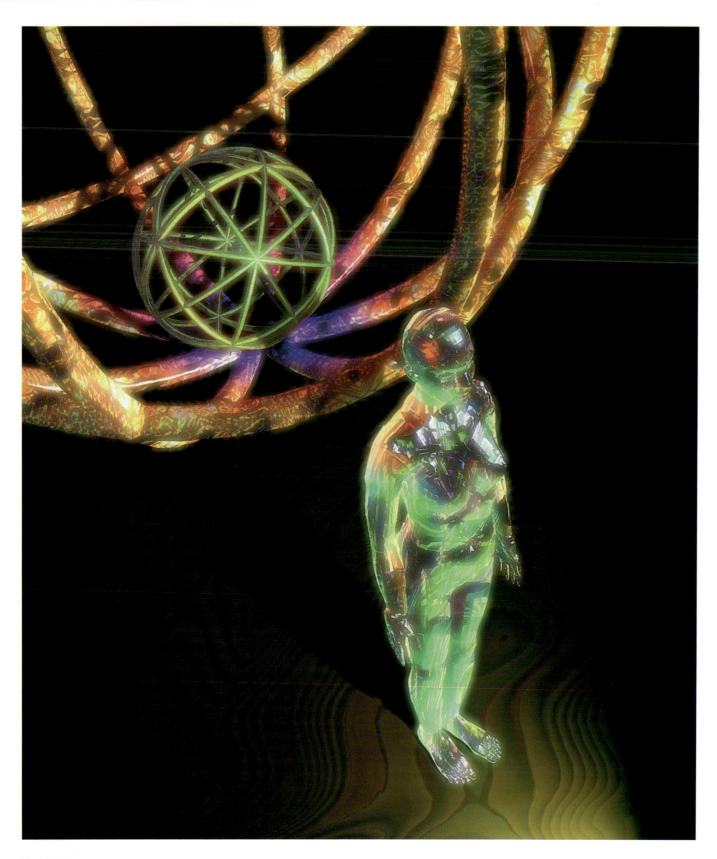

From Within

1994 / Step-By-Step Electronic Design (Japan) : Cover Illustration
Software: Electric Image1.5, Strata Studio Pro1.0, Adobe Photoshop2.5.1, Fractal Design Painter X2

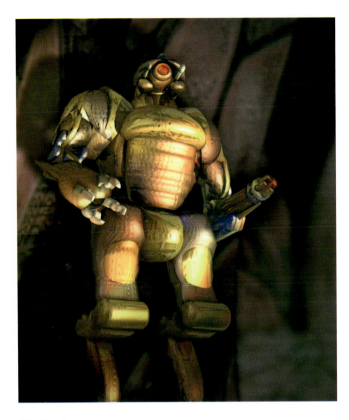

Alloy Beast
1994 / Presto Studios
Software: Electric Image1.5, Strata Studio Pro1.0, Adobe Photoshop2.5.1,
 Fractal Design Painter X2

Journeyman Calendar Robot
1994 / Presto Studios : Calendar Illustration
Software: Adobe Photoshop2.5.1, Adobe Illustrator 5.1

Alphabit
1992 / Verbum : Interactive CD/ROM Screen
Software: Adobe Photoshop2.0, Adobe Illustrator3.1

Blendo Atom
1991 / Verbum : Magazine Cover
Software: Adobe Photoshop1.0, Swivel 3D Pro1.0

Jack Davis

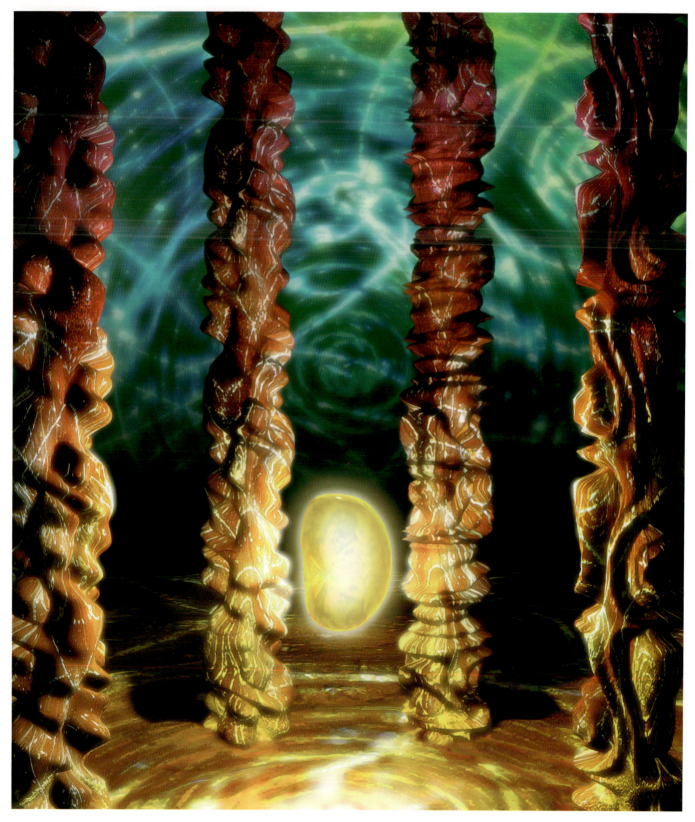

Ocean Seed
1994 / Step–By–Step Electronic Design (Japan) : Cover Illustration
Software: Electric Image1.5, Cybermesh1.0, Adobe Photoshop2.5.1

Planet Studio Logo
1994 / Self-Promotion
Software: Strata Studio Pro1.0, Adobe Photoshop2.5.1

Hi Rez Audio
1993 / Self-Promotion
Software: Adobe Photoshop2.5, Adobe Illustrator3.1

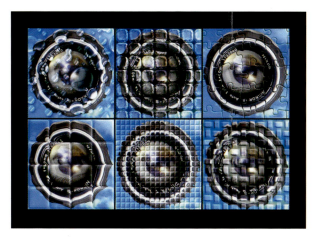

WOW Widgets Samples
1993 / Self-Promotion
Software：Adobe Photoshop2.5、Adobe Illustrator3.1

Photoshop WOW Book Cover
1992 / Peachpit Press
Software: Adobe Photoshop2.0, Adobe Illustrator3.1

Aiga Opening Title
1993 / American Institute of the Graphic Arts : Video Animation
Software: Electric Image1.5, Adobe Illustrator3.1

GALLERY
Jack Davis

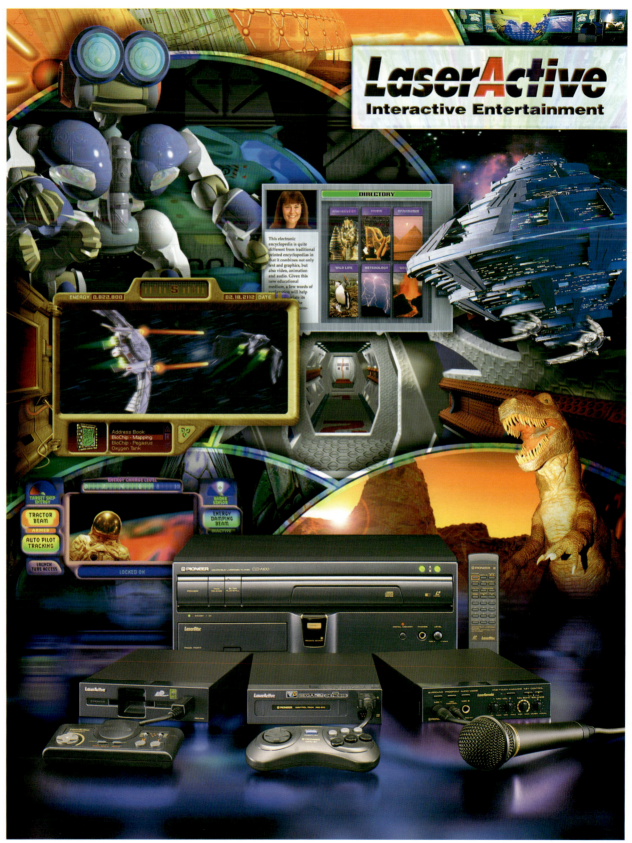

Pioneer Laser Active

1993 / Pioneer (Japan) : Poster
Software: Electric Image1.5, Swivel 3D Pro2.0, Adobe Photoshop2.5.1
Art Direction: Kazumoto Yokouchi (AXXi)

Alien Planet
1994 / Step-By-Step Electronic Design (Japan) : Cover Illustration
Software：KPT Bryce、Adobe Photoshop2.0

Earth to the Big Apple
1994 / Thunder Lizard Productions : Brochure Cover
Software: Strata Studio Pro1.0, Adobe Photoshop2.5.1

American Tease
1994 / Thunder Lizard Productions : Brochure Cover
Software: Strata Studio Pro1.0, Adobe Photoshop2.5.1

Loeb Title
1994 / Intuit
Software: Adobe Photoshop2.5.1, Fractal Design PainterX2

Collage 2.0.1 Feature

Collage 2.0.1 Features

Throughout "Collage with Photoshop" are step-by-step descriptions about 14 images created specifically for this book using Specular Collage 1.0. This means that some of the new features and improvements included in Collage 2.0.1, released in the fall of 1994, aren't reflected in the step-by-step projects. But since the major changes in Collage 2.0.1 are related to performance, such as Power Macintosh and CMYK support, the contents of the step-by-step projects still accurately portray working in the Collage environment. There are, however, several new functions which, had they existed in Collage 1.0, would almost certainly have been used by the artists involved with this project. These features are introduced in the next several pages.

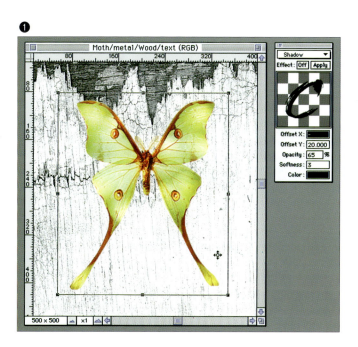

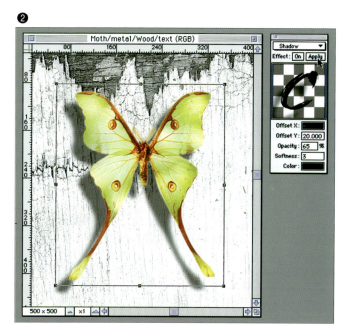

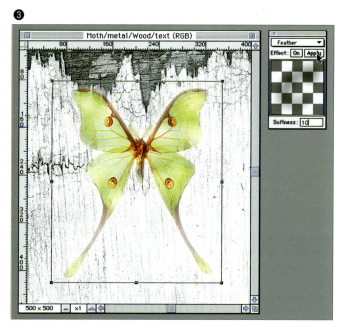

Shadow and Feather Palette

In Collage 1.0, shadows and feathers were added to elements by using separate Shadow and Feather dialog boxes. However, in Collage 2.0.1, the separate dialog boxes have been consolidated into a single Special Effects palette from which both effects can be applied.

For example, an image first imported into Collage and placed onto the palette has neither a shadow nor a feather effect (*Fig. 1*). A shadow can be added by turning on the Shadow function in the Special Effects palette and pressing the Apply button (*Fig. 2*). Likewise, a feather can be added by switching the mode of the Special Effects palette from Shadow to Feather (*Fig. 3*). Both effects can be applied at the same time to the same object, if desired.

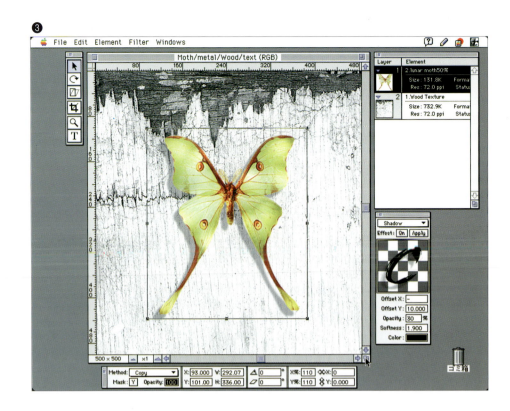

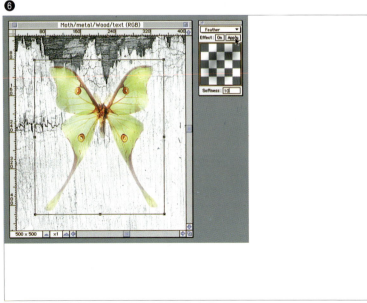

Mask Switch Capability

Unlike Collage 1.0, which only recognized channel #4 of a typical Photoshop image as a mask file, Collage 2.0.1 allows the creator to select from a number of masks saved with the image. This means more options can be tested in Collage without having to return to Photoshop to create new masks or modify existing ones. For example, the image of the moth has two masks saved with the file. One mask is used for cleanly silhouetting the object *(Fig. 1)*, while the other mask includes a radial gradation for blending the edges of the object into the background *(Fig. 2)*.

When the outline mask is turned on, the moth becomes silhouetted against the background *(Fig. 3)*.

To change masks, the Element, Mask, Switch Masks menu item is selected *(Fig. 4)*. In the Switch Mask dialog box, the second mask containing the gradation is selected *(Fig. 5)* and the moth fades into the background *(Fig. 6)*.

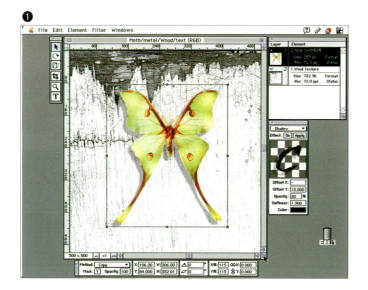
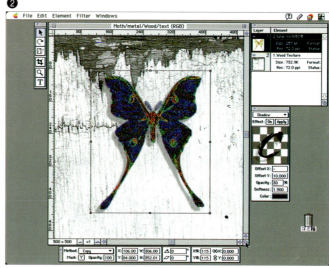

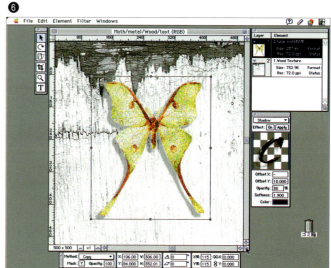

Filter Editing List

In previous versions of Collage, once a filter effect was applied to an element and the file was saved, the effect was permanent. With Collage 2.0.1, filters can be removed from any element, at any time, in any order.
For example, the image of the moth is placed onto a background *(Fig. 1)* and several filters are applied, including Contrast, Trace Contour, and Add Noise *(Fig. 2)*.
Afterwards, it's determined that the Trace Contour filter creates an undesirable result. In this case, the Filter, Remove Filters menu item is selected *(Fig. 3)*. The Filter List dialog box opens *(Fig. 4)* and the Trace Contours filter is removed *(Fig. 5)*. The result is that the moth is affected by only the Contrast and Add Noise filters *(Fig. 6)*.

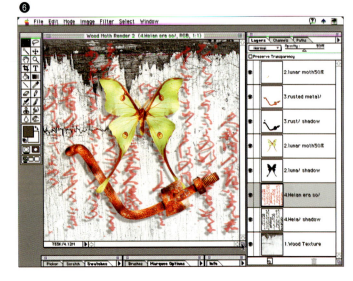

Photoshop 3.0 Compatibility

From the beginning, Collage provided a novel method of using proxies to composite high resolution images on low-end systems. But this was only a part of the package. Just as important was Collage's layer structure which, for those used to working in Photoshop, introduced a welcome degree of flexibility to the imaging process.

Then, in the fall of 1994, Adobe Systems released Photoshop 3.0 with its own layering scheme. This development, however, hasn't made Collage redundant. In fact, since the file size of a multi-layered Photoshop 3.0 image can increase very quickly, Collage's proxy system continues to be useful.

Additionally, to insure a continued role for Collage, Specular enhanced Collage's compatibility with Photoshop by including the ability to render and save images in Photoshop 3.0 format. This means that a multi-layered image composited in Collage 2.0.1 can be re-opened in Photoshop 3.0 with the layer structure from Collage intact.

For example, a project begins with a number of files prepared in Photoshop for compositing in Collage *(Fig. 1)*. After all elements have been imported into Collage, they're placed onto the palette and given special effects, such as shadows *(Fig. 2)*.

After the compositing is finished in Collage, the image is ready to be rendered. First, the File, Render Image command *(Fig. 3)* is used to access the Render Image dialog box *(Fig. 4)*. Under the File Type pop-up menu are several file format options, including an option to save the rendered image in a layered Photoshop 3.0 format *(Fig. 5)*.

Once the image has been rendered, the file can be opened in Photoshop 3.0. All of the layers created in Collage appear as layers in Photoshop, including separate layers for each of the shadows generated in Collage *(Fig. 6)*. Because the composited image still incorporates layers, Photoshop's full-range of editing tools can be used on the image. In this case, the Lighting Effects filter was applied to just the background layer *(Fig. 7)*.

Credit

Collage with Photoshop
by Russell Sparkman

Production	:	AXXi
Planning	:	Kazumoto Yokouchi, Hiromi Kawanaka, Ichiro Hirose
Editor	:	Ichiro Hirose (AGOSTO)
Art Director	:	Kazumoto Yokouchi (AXXi)
Production Manager	:	Hiromi Kawanaka (AXXi)
Computer Illustration	:	Kazuaki Takagi
Layout	:	Kazuaki Takagi, Kuniko Isokane
Photographer	:	Claude Charlier
Cover Illustration	:	Joseph Kelter
Proofreading	:	Summit Creative, Douglas W. Jackson
Interview Coordinator	:	Christopher Rutter (Resource Japan), AGOSTO
Digital Font Supplier	:	Rick Valicenti (Thirst)
		T-26
DTP Consultant	:	Takao Takeshita
Digital Prepress	:	Mu, Inc.

About Author / Editor

Writer
Russell Sparkman

Sparkman graduated from Northeastern University in Boston and later worked as a commercial photographer at the university until 1992. After a year as an assistant instructor at Kodak's Center for Creative Imaging, he moved to Nagoya, Japan in August 1993 and opened Sparkman Communication Services, a photography, digital illustration, writing and translation firm.

Production
AXXi ("Akshi")

AXXi is a Tokyo ad planning firm specializing in computer art. AXXi's Kazumoto Yokouchi has worked as an art director with illustrators Jack Davis, Bert Monroy, Jake Tilson and others on projects for major clients such as Pioneer and NEC.

Editor
Ichiro Hirose, AGOSTO

Hirose founded AGOSTO in 1989 to handle electronic design-related editorial work. He is editor-in-chief of Step-By-Step Electronic Design Japan, and translated the Photoshop Wow! Book into Japanese.

Prepress Production
MU, Inc.

One of the leading Macintosh service bureaus in Tokyo, MU is also active in the CD-ROM publishing business. MU recently released its CD-ROM interactive game Horror Tour in the United States.

This book was produced entirely on the Macintosh. The printing film was output with a Screen DT-R1035/1065 using alphalogic screening at 175-lines/4064 dpi.